THE

LIVING TREE

ART

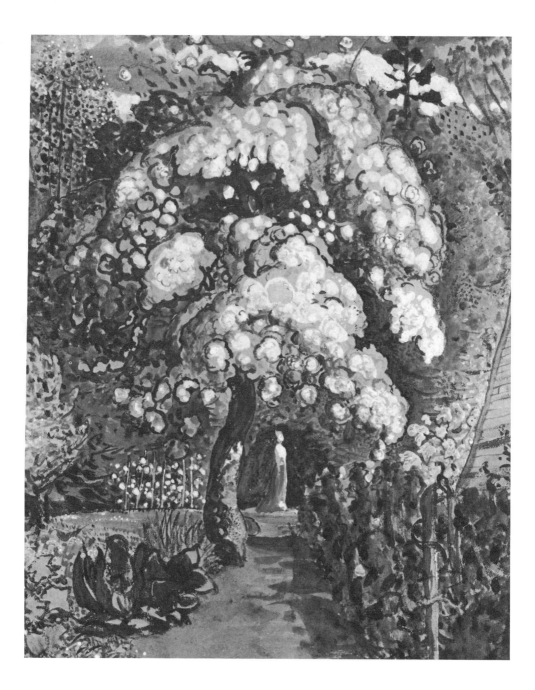

THE
LIVING TREE
ART AND THE SACRED

John Lane

Foreword by Cecil Collins

GREEN BOOKS

Frontispiece
SAMUEL PALMER
In a Shoreham Garden,
(c. 1829)
Water colour and body
colour; $11\frac{1}{16}''$ × $8\frac{3}{4}''$
Victoria & Albert
Museum, London

First published in 1988 by
Green Books, Hartland, Bideford, Devon EX39 6EE

© John Lane 1988

Printed by Hartnolls Ltd
Victoria Square, Bodmin, Cornwall.
Typeset by Computype, Exeter.

British Library Cataloguing in Publication Data

Lane, John
 The living tree: art and the sacred.
 1. Religious visual arts.
 I. Title
 704.9'48

 ISBN 1-870098-15-3

There is something above inspiration, a ray from above which is not ours. I cannot say it exactly; it must be a *je ne sais quoi* in man that keeps his mouth closed and makes him active, that is silent even when he speaks, an inner silence that leads to action.

Vincent Van Gogh

I claim that human mind or human society is not divided into water-tight compartments, called social, political, religious. I do not believe that the spiritual law works in a field of its own. On the contrary, it expresses itself only through the ordinary activities of life. It thus affects the economics, the social, and the political fields.

Gandhi

Who need be afraid of the merge?

Walt Whitman

Learn how to love the art in yourselves and not yourselves in art.

Constantin Stanislavski

The artist is not a special kind of man, but every man is a special kind of artist.

Ananda Coomaraswamy

Contents

Acknowledgements

THE AUTHOR AND PUBLISHERS would like to thank the museums, galleries and private collections, photographers and photographic agencies and institutions who provided photographic material and kindly permitted its reproduction.

Specific acknowledgement is made as follows: to the Tate Gallery, London for Plates 13, 15, 16, 17, 24, 27, 30, 33 and 36; to Trustees, National Gallery, London for Plates 2 and 20; to Windsor Castle, Royal Library © Her Majesty the Queen for Plate 43; to the Victoria & Albert Museum for Plate 12; to the National Gallery of Art, Washington, Andrew W. Mellon Collection, for Plate 10; to the British Council, London for Plate 6; to Smith College Museum of Art, Northampton, Massachusetts for Plate 29; to the Centre Georges Pompidou, Musee National d'Art Moderne for Plate 28; to West Sussex Record Office, and County Archivist for Plate 42; to Musee d l'Armée, Paris for Plate 23; to the Stanley Spencer Estate for Plate 31; to Jake, Kate & Andrew Nicholson for Plate 41 and Helen Bequin for Plate 40; to Cecil Collins & Clive Hicks for Plates 34, 35, 36, 37, 38 and 39; to Peter Burton for Plates 3 and 4; to Andy Goldsworthy for the three photographs which compose Plate 9; to Bobby Cox for Plate 43; to James Ravilious for Plate 5 and my wife for making the drawing reproduced as Plate 1.

Foreword

THERE IS A GROWING AWARENESS that modern art is approaching a severe crisis and that sooner or later it will have to undergo a ruthless revaluation.

John Lane has written an important book which goes straight to the heart of this crisis, showing the causes of the disorientation of modern art, which for so long now have been made a virtue of, or have been accepted without intelligent criticism or questioning.

John Lane shows the outlines of man's creativity in the great cultures, that is in the periods when man's consciousness is collectively focused on a creative centre of life, which is called the sacred. He does this by showing this creative orientation not only in its general form as history, but also in the work of individual artists, and in the paintings of some contemporary artists who have endeavoured to turn towards this centre of life.

Ultimately, artists are by far the best guides to the inner world of beauty and vision and one of the reasons why I think that this is an important book, is that John Lane does not write as an art historian, he writes as a practising artist, that is from his actual existential experience as a creative artist, allowing the paintings to speak to him directly. It is in this actual experience that he finds confirmation of that universal reality, the rediscovery of which alone will save our culture and our civilization.

Cecil Collins
July 1988

Preface

T H E R E I S N O R E A S O N why a painting should not bear as succinct a metaphysical message as a philosophical treatise, a novel, or a collection of essays. Both can be carriers of life and the present. I hope, therefore, that both my words and the paintings which accompany them, will convey something of the same qualities, not as illustrations or explanations of each other, but expressions of the same vision.

The Living Tree could not have been created without the support and encouragement of a number of people. To acknowledge all my debts of friendship in this preface would be a daunting task – probably an impossible one – since I am certain I have forgotten most of them. But I would like to express my gratitude at least to those friends whose value to this book, whatever its merits, I know to have been direct: Maurice Ash, Kathleen Raine and Henryk Skolimowski who encouraged me to write some of the original material, Satish Kumar who suggested its expansion into book length, and William Anderson and John Moat who ran their critical eyes over an early draft. Lastly, but by no means least, I wish to acknowledge my debt of gratitude to Cecil Collins for his foreword, to my son Adam for his design and to my wife and other children for their support and forbearance during the book's inception. I am grateful to them all.

Introduction

T H E L I V I N G T R E E is a living culture, symbol of a
civilization in which religious, aesthetic, and practical life are
one.[1] It is therefore the antithesis of the dissipation and
despair I find in the modern world. This, by contrast, I'd call a
dying tree, an unhealthy tree or a withered tree – like one
affected by acid rain.

The modern world is sick from many causes but a
diminution (and denigration) of feeling is one of the most
serious. We can, for example, barely talk of love or beauty,
purpose or meaning, without embarrassment. We have done
dirt on the soul. The arts, too, 'the embittered arts of the
twentieth century', as Alexander Solzhenitsyn has described
them,[2] 'perishing from ugly hate', are themselves emblematic
of a greater starvation and unease.

What then can we do? This book touches on some answers
to this question. It considers the impending changes in our
civilization and the need for a renewal of relationship and
creativity. It discusses the central crisis, the one about which
we so rarely hear, the crisis of religion and the arts. And
attempts to answer the question the poet Hölderlin raised
over 150 years ago – what are poets for in a barren age?[3] One
answer was given by Michael Tippett when he said that the
artist's job was to 'renew our sense of the comely and the
beautiful: to create a dream'.[4] I have tried to give my own
answer by making this book.

In so doing I, too, have done something as foolhardy as it is
possible to do. I have dreamed. I have dreamed of the hunger
for expression so alive in all of us, I have dreamed of the
repressions we have suffered as a result of our scientific
'success', I have dreamed of a world uneasily awakening from
three centuries of materialism. I have dreamed the Living
Tree, an amalgam of life and the sacred.

The terms man and mankind are used throughout this book as a generic description of humanity as a whole; they should not be taken to infer the superiority of the male of the species over the female. Far from it. As the book develops it should be apparent that the whole argument is in favour of the re-establishment of the great feminine principle, as recognized by the nature religions of the past and their reverence for the Earth Goddess.

1

A PAINTER'S QUEST

A Painter's Quest

I REMEMBER A MORNING – I MUST HAVE been about eight or nine – when I was watching snowflakes as they brushed and melted against the cold glass of the window of my parents' room – a bay, like all the others in the road. The sky was as brown as wrapping paper, a wonderful mustardy umber (never that colour now) and the white vortex of descending snow, the smoking chimneys, the dark, pruned trees, had a mystery more real than everyday. I knew then I would be a painter. That painting was to be my life. I didn't and couldn't put that thought in words. I just *knew*. The remembrance stayed in my mind, would keep returning like waters drawn to the same shore. Sometimes in the middle of the night I would wake up and lie unable to sleep feeling the burden of the knowledge, solemn, unalterable and secret.

Secrecy was imperative. My mother and father were kind but conventional; not the least notion of my ambition occurred to them. But why should it? Like so many others, like multitudes of others in our suburb, my parents had no need for books or music, let alone painting, in their busy, practical lives. The environment where we lived with its diminutive lawns, yellow privet hedges, flower beds edged with crazy paving paths, was no more conducive to the grandeur and mystery of the arts than our comfortable but undistinguished house. Then, too, there was the war; it had been declared about the same time as the secret 'consecration' to painting. Much of it, for me at least, had a dream-like quality even in the light of common day. I can still see the enemy planes advancing, rank on rank, like glinting fish and the barrage-balloons – floating in the morning light or

Plate 1 (left)
TRUDA LANE
Man and Soul, (1988)
Brush drawing on paper

3

covering up, with their huge bulk, the dark and glittering majesty of distant galaxies – which were a familiar sight. For my parents, however, the war meant less dreamy things. My sister's budding interests – she was interested in the theatre – and my own enthusiasm for painting and presenting puppet plays – were for them hobbies, 'something one got over' in maturer years. Yet our parents never actively discouraged us; they did everything in their power to give support. They gave us, too, the most precious of all gifts: an unhurried space to dream.

I can't remember a time when Croydon's ugliness didn't hurt, really dis-orientate and perturb me. In contrast, I always loved the look of things; their beauty helped me to discover my own reality. I loved the feel of a stone or the plane trees in our road breaking into light, and their mould-coloured patches of bark. For long periods of time I would gaze into the crimson depths of antirrhinums and at insects whose wings, in a glittering laurel, also shone like glass. I remember, too, the lilac-green shadow of a milk bottle on a cream cloth, and the charge, like electricity, of the livid and coppery gloom of a storm. Whenever I could I would cycle to Shirley Hills, a dream adventure amongst trees and sea-washed pebbles. Born in a town, brought up in a town, made wretched by suburbia, one of the routes of escape was through a descent into the interior world. The other way was through nature. I have always been drawn to live in the countryside.

My parents sent me (so they hoped) to the 'best' school – Whitgift – in the town and I went there for six years as a day pupil. To this day I can see the black-gowned masters in the various 'subject' rooms and the rows of iron-framed desks in which we sat facing enormous blackboards. Outside the window I'd see great cream cumulus rise above the school's copse; I'd watch butterflies dancing in the light and the grain of the wood of my desk. It's not that I actually hated school; from the day of my arrival to the day I left, I simply felt out of place, ill at ease, like one living in occupied territory.

Yet, paradoxically, the school gave me something of

4

inestimable wealth – it brought me into contact with the first human being who had intimations of my secret purpose. Frank Potter, the art master, was a man of unusual culture. He loved the arts with a more than academic interest and shared with me, an ignorant suburban child, a treasure-house of insights. To Potter I am indebted for the first sight of Corot, the first Bonnard; Poussin, too. He lent me Proust, talked about the Paris he had known between the wars, about wine and cheese, Eric Gill and Matisse. More important activity still, he himself painted and regarded the art as the most important in the world. No one, no one at all, had ever revealed so much. It was revelation. Revelation, too, was my first sight of Chartres – dove-grey against a thunder-black sky with the gold of harvest all around it – on my first visit to Europe after the end of the war. It was 1947 and I was seventeen. Such experiences bore witness (as the arts do) to deeper mysteries than are evident in Croydon High Street.

In my last years at school the art room was both refuge and Aladdin's cave: a great coffee-scented treasure of books, odd-shaped coloured shells, reproductions, bunches of red tulips and sprays of hawthorn. It always smelt unlike the other rooms – the acrid-tasting physics lab, for example, or the sulphurous smell of the chemistry department – as if it were alive. It was in the art room and the school's wood, heavy with leaves, motionless in the morning light, black caves of shadow in the midday sun, that I felt most at peace in my stirring adolescent self. I'd go there to paint whenever I was free. Here the magic was astir again.

At home, too, I was either painting or reading much of the time. I painted a mural based on some Gauguin-like figures on the steamy kitchen wall. Then in the evening, alone in my room, I'd read the lives of the painters as in an earlier century a novice might have read the lives of saints. This is my version of the story of adolescence. For the rest of the family, however, there was no doubt a different tale to tell.

My time at the Slade – it was from 1949 to 1953 – was both a

5

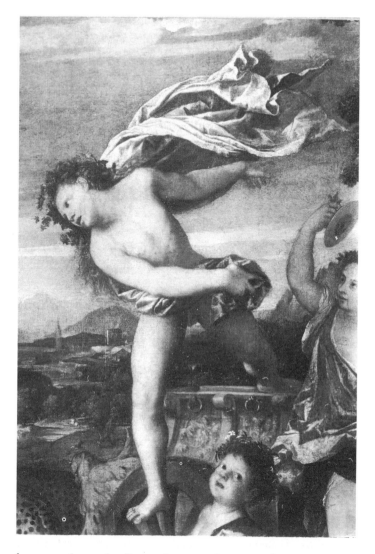

Plate 2
<small>TITIAN</small>
Bacchus and Ariadne,
(1523), detail
Oil on canvas; 69″ × 75″
National Gallery, London

homecoming and a disappointment. It was good to be painting and making friends for whom painting was no hobby, no distraction, but a consecrated path. Some of those friends are still my friends and one of them, Truda, is my wife; another, my sister's husband. We had good times together, they and all of us.

6

But these years none the less exacted an unexpected price. William Coldstream, the new professor, was in the process of changing the school's ideology. Out went the emphasis on 'art school' drawing; in came the Euston-Road School method based on exact measurement, the plumb line and old-fashioned materialism. It was a chilly discipline. Harmed in subtle ways by its almost moral, puritanical approach, it took a considerable time, about twenty years, for Truda and me to unlearn what we had been taught. Yet, as I enlarged the treasure-trove of insights Potter had provided at Whitgift, the Slade was also a period of unequalled abundance.

After long and concentrated study – having gazed, for example, at the curving form of a shoulder where, miraculously, it meets the white column of a neck or, in the Antique Room, amongst cool ferns, at the rippling muscularity of a bone-white torso, grey against the closing light, I would walk straight to the National Gallery to stand before a favourite painting, say, Titian's glorious *Bacchus and Ariadne,* (Plate 2) glowing like sensuous fruits in those empty, fog-laden rooms. With rapture and a kind of grief I would stand before the Duccios, all blue and gold and green, the Piero della Francescas and the Sassettas, clean, pure and new as spring water, but wrenched from the sacred places they had once inspired.

Carrying the remembrance of their radiance within me on the swaying, smoky, crowded, home-bound train (for at this time I was still living in Addiscombe in my parents' house), I would glimpse the backs and gardens of the terraced houses, the sooty spires, the iron-framed swings in the parks, with a kind of shuddering despair. Was this, I thought, what we had been made for? Why had our civilization put out its eyes? Where in the darkness of these dreary streets was the light I had seen in Sassetta, in Corot and in Claude? At the time I was reading Lawrence, another victim of Croydon.

After the Slade I was self-centered, conceited, humourless – and, I assumed, unemployable. Nonetheless some kind of sanity prevailed; when given the choice between starvation or a job I

7

chose teaching, however ill-equipped. Facing classrooms of raw-faced, country boys, I took a risk – but survived. The three years I lived in and taught 'art' at Ripon Grammar School, though painful (and I was then as green as grass), weren't without their own fund of enjoyment.

There were, in fact, two special pleasures at this time: the children and the Yorkshire countryside. I liked both the teaching and the boys and was genuinely surprised how readily their 'art' would blossom into life. At the time, delighted as I was, I took this development for granted. Only later, on reflection, I saw it as a demonstration that each of us, call it what you will, is an artist in his or her own right. In the modest shed that served me as an art room I discovered that human creativity is not rare, but universal; as potent, almost impersonal, transformative, as the power of sex or the rising of sap in spring.

I also received the greatest pleasure from the walks I took most evenings and at weekends in the countryside around the town. As soon as school was over I'd set off across the fields, not following paths, but through gaps and over walls, towards the north. Walks took me in all directions – to Sawley and Winkley, Littlethorpe and Hutton Convers; along the dry beds of the stony rivers in high summer and the crow-haunted avenue of limes in Studley Park where the landscaped park of Fountains Abbey lies. (Plate 3). I had no car but travelled slowly, observing, as I went, the minutiae of earth and life: the wild garlic in bird-haunted coppices; sticks and stones on a pinky brown path; a calligraphy of red, rotting leaves; an earthworm slithering into grass. Intoxicated by what I had seen I would return in the twilight, shoes frothing with sap, exalted by a visionary insight both confronting and enriching the daily routine in the classroom. Then, as the first star rose and swallows turned and twisted about the field – I hear their wings vibrating now – I often felt as if my life, all life, had flooded back, tingling to my fingertips. Sometimes this feeling rose to unexpected heights when I, the wet grass, the birds, and star were in complete accord, all knitted into one. Much that has taken place since then,

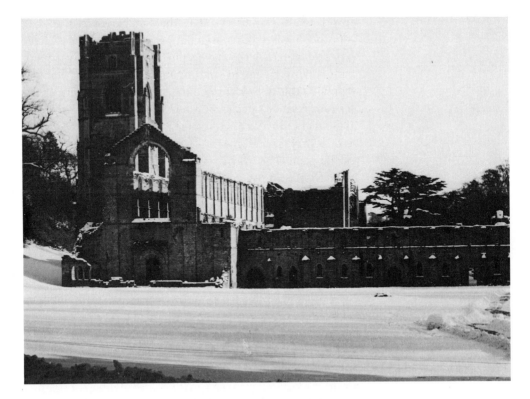

however mundane, has been informed by the knowledge I acquired on those walks, amongst the most important experiences of my life. Few languages, except perhaps music and poetry, and painting too, are adequate to this knowledge of the heart.

Plate 3
Fountains Abbey
Photo: Peter Burton

Three years later – it was in 1955 – I left Ripon for Devonshire. I lived rent free (in exchange for relief milking) in an orchard on a farm in Colyford, near Seaton on the south coast. The move, long premeditated, was part of a plan to build up savings, abandon teaching, and paint. But in turning my back on urban values, on material 'success', on materialism, on Modernism in the arts, I now suspect I was obeying an impulse no more personal than those which instruct the flight of birds or the movement of the eel. I was simply obeying an historical

9

process which may affect many others in due course.

Colyford was a gift; a brief but paradisical interlude. Here I experienced turbulence and deep peace; living simply, reading widely – English poetry and mysticism – and going for long walks. To this day I can smell the swathes of hay lying in the dusk and hear, far off, like the echo in a shell, the sound of the sea in the night. But the point of being there, of course, was not to read poetry or milk cows, but to paint; and this I did, indefatigably. The work of this time, clumsy, unrealized as it is, is the first I can recognize as my own. There are paintings of birds and of rounded hills, and the sea, of great yellow suns and in one, a white foxglove, almost phallic, a spire of irridescent white. For a year and a half – two summers – I lived in a wooden shed in a little orchard attached to a farm. It was a joyful, enriching, but, at times, a very lonely life.

Truda and I were married on a gusty morning in April 1957. From York we travelled by bus to a cottage on the green at Goathland, a remote village on the North Yorkshire moors. (Plate 4). Instead of rent Truda dusted the adjoining property. I returned to part-time teaching in a Scarborough school. We also drew and painted, explored the moors, read and listened to music, made new friends and, in the course of time, as things are as they are, we had four babies, four vigorous sons. It was the kind of life we had always desired.

And so it might have remained if it had not been for something I have never really understood. Painting – even taking into account its agonies and failures – had been as necessary for the fulfilment and happiness of my spirit as daily food. But now, about my thirtieth year, multiple corrosions of doubt began, like shadows, to appear. I assumed they wouldn't last. But the shadows deepened, darkened, multiplied, spreading at last into my work. Some of the oils I painted at this time – of blood-red suns and landscapes raked by fire – are ominously dark, dark with the darkness of disturbance, not tone.

To this day I haven't the faintest idea why I stumbled into this valley of the shadow of death. Perhaps the part-time teaching in

10

Plate 4
Goathland on the North
Yorkshire moors
Photo: Peter Burton

11

a school I actively deplored exacted its own subtle revenge. Perhaps our growing family distracted concentration. Perhaps my isolation and the alien northern landscape disconcerted me? Who knows.

There was however, a less personal reason why, after a struggle, I ceased to paint. Living in remote villages I began to feel the pain of the modern artist who discovers his futility and uselessness. As it happened I experienced this most keenly at a time when we were living in a Yorkshire village, Wykeham, under the shadow of a hill. Here the sense of alienation, the experience of rejection, began to have a paralyzing effect. For years, I'd sweated over my work, groaned, hauled over it, but to what purpose? They didn't need me, I knew. As an artist I was functionless. At the same time contemporary work in the arts began to fill me with distaste. I remember leaving the Tate having seen *Painting and Sculpture of a Decade, 1954 to 1964* with something close to dismay. There were authentic and beautiful things on view but also, it seemed to me, a widespread state of aesthetic loss, of imaginative and spiritual exile. Almost the whole show felt empty, denuded of both human and sacred power.

Looking back I am not surprised I felt so discouraged at the time; it takes dogged courage, obsessional energy and unwavering dedication to go on painting in isolation. So when the time came I decided to give it up – and, at once, I felt a blessed release. It took a load off my shoulders and a great worm of rubbish from my guts – all the lies and betrayals, the propaganda and the false assumptions I had ingested since childhood. More personally, I like to think it also cleared away at least some of the head-in-heaven priggishness – the shadow side of the romantic – which had kept me apart. Released from this heroic burden I felt like a fat man after a diet.

In 1965, we left the North Riding and travelled west towards the Pennines; I had taken up a full-time post (the first in ten years) as a lecturer at Bretton Hall College of Education near Wakefield – a specialist college for the preparation of teachers

12

in the arts.

It was hard work – but at times rewarding. Once again I enjoyed teaching and helping the students discover their own art. I also loved to visit some of the schools where amazing work was being done in desolate surroundings. For, here and there, thanks to the human spirit (and the enlightened guidance of the County's Chief Education Officer, Alec Clegg) the children's work astounded; it had a passion and a beauty which was the gift of life. I'd seen nothing like this at the Slade or in exhibitions of contemporary work. I left these schools humbled by the fine free sensuality of children otherwise and apparently 'deprived'.

I was at Bretton only a short time – only eighteen months all told – when I applied for and was accepted to run a new venture in the south. It was an arts centre in a remote village in North Devon which the Dartington Hall Trust (of which I had then barely heard) was seeking to set up. Truda and I jumped at this chance. Truda, because she wanted to leave the grey, inland light of the West Riding and I, because I was interested in the restoration of the creative imagination to a people butchered in soul – which was what the establishment of the Beaford Centre seemed to offer. I began work in April 1966 with the blessing of the trustees, an eight-bedroom house, and a grant of £12,000 a year. There was nothing else – or, rather, nothing of a physical kind though a few ideas were already 'in the air'.

Beaford opened with a shout – an entertainment – taking place all over North Devon, a region comparable in size to Derbyshire. There were thirty-three different events, amongst others, performances by Mike Westbrook, Jennifer Vyvyan, Thea King and the Treviscoe Male Voice Choir; Roger Norrington sang in an opera, Bill Brandt showed photographs. There was also the first performance of a specially-written play, *The Royal Pardon,* by John Arden and Margaretta D'Arcy with both authors in the cast. There were, too, performances by local people; venues ranged from churches and school halls to the centre itself. 'The Beaford Centre was opened in August 1966,' declared the *Western Morning News,* 'it opened with a bang

13

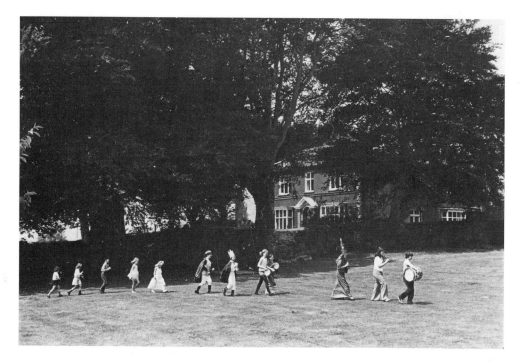

Plate 5
Rumplestiltskin in front of
the Beaford Centre
Photo: James Ravilious

that shook North Devon, one of the last of the world's great
capitals of sleep, and which was registered, if for the most part
incredulously, throughout the South West.'

This was the beginning of a period of unprecedented work.
While the programme of events was sustained (at a rate of three
a week), day and evening classes in the arts were set up. In 1969,
I established a peripatetic theatre company, the Orchard, which
is still touring (but now throughout the entire south west); then
a community arts group; residential courses in the arts (Plate 5)
for the county's children; an 'archive' of local photographs taken
by a 'resident' photographer. 'All art is an attempt to manifest
the face of the God of life,' said the painter Cecil Collins whom I
count as one of my friends. Behind every one of Beaford's
manifold events – every occasion, every exhibition, every
workshop – was the wish to reveal that face.

I loved the work and the vision behind it which was –

14

nothing more – the experience of my boys at Ripon, of the old West Riding desert made green, writ large. For here was a chance to offer service; here I could return at least some of the riches which others had heaped onto me, not only Mozart and Verdi, Shakespeare and Rabelais, but my parents, Potter at Whitgift, some tutors at the Slade, all my friends, Alec Clegg. Even the anonymous driver who had picked me up on the way to Cornwall some twenty years before – taken me to his house, offered mead, a bed and *Die Schöne Müllerin,* heard by me for the first time. Like others before I wanted nothing more than to share my own deep pleasure in the arts.

I had, too, a vision of a regenerated countryside flowering with creative life. I dreamed a dream in which the centre's energy, the energy of the arts, might penetrate the community's life-blood and infect it with an excited self-awareness of its own communal life. And there were occasions – with groups of bell ringers, with Ravi Shankar, with the poet Stevie Smith, unknown guitarists, during choral concerts, town festivals, in the light of bonfires with processions of giant effigies or the hushed intimacies of a lute recital on a still summer's night – their number is legion – when something of the kind took place. The world awakened and a finger of light from the risen sun pierced the dark sky.

Beaford grew in size and scope. It stimulated people's enjoyment of the arts in an area where relatively few activities of this kind had previously taken place. Yet in a sense, as I now understand it, our efforts were not so much wasted (for how can the benediction of life-giving action ever be considered a waste?) as forlorn; the Sleeping Beauty of a dying culture can't in this way be brought to life. Our civilization needs more, much more than artificial restitution, the oxygen of the arts, to awaken its soul. It demands, and will in time acquire, a profounder spiritual renewal.

As the years went by it was only natural that I should in this way ponder some of the questions raised by Beaford's work. Haunted by evidence of the ruins of the old order in which we

15

lived I began to think more deeply about the role of the arts in life – the relationship, too, of the 'high' and 'low' arts to one another: the art of thatching, for example, to the art of sculpture. I began to read Ruskin, H.J. Massingham, Ananda Coomaraswamy and Carl Jung. Eric Gill was helpful, too, and of course, Blake, and all others who had spoken, in our materialistic culture, from the soul, of the soul, to the soul. And slowly – for I am a slow kind of man – I began to understand what in a sense I had always known: that life and art and religion are all one; names for the same experience – the same intuition of reality and identity. More and more clearly I began to see that without the fullness of a sacred vision, imaginative art cannot flower.

About this time – and I am thinking of the early seventies – some threads began, at last, to interweave and form a fabric, however capricious, I might call my own. I was now in my forties and administration of the centre, though volatile, was more settled than before (by 1974 it must have been employing some two dozen staff). At this time, too, like many people approaching the second half of their life, I felt the need to review what I had done and consider the future. One thing was clear. Without planning I had drifted into 'arts administration'; a life of committees, engagements and 'responsibility'. I had become a parent of four energetic boys. I had acquired property and land. Yet all these parts, 'successful' in themselves, did not, I felt, add up to a whole. There was something missing. I began to yearn for the kind of life in which acts and makings, philosophy and dream, come together as a whole. 'Only connect', the motto of E.M. Forster's *Howards End,* became my own.

As a first step I decided I should broaden my experience and in so doing found myself drawn to Beaford's parent body, the Dartington Hall Trust, where by invitation I became a trustee in 1974. Working for the trust I became engaged in wider fields – for example, commercial activity, rural research, education, and the maintenance of a great garden – than I had experienced before. I learned, for instance, how the accountant budgets and the retailer sets out his stall, how furniture is manufactured, and

16

a range of pottery re-designed.

The Trust had been born out of a unitive vision (largely inspired by the Indian poet and writer Rabindranath Tagore). And if in practice it sometimes forgets or ignores its ideal, it remains committed to the belief that the parts are only healthy in so far as they are joined harmoniously to the whole. The interdependence of one thing with another is the central tenet of Dartington's work. For me at this period it was therefore good to work there, more so than anywhere else.

Then the strangest thing occurred. The further I was drawn into management, business practice, quotidian affairs, the more urgent, imperative became the necessity to return; to retrace the path I had abandoned in Wykeham over a decade ago. Suddenly I began to live the life for which I had been preparing or had been prepared. At the end of the years of watching, of evacuation, of futility and questioning, my crude blurred life began to focus into what might be called a whole. Starting to paint again after so long a gap was not as difficult as I had imagined; I seemed to know what I was doing in a way I had not known before. Painting began to take its place alongside living; it became the most important single activity of my life.

Although some of the work I have made in recent years does not appear to be anybody else's, I am no longer bothered about originality – or, for that matter, the dreams of personal fame which haunted me as a boy. I am too old for most of the aberrations upon which I fattened my ego in the first half of life. The burden of loneliness, the pressure to be heard, the sense of mockery that dogged me at Wykeham, have largely – but not entirely – fallen away. I take pleasure in my work as an artist. A day without work is never a real day for me.

So, nowadays, when I'm not at Dartington I'm painting most of the time. And when I'm not painting, or cooking, or gardening, or helping the boys, I go for little walks in the surrounding countryside. Out of the gate, turn left, and right again down Peggy Trigger's hill to the valley bottom where the crows rise from the trees as I approach. Between fields of grass

(blowing like water) I walk for several miles. At a certain bridge I return. It is twilight now, then dark. The moon has risen, a slight breeze stirs the shadows of trees across fields of corn, white like water. On other days I'll take another walk. This one takes me across Farmer Lake's flat fields above our house (the sky seems closer here) to the brink of the slope which descends, in a rush of silvered oaks, to the glinting river below. Two mornings ago I saw a black bull, steaming in the golden frosty light.

For me painting is me, justifies my existence. It reminds me of what I have been and grows from what I am – Croydon, Ripon, Beaford, Dartington, are all part of my story – alongside Truda, and the temple dancers of Jaipur, dreamtime, sea marvels and this morning's rainbow. And though I can't say if I have become what everyone is in their soul, an artist, I can recognize that my story, rambling, inconsequential, incomplete, has been subject to a mysterious design.

2

THE DEATH
AND RESURRECTION
OF THE ARTS

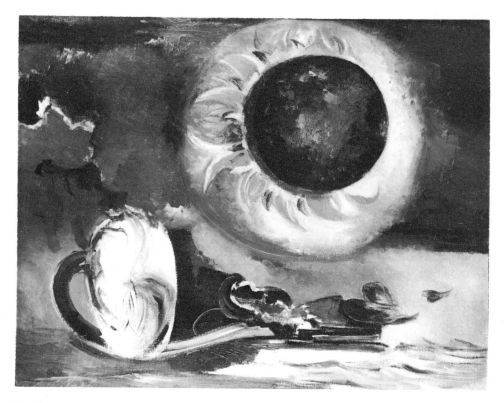

Plate 6
Paul Nash
Eclipse of the Sunflower,
(1945)
Oil on canvas; 28″ × 36″
The British Council

The Death and Resurrection of the Arts

PROPHESY AND YOU TAKE your life in your hands.

It is inevitable that present attitudes and expectations should colour ideas about the future. No less inevitable that we should live in ignorance of the lives of generations not yet born. How, after all, are we to consider the effect of Third World competition or of yet-to-be-invented technologies? How can we even imagine what effect the shift of power from Europe to the Pacific bowl will have on our children's children's lives? It is folly to assume we can know.

Yet in spite of our ignorance, the facility with which false judgements can be made, I have a feeling, approaching certainty, that a mutation of consciousness is changing the way we live and think about ourselves. A new vision is moving through our feelings, through our dreams. To put it another way: we are on the verge of a new age – a New Renaissance – which could alter everything.

There is no single explanation for this change. The holocaust and the nuclear arms race; the general failure of what Erich Fromm[1] has called the 'Great Promise of the Earthly City of Progress'; the discoveries and concepts of modern physics which have revolutionized the way we think about our world[2] – all these have contributed to the process of questioning and doubt. Other factors – for example, rock music and the use of drugs – have also contributed to the loosening of the straitjacket of rationalism.[3]

Signs of the mutation are observable from many quarters. There are, for example, increasing displays of disaffection and violence within our fragmented social system. Many people feel

21

cheated, for meaning matters as life matters, and life and spirit are entwined. Likewise bafflement pervades those certainties like education, medicine, and economics out of which we have made our myth.[4] People are dying of 'new' diseases or suffering as a result of prescribed medicines; paradoxically, too, schooling has reared more than its share of philistinism. In the visual arts and in architecture, too, a similar dehumanization can be seen. The achievements and values of the world we have ourselves created seem to have gone deeply awry.

Attitudes have greatly changed in the course of my own lifetime. I see these changes as the result of an irreversible social revolution, a revolution in which some of the century's best minds have joined.[5] These have turned their attention not only to the underlying malaise but, more significantly, to the creation of a new world view – a change of the premises of a civilization. They have sought to replace the materialist and consumerist values of our society with more sustainable, holistic ones, rooted in an order beyond any merely personal construction or fantasy. It is this vision – the connective or holistic vision – with which this book is concerned.[6]

Western ideas about art are an unprecedented departure from universal human culture as it has existed and developed from the Stone Age to our own time. They stand in opposition to the last 5,000 years of recorded history, in opposition to what we know about the lives of the majority of human beings who have lived on this planet, in opposition to what we can see with our own eyes in the great western anthropological collections.[7] So if I first turn our attention to a number of other cultural paradigms I do so with no intention of proving them either better or worse than our own. I do so simply that we may see our western culture in the widest context.

The earliest of the three (and the only one now extinct) has been described in a book by Malcolm Margolin[8] which has recreated the world of the Stone Age Indians who lived in

22

California in the San Francisco-Monteray Bay area. In our terms these people, the Ohlone, were 'backward' to an almost incalculable degree yet the complexity and subtlety of their culture, and the wisdom that permeated their way of life, can come as a revelation to a sensitive interpreter. Malcolm Margolin writes:

> In studying them, I was struck by the strange familiarity of certain aspects of their lives. A balanced (rather than an exploitative) relationship; an economic system based on sharing rather than competing; a strong sense of family and community; social moderation and widespread artistic creativity; a way of government that serves without oppressing; a deeply spiritual sense of the world: those are the very things many of us are currently striving to attain in our own culture. The irony is that while we look forward to a dimly-perceived future when such values might be realised, we have failed to understand that they existed in the not-so-distant past as the accomplishments not only of the Ohlone, but of Stone Age people the world over.

The feeling-tone and bias of Ohlone life are obvious. Myth, ritual, worship, craftsmanship, love-making, play, and festival were not separate, water-tight compartments but an expression of the Ohlone's profound nostalgia to inhabit a 'divine world'; they were, for them, the earthly reproduction of a transcendent model. For the Ohlone the whole of life was capable of being sanctified. 'Art' and 'religion' did not merely overlap, they were indistinguishable from one another and the rest of life.

There is a record that when the Spanish missionaries 'discovered' the Ohlone territory they expressed their displeasure, and no doubt their censure, at what they perceived to be the total absence of religion. Without churches or priests, holy books or sacraments, these savages were for them little better than beasts. The exact reverse was the truth. No record exists of the Spaniards' attitude to the Ohlone's 'art' which

23

would have been for them no less invisible. Yet it, too – in so far, that is, that their 'art' could be separated from life – was no less vigorous or ubiquitous. It, too, was as integral as the grain in wood or the pith in a stalk. Somewhere I once read: 'Fish living in sea and lake do not have to think about water.' In like manner the Ohlone did not have to think about 'art'.

Nonetheless what might be called artistic activity also flourished in Ohlone society: they produced baskets of unrivalled beauty and were, by all accounts, exceptional dancers. Dancing was a passion for all the Californian Indians. They spent days, nights, even whole weeks dancing. They had dances for all occasions and moods. Shamans danced to achieve clairvoyance, to influence the weather, to thwart death, or to make contact with the ubiquitous spirit world. Families held special dances to honour their spirit ancestors. There were wild dances to prepare for war, and others, even wilder, to celebrate victory. There were strictly social dances where enjoyment was the only object, and a multitude of religious dances.

Dances were woven into the Ohlone world – their medicine, their work, their law, their technology – like sedge root into the weave of their baskets. Dancing, like their other arts, was a natural part of living like eating and sleeping.

> The dance was, of course [writes Malcolm Margolin] an important religious event. The dancers had fasted, abstained from sex, cultivated dreams, and otherwise prepared themselves for the experience. They were now dressed in beads, bird feathers, and animal skins. Such things were not just ornaments but had extraordinary power – power which as the dance progressed would utterly transform the dancers, transform the spectators, and (at least this is how the Ohlones felt) transform the entire world.
>
> The beat never changed, but as time passed it seemed to grow more intense, coming not so much from the rattles or the clapping of hands as from the houses that surrounded the plaza, the trees around the village, the earth and the sky itself.

24

In long rhythmic and repetitive sequences the dancers stamped flat-footed on the resonating earth of the plaza. The dance went on for hours, sometimes for a whole day or even longer. The dancers stamped and stamped. They stamped out all sense of time and space, stamped out all thoughts of village life, even stamped out their own inner voices. Dancing hour after hour they stamped out the ordinary world, danced themselves past the gates of common perception into the realm of the spirit world, danced themselves towards the profound understanding of the universe that only a people can feel who have transcended the ordinary human condition and who find themselves moving in total synchronization with everything around them.

I have singled out the Ohlone's dancing – and could with equal ease have written about their rituals or their mythologies – because it is such a good example of the deep sense of enchantment at the heart of their world. This, of course, applies to all sacred art and if the Ohlone did not specifically experience their art as 'sacred', it was because an art completely divorced from religion or daily life was inconceivable to them. In fact the ceremonies I have mentioned were not 'shows' or performances in the sense which a westerner, who experiences his own body very differently, would use the word. They were used to induce (in conditions prescribed by ceremony) a state of self-abandon. They were performed in the course of everyday life. They were a communal art which almost everyone joined in and learnt by participation. They were a form of sacred play; indispensable, as Huizinga wrote in *Homo Ludens,* 'for the well-being of the community, fecund of cosmic insight and social development'.[9] Nothing less like our own dancing can be imagined.

No less ubiquitous than the Ohlone's dancing, is (or was – for it is under sentence from western 'progress') the music of Bali, that paradisical island boasting one of the richest artistic traditions of the human race.[10] Yet once again so common are its arts that no word meaning art occurs in the Balinese language.

25

Art is not regarded as a separate activity but something for everyone, in which everyone can join; testimony of the Balinese concern for 'doing all things as well as possible'.

Few Balinese even now would understand music in the European sense of the word. The Balinese cannot live, worship, or celebrate without music; they hear it and make it in their temple-festivals, their dance-dramas, their night-long performances involving either live actor-dancers or intricately designed *wayang* shadow-puppets almost every day of the week. Life is perpetually creative because it is continually renewed. It is therefore hardly surprising that the character of the music is so fundamentally different from our own – it is almost never played by professionals and never written down. Neither is it understood, as we experience music, as a form of personal expression. For the Balinese the arts have little or nothing to do with self-expression in our western understanding of the word. They have a different role – a religious and social function. Musicians and spectators, too, as Margaret Mead has commented,[11] are united in more ways than one:

> The Balinese may comment with amusement but without surprise if the leading metallophone player in a noted orchestra is so small that he has to have a stool in order to reach the keys: the same mild amusement may be expressed if someone takes up a different art after his hands have a tremor of age to confuse their precision. But it is a continuum within which the distinction between the most gifted and the least gifted is muted by the fact that everyone participates, the distinction between child and adult – as performer, as actor, as musician – is lost, except in those cases where the distinction is ritual as where a special dance requires a little girl who has not yet reached puberty.

Nor is there any gap between rehearsal and performance. From the moment an orchestra begins to practice an old piece of music, there is a ring of spectators, aspiring players, substitute players, small boys and old men, all equally

engrossed in the ever fresh creation of a new way of playing an old piece of music.

A further significant difference between our music-making and theirs is the Balinese attitude to the preservation of a work. Once a composition has served its purpose it is invariably discarded – a sign of musical self-confidence on the part of these richly creative people that is lacking in ourselves.

These are examples, two amongst dozens, which involve numbers of people in noisy ceremonials. In complete contrast I'd like now to turn to another continent, Africa, and to the work of a craftsman, a Muslim, Mohammed Umamama, a smith of the nomadic Tuareg tribe of Kel Agalal in the Air massif. His life has been described by René Gardi.[12] Working with the simplest equipment – in a straw-mat hut on the edge of the desert – Mohammed makes silver pendants, jewellery, and small, richly engraved sugar-hammers:

He would squat cross-legged on his mat for hours; he seldom stood up. Again and again he pushed back the wide sleeves of his robe or re-arranged his head wrap, which often slipped. From where he sat he could reach everything he needed. In front of him in the sand stood a broad anvil that served as a little work table. A little to the right of that was the forge, nothing but a little pit in the sand with three stones around it. The moveable bellows was worked by one of his sons. A few tools, tongs, a hammer, and files lay about, and some scrap metal nested against the supports of the hut. A little wooden box contained all sorts of precious things: snuff, matches, cartridge cases, the silver supply, the chisels for engraving. That was the entire equipment of the 'atelier'. Here Mohammed felt good, and in his element. He liked a laugh, and seemed always to be happy and in good spirits. And he always had time, even while working, to chat a bit. Whenever we arrived, he was seldom alone. The boys helped . . . neighbours' children sat on the sand and watched

27

interestedly . . . everyone who passed by stopped, greeted the respected smith ceremoniously, and said, 'Lafia, lafia, loo' (Peace be with you) and then sat down in the shadow of the roof It was all so incredibly normal, such a matter of course. It was life enveloped in friendliness, in mutual participation, and also in curiosity about others.

Nothing could be further removed than the completely secularized attitude to work in the West[13] with its system of quantity production dominated by pecuniary values. For here, 'on the one hand we have', writes Eric Gill, 'the Artist concerned solely to express himself; and on the other the workman deprived of any self to express'.[14] Or to put it another way, we have Hölderlin,[15] a poet contemporary with Beethoven, mourning for his loss of function, crying 'What are poets for in a barren age?' And a 23-year-old fork-lift driver working for Ford who says, 'When you're doing the same job, day in, day out, you'd rather do almost anything for a change. Sometimes you look around and ask when you are going to be anything other than a clock number?'[16]

We have travelled a long distance from the Ohlone or the Balinese who say 'We do not have any art, we do everything as well as possible; *we do all things properly*,' Perhaps one need only compare the calm certitude of Sancta Sophia,[17] endowed by its makers with something of the wonder and the transcendental beauty of the promised City of God, with the cosmic abandonment, the triviality, the sense of a gaping void without redemption in a work by Gilbert and George,[18] to become aware of the distance we have travelled in the last 1400 years.

In the last decades of the sixteenth century and the first half of the seventeenth, a number of words came for the first time into common use in the West, or acquired fresh meanings which are still in use today. Changes in language can be used as a special

kind of map by which it is possible to understand wider movements of life and thought.

Throughout the European Middle Ages there was, as in Bali and in common with the rest of the world, no word for what we now understand as art; art in traditional societies is unknown as a separate activity or feature of any creative act. All those who worked with their hands, amongst them painters and sculptors, were simply workman, their trade regarded as one of the manual crafts. Jean Gimpel has even shown that during this period the Latin terms that designated the workers who cut the stone did not generally permit a distinction between those who simply quarried it and those who carved the window tracery and monumental porch sculpture. The best sculptors were as lost among the mass of stonecutters as I have heard the finest voices in a monastery, for example, at Solemnes, 'lost' amongst the general body of the monks for whom the singing of the liturgy prompts the heart to prayer. Gimpel writes:

This is really rather extraordinary for us because an enormous difference seems to exist between those who perform a seemingly mechanical task, such as cutting blocks of stone, and those who sculpt, with their very souls, the magnificent statues in the cathedrals. The truth is that for the great majority of men in the Middle Ages there was between a good work and a masterpiece only a difference of degree, not a difference of kind. The idea that there is an unbridgeable gulf between a worker and an Artist (in the modern sense of the word) did not really occur until the Renaissance, when it was expressed by intellectuals who judged, classified and evaluated manual labour which was very foreign to them.[19]

It occurred, in fact, around 1500 in the struggle of late quattrocento painters, sculptors, and architects – amongst them Leonardo and Michaelangelo – to disassociate themselves from the accusation of being merely craftsmen and to seek the

29

admission of painting and sculpture among the so-called liberal arts.[20]

It was in painting, in startling advance of both music and drama, where the new ways of experiencing man's possibilities first found expression: in the art and science of perspective. This science, prefiguring the spatial discoveries of the world explorers such as Columbus and Vasco da Gama, perfected a method of conveying an impression of spatial extension in depth. The interest in depth, in itself symptomatic of a new interest in externalities, was only one of a number of radical new elements – amongst them, a single viewpoint, an analytical approach, and a concern for the representation of the visible world on a flat surface – which were aspects of the changed, or rather changing, worldview.

Within a matter of decades, the researches of Brunelleschi, Alberti, Uccello, and Piero della Francesca had replaced traditional attitudes with a method predicated on a point of view at once unique and rational – the point of view of a single observer, a human being, who no longer inhabits Eternity but time; no longer inhabits Infinity, but space. This then, is more than a mere technical procedure. By the adoption of perspective the primal vision of unity is shattered beyond restoration; the hypothetical perceiving subject of the painting ceases to be God, becomes man. Pride in human reason takes the place of the paradigmatic universe created and inhabited by God and animated by His spirit. Pride in man sets us apart from the world. Knowledge demands this detachment because certainty cannot be had without it. A small enough change, it might be thought, but one colossal in its implications.

Look, for instance, at Piero della Francesca's *Flagellation of Christ* (1455-60) (Plate 7)[12], where light and space are outward, their domain no longer the inward journey of the spirit. Instead the physical space has been mapped, every form has been measured, every character made distinct and individual, and Christ, the Son of God, has been relegated to the background – a mere counterweight to the three men in the foreground. This is

30

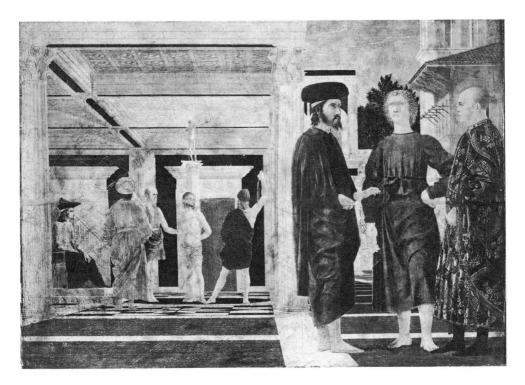

a perfect symbol of the humanist cosmology and, paradoxically, surely as eternal as anything made by man can be.

Another Italian development, the widespread adoption of oil-paint, brought further flexibility and a wider range of opportunities to painters obsessed with the imitation or representation of the external world – 'that vivid and intense desire' as Claude Lévi-Strauss perceptively observed 'to take possession of the object for the benefit of the owner or even the spectator'.[22] It made possible the naturalism that was, perhaps of all Renaissance discoveries, the one with the most far-reaching consequences.

Leonardo's glorious *Annunciation,* (Plate 8)[23] an early oil on a wooden panel with its naturalism of atmosphere, and three-dimensional modelling, is a case in point. Today it stands in the Uffizi, framed, on an easel. Framing was then new: its function

Plate 7
PIERO DELLA FRANCESCA
The Flagellation of Christ,
(c.1455–1460)
Tempera and oil on wood;
23¼″ × 32″
The Gallery, Ducal Palace,
Urbino

31

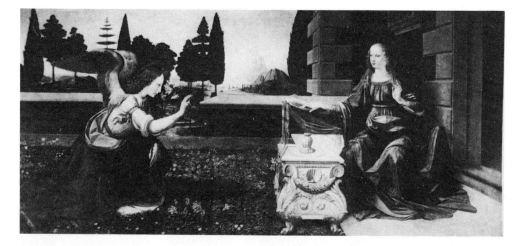

Plate 8
LEONARDO DA VINCI
Annunciation, (c.1478)
Oil on wood panel;
38½″ × 85¼″
Uffizi, Florence

(symbolic of the special, isolated position of art in the Renaissance) was not merely to enhance the picture but ensure its separation from the world around it. For the art-object, too, on a transportable (and therefore collectable) panel had already become an object of private rather than civic possession. (In Florence its merchants and burghers, wharves and counting-houses, did as much as the scholar to bring in the new age.)

Another feature of the attitude towards painting, sculpture, and architecture which relates it to our time is the new adherence to a linear view of progress emphasizing progression, development and change. First articulated by the painter-historian, Giorgio Vasari (whose influential *Lives of the Artists,* published in 1550, interpreted art history in terms of an inevitable development), the concept of progress in the arts, creating obsolescence as new methods do in technology, has inevitably encouraged an exaggerated pursuit of originality. Vasari's assumption of the axiomatic superiority of Italian (and in particular Florentine) painting, sculpture, and architecture also revealed a further aspect of the new arrogance.

Another feature extending from his to our own age, is the concept of the artist as hero, as outsider – a unique individual striving to bring new consciousness to birth. The earliest

32

document concerning the Sienese painter Duccio, dated 1278, refers to the decoration of twelve coffers for civic documents for which he was paid only 2 lira – a clear indication of the lowly social status of the medieval painter.[24] Sign painting, the decoration of chests and gilding of every kind were as much a part of Duccio's normal activity as was the painting of altarpieces. Yet by the 1520s, Michaelangelo, sculptor, painter, poet, architect, was deeply convinced his genius was divine. Among living competitors he would accept only God as a rival.

But in the matter of change, the art of painting was far from unique. It could, in fact, be argued that the emergence of western music into what has been described as the logical, daylit world of tonal harmony – the formalized movement of chords in succession – was analogous to linear perspective. With harmony, too, goes the concept of music as a drama of the individual soul, adumbrated in the work of the Renaissance masters, and brought to early maturity with the performance of the first real opera, Jacopo Peri's *L'Euridice,* by a group of Florentine literati and amateurs of music in 1600.

So, for the first time in western art, both in painting and in music, we come across an emphasis on a central humanist theme: the atomistic individual, pitted against fate, society, and other human beings. The tragedies of Hamlet, Macbeth, and Lear are that each 'hero' has been fatally set apart. Set apart, too, is each member of an audience, each performer and each individual spectator, each artist and his interpreter; each in his individual world, each alone with his own private thoughts and feelings. Yet if this is true of the mere subject-matter and styles of performance of western art, it also reflects a devastating truth about the separation of the majority from the necessity and fulfilment of the creative act.

In 1882 William Morris,[25] poet, socialist, designer, delivered an address in which he spoke of his belief in the changes ahead, his 'hope for the days to be'. He called on people to consider the

33

ways of happiness which they had missed in the labyrinth of industrialism. And, in a powerful passage, sketched a sequence of events which anticipates the dawning shift of paradigm:

> Once men sat under grinding tyrannies, amid violence and fear so great, that nowadays we wonder how they lived through twenty-four hours of it, till we remember that then, as now, their daily labour was the main part of their lives, and that their daily labour was sweetened by the daily Creation of Art; and shall we who are delivered from the evils they bore, live drearier lives than they did? Shall men, who have come forth from so many tyrannies, bind themselves to yet another day upon day of hopeless, useless toil? Must this go on worsening till it comes to this last – that the world shall have come into its inheritance, and with all foes conquered and nought to bind it, shall choose to sit down and labour for ever amidst grim ugliness? How, then, were all our hopes cheated, what a gulf of despair should we tumble into then?
>
> In truth it cannot be; yet if that sickness of repulsion to the arts were to go on hopelessly, nought else would be, and the extinction of the love of beauty and imagination would prove to be the extinction of civilization. But that sickness the world will one day throw off, yet will, I believe, pass through many pains in so doing, some of which will look very like the death throes of Art.[26]

If one takes the long historical view, Morris, I believe, is right: the personal work of art, by the first quarter of the twenty-first century, will have lost its commanding relevance. As the dominant paradigm of art in western culture loses its authority, as the magical or participating consciousness replaces the rational, the old manifestations of bourgeois individualism, social realism, political propaganda and personal self-expression – the four-movement symphony, the secular 'entertainment', the domestic novel and the gallery painting – will be abandoned in favour of more participatory, communal

34

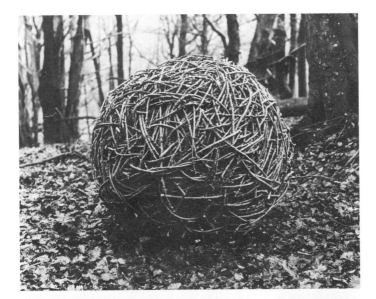

Plate 9
ANDY GOLDSWORTHY
Top: *Woven Ash,* (1983)
Grizedale Forest, Cumbria
Below left: *Horse Chestnut leaves pinned together with thorns,* (1986)
Loughborough
Below right: *Horse Chestnut leaves stitched with grass stalks,* (1987)
Yorkshire Sculpture Park

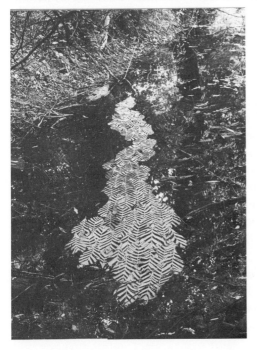

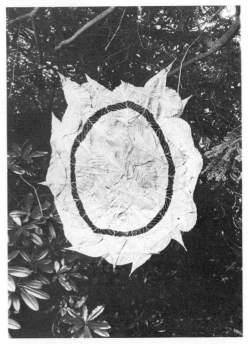

35

forms, emphasizing celebration, and the sacral mystery. 'The sterility of the bourgeois world will end in suicide or a new form of creative participation' declares Octavio Paz.[27]

Already, the signs of the times suggest great change. Many artists no longer wish to work in isolation; they wish to serve a community. Some, like Andy Goldsworthy,[28] (Plate 9) making 'sculpture' out of twigs and leaves, have rejected the gallery system; others, like Peter Brook, have returned 'theatre' to its religious roots. Yet others, have taken their activity into areas more remote from understanding. In them the nadir of aestheticism has been reached.

Yet, in this turmoil, certain things become clearer and one of these is the necessity for fresh definitions. The American writer, Joseph Campbell,[29] tells a story about a western philosopher who visited a Shinto monastery, did homage to its beauty, and said he did not understand its theology. The head monk told him: 'We have no theology. We dance.' We ourselves have no way to work at this statement unless we are prepared to revise our understanding of both the arts and religion. The key questions of our time are of a new kind, not amenable to the solely technical solutions upon which we have come to rely.

These, then, are the 'death throes of Art' of which Morris spoke with such prophetic candour, adding in an earlier lecture:

> I do not wish her to live I do not want Art for a few, any more than education for a few, or freedom for a few. No, rather than Art should live this thin poor life among a few exceptional men despising those beneath them for an ignorance for which they themselves are responsible – rather than this, I would that the world should sweep away all Art for a while as (I believe) it possible she might do.[30]

Morris's pessimism was tempered, as ours must be, by the conviction that all that seems lost will return. Humans and nature possess ineradicable capacities for self-renewal; the death of 'art' will be followed by its re-birth. The creative imagination,

36

of which our world appears to be so dispossessed, cannot and never will be erased.

Of the pattern of re-birth, I am uncertain. That we are experiencing, as Yeats declared, 'the rise of soul against intellect now beginning in the world', I have no doubt. But it is a different and more difficult task to describe a future 'art' when it has become integral to life itself; when, that is, we should be seeing artistic activity as the element in which social and cultural expressions are synonymous. When, too, it is no longer a surrogate for religion but an aspect of the spiritual life.

I may be wrong but I do not believe there will be great artists in the old (Renaissance) mould again. But if poetry and painting, music and theatre, will have little more to give as 'arts', perhaps they will have much to give as modes of self-discovery, awareness and personal exploration; as aids to the rediscovery of *being* and existence. Expansion of awareness could become the final end of all creative work. As Kathleen Raine says:

> We live in a time of a change of the premises of a civilization, and what is to come may be a beginning of a new age in which people will, as in the monastic middle ages – only differently – work on themselves; it is, after all, the only final usefulness of 'works of art' to enable us to do so.

In these pages I can then present little more than the sketch of a way of life in which celebration, ritual, the expression of identity and a sense of community are closely interfused. The imagination, which is the shared property of each of us, will unfold according to its own dreaming. As a start, however, let us begin by looking at the most popular and accessible of all art forms – music.

From the intimate to the most public, from the casual to the ceremonious – whether in the home or out of it – music will in all probability again provide an habitual element. Making its entry at every possible occasion it will flourish at all the rites which mark a transition in life – at baptisms, initiations,

weddings, funerals, at holy times, and worship, as well as in those small private celebrations, like family meals, which also symbolize our unity with each other. Much of this would be performed both vocally and instrumentally by men and women in the normal course of their lives but part-time 'professionals' (such as our miners with their choirs and brass bands) might also play an important part with groups of itinerant musicians providing music for the big occasions as they do in certain eastern countries today. Much of it, too, will have a meditative character close to plain chant and the melodic music of the East.

The ability to use healing influences on the physical world through the use of sounds may also develop. So, too, the conviction that there is a power in sounds which if properly acknowledged, can lead to a perception of the divine. For this reason I can imagine a revival of the allied art of dancing which, ministering to the enrichment of social life, can also play an important part in worship where rhythmical music and movement can induce states of trance.

Another sign of an imaginative culture would be the development of a new kind of 'theatre' celebrating the life of each community. A 'theatre' that is rooted in the place and the people for and from whom it is made; reflecting their way of life, their identity, their ability to see beyond the symbol to the truth it represents.

Work of this kind is already under development by a number of groups, amongst whom that of Welfare State International[31] is probably the most innovative. 'We have to re-establish communities,' says John Fox, its founder; 'awaken imagery and celebrations which are part of an agreed set of values, values expressed through a symbolism with which we can all identify.'[32] Drawing upon the traditions of carnival, music-hall and fairground (in which the barriers of our specialisms have been temporarily breached) the work of Welfare State comes as close as anything to giving form to elements which elsewhere have been lost or overshadowed. Much the same achievement has been won by Peter Brook in his celebrated *Mahabharata*, a

38

profound and mysterious ritual more serious and meaningful than the conventional play. The exercise of ritual, the development of myth, is as an integral element of any healthy, living and growing culture.

Another revival of an entirely different kind occurs every June near where I live. Rural in spirit, the celebrations are designed to welcome midsummer. One year the festivities were based on two traditions including the rolling of a cartwheel, bound with lighted straw, symbolizing the descent of the sun from the solstice day. Such occasions, attended by large numbers for whom Gaia, a vast living being of which we are part, is a reality, already suggest a new sense of the once common intuition that the landscape is alive in some unacknowledged way.

To my mind the young have already discovered many aspects of the future I am trying to suggest. Their style of dress, of bodily stance, of idiomatic reference, are all expressive of the life of a more primitive being returning. The explosive emergence of rock music throughout the seventies and eighties is another example of how life preserves proportion by continually going over into the opposites of its excesses. Many features of this orgiastic music – its connections with bodily rhythms and sexuality; its transformative, unbridled, occasionally demonic, power; its mix of performer and audience – and of different media, too – are expressive, albeit in a rough, commercial way, of the participatory consciousness I have been attempting to suggest.

Imagine, then, a culture more developed than our own, more balanced and homogeneous. Imagine, too, the expressive nature of a future transformation in the 'arts'; a transformation made possible by the sacralization of the cosmos accomplished by need and the sensational discoveries of the new science. Only then can we begin to grasp the immensity of the changes which will affect our world. Only then can we grasp what re-enchantment may actually mean. Only then can subtleties of expression, contemplative and sensual, begin to take shape in our mind. This takes time but it can be done.

No less revolutionary than this new awareness must surely be the rediscovery of meaningful work. The great, aesthetic philosopher, Ananda Coomaraswamy,[33] always argued that there were two paradigms for the work of (visual) art: the icon and the useful object. The icon – whether carved Buddha or painted head of Christ, Chartres or Blue Mosque – was, he contended, a 'support for contemplation'. Through its traditionally prescribed iconographic features, brought to life and beauty in material form, the worshipper is reminded of another world more real than daily life. But there is, as Coomeraswamy declared, also another kind of work no less skilled and imaginative. It is the work of the maker of useful things; the work of the craftsman who lives the self-expressive life.

Long before the present industrial shambles, over fifty years ago, that pioneering educationalist, W.R. Lethaby,[34] was writing about the need for a proper regard for skills in making – skills not only to be valued for their contribution to society but 'as instruments of their (workers') redemption'. He wrote, in 1920:

> As work is the first necessity of existence, the very centre of gravity of our moral system, so a proper recognition of work is a necessary basis for all right religion, art, and civilization. Society becomes diseased in direct relation to its neglect and contempt for labour.

Needless to say, Lethaby was ignored: economists, industrialists, politicians knew 'better'. The secular heroic mind cannot understand such thinking. Yet facing a future, in which Britain will have to be not so much farmed as gardened, and many things will be made by hand, his words still retain their shimmering truth.

To make fertile again the vast arid stretches of our culture related to work we need a change of heart. We need, as James Hillman[35] has suggested, 'to revision' it, to experience it in an aesthetic way, rather than, as he says, 'the all-too-economical

Marxist view of it as drudgery, the alienation of man in work'.

In his book on the Moroccan city of Fez, Titus Burckhardt describes his meeting with an old craftsman who followed the traditional ways. He was a comb-maker who worked in the streets of his guild. [He told Burckhardt]

> My work may seem crude to you but it harbours a subtle meaning which cannot be conveyed in words. I myself acquired it only after many long years The craft can be traced back from apprentice to master until one reaches our Lord Seth, the son of Adam. It was he who first taught it to men, and what a Prophet brings – and Seth was a Prophet – must clearly have a special purpose, both inwardly and outwardly. I gradually came to understand that there is nothing fortuitous about this craft, that each movement and each procedure is the bearer of an element of wisdom. Not everyone can understand this. But even if one does not know this, it is still stupid and reprehensible to rob men of the inheritance of Prophets and to put them in front of a machine where, day in and day out, they must perform some meaningless task.[36]

Some such attitude to work, I believe, will one day be more widely shared, not because of automation, or conversion to Islam, or a belief in the Prophets, but because meaningful work is a human necessity. It is an opportunity for fulfilment as well as for earning a living.

And an opportunity for delight – aesthetic delight. For this reason I can imagine a renewal of the expressive life as a dominant feature of the new civilization. I can dream of a beautiful environment, one gardened and cared for with houses embellished and richly decorated. I can dream of well-made food and people, not richly, but graciously dressed. I can dream of every act and place revealing not self but spirit.

People, in fact, have always made with ceaseless energy the reality they believe in. Each age has created the values, the

41

beauty, and forms of usage which characterize its world view – in mediaeval Europe, for example, the cathedrals and churches which expressed a philosophy of cosmic order. And our own? Surely our civilization with its billion pound Trident systems, Nat West towers and featureless concrete motorways (which seek as far as possible to avoid contact with the landscape, to go over rather than through it) is no different. It, too, has made buildings, an environment, a culture, which is as expressive of the Newtonian mechanistic philosophy as the cathedrals were of the Scholastic one, the world of the *Summa Theologiae*, where everything was in its proper place.

In its turn the emergent culture will discover its own culture: the poetry and the music, the myths and magic, the icons and the useful objects which express the eternal worlds within ourselves. With its imagination it will come into the unimaginable and with its speech into the unspeakable. The ancient springs, now polluted, will nourish again.

(First published by The Green Alliance, London, 1982. Revised)

3

LANGUAGE OF THE SOUL

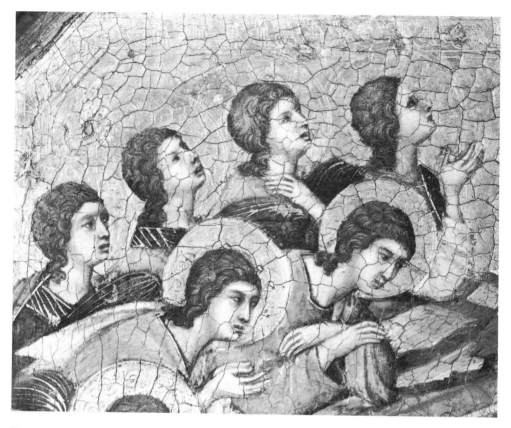

Plate 10
DUCCIO
*Nativity with the Prophets
Isaiah and Ezekial* (middle
panel), (1308/11)
Tempera on wood panel;
$17\frac{1}{2}''$ × $6\frac{1}{2}''$
National Gallery of Art,
Washington

44

Language of the Soul

ON ONE OF THE painted walls of the Lascaux cave surrounded by those haunted, exquisitely shaped and coloured animals, there is a stick-like figure of a man, a shaman. He has cast his spear into a bison, is weaponless and vulnerable, poignantly exposed and incomplete. From the wound in the bison's flank a rope of bowel is gushing. Elsewhere, in other caves, there are wild horses dotted with spots and the silhouette prints of human hands. Delicate deer with branching antlers run like young gazelle. Anthropologists have calculated that the ancient hunters started to draw and paint some 30,000–40,000 years ago. At Lascaux, in the Kalahari, in the Tassili, imagination smoulders and breaks out at last into flame.

Since its first but magnificent appearance man's most mysterious power has given rise to an intricate and enchanted world – a world of worship, creation and art. There is scarcely a landscape or an object, let alone a culture or a place of prayer, which cannot be read in both imaginative and material terms. Buildings and vessels, wells and harnesses, utensils and clothing, music and poetry, 'all that is' as Julian of Norwich[1] puts it, have been substantially ordered by a diurnal pattern of worship and work. In all this making, this embellishment of life, we may find an intimacy of human, natural, and divine.

We may also discover a quality of beauty. It runs like a singing thread through the tapestry that is buried under all minds. It breaks out on the surface and then runs deep and underground. But in so far as men and women have made things which reflect the changeless sanctity of life, beauty has been a by-product of work. As the Navajo used to sing:

45

In Beauty (happily) I walk
With beauty before me I walk
With beauty behind me I walk
With beauty below me I walk
With beauty above me I walk
It is finished (again) in beauty
It is finished in beauty.[2]

In the absence of a recognition, in our modern West, of any sacred tradition – or tradition of the sacred – we may recognize, not beauty but, as Yeats said, 'a certain ugliness that comes from the slow perishing through the centuries of a quality of mind'. With this change, this loss of confidence in the invisible life, this movement towards externality, the despotism of fact, this slow dying or drying of men's hearts, we may also recognize the descent of a grey kind of trance. We walk in ugliness across the earth. Creation, too – the world of cowslips and moths, trees and fish[3] – has lost its gleam. It, too, is dying, dying before our eyes – poisoned and bulldozed. The roots of the Tree of Life, the great tree of European civilization, are withering and grown sick. This is the poverty which comes when human beings claim that their consciousness is all for themselves.

Yet if our culture is divided, arrogant, out of touch with nature both wild and inner, 'all out of shape from toe to top'[4] as Yeats describes it, the wisdom of the imaginative mind can never be entirely erased. Our world is made up of human beings who by nature are sacred and imaginative.

Whatever the cultural context, whatever the conditioning background of their time, men and women have always sensed the presence of a greater reality which transcends their life and yet is immanent, sanctifying and making it real. Such experiences, 'religious' by nature, are not, however, the property of any one faith; nor the property of the world's religions as a whole. These experiences are reported by individuals from within each of the world's religions as well as from avowed agnostics and even aetheists. They are the property of all

46

mankind. They take, too, an almost universal variety of forms. Some people experience unusual light, others a direct perception of something beyond the usual range of the senses. For others none of the five senses are involved. Instead there appears to be a spontaneous awareness of a breadth and depth of knowledge not previously known. Joy and peace are feelings which are reported almost universally – and, no less significantly, a deep sense of beauty.

In these timeless moments, however brief or rare, there is a response to the call of the beautiful where the pattern is complete. They enable us to live fully in the present without attachment to the past and thus to find the reality of ourselves which – for some – is also to find God. They enable us, however temporarily, to see the piercing, other-worldly beauty of Creation and the power of spirit that pervades everything. The poet, Gerard Manley Hopkins, seeing a bluebell said it all: 'I know the beauty of our Lord by it.'[5]

Experiences of this kind are not uncommon; they can touch us all and change our lives for the better. We then know in a different and much finer kind from our all too-familiar, habitual way of seeing that places activity over contemplation, having over being, yang over ying, and seems increasingly incapable of labouring for their integration. We know, not by information but experience, sacred and numinous. We know that seeing with this inner eye, points to the living experience of reality – into what life is in itself, unmediated by words and ideas.

What then is happening in these little moments that can have so great an influence in our lives? We do not in fact know nearly enough about the nature of the 'religious' experience. Yet if the secret language of mystery can never be explained it may be possible to pick up a few clues – little more – along the way. This I should like to attempt in this chapter.

The idea that the self of which we are ordinarily aware is only a very small part of the total psyche is nowadays a commonplace.

There is nowadays an immense array of evidence suggesting that unconscious processes ranging through dreaming, habitual behaviour, pattern recognition, creative imagination, intuition, religious experience, and now, increasingly our illnesses, make up a large portion of our lives. Consciousness, then, might be described as a narrow visible spectrum between the subconscious – for example instinctual drives and repressed memories – and the supraconscious including creative imagination, intuitive judgement, aesthetic sense and spiritual sensibility. Yet beyond everything which we can still, however remotely, call 'ourselves', there is what mystics have called 'the divine ground'; a deeper centre of personal being which is one with the universal spirit. As Ralph Waldo Emerson puts it, when this other mind 'breathes through (our) intellect it is genius; when it breathes through (our) will it is virtue; when it flows through (our) affections it is love. And the blindness of the intellect begins when it would be something of itself.'

This mystery goes by many names; *nous* for the Greeks, *mens* for the mystics, *pneuma* or spirit for St Paul who described this presence in the deepest and most central part of the human psyche as the living breath of God by which all things are continually sustained and created. Today, we use other less beautiful words – the Self or 'higher' or Transpersonal Self – as contrasted with the limited, conscious, personal ego-self to which it is entirely opposed. I myself prefer the ancient, hallowed name: the soul. The word soul has been hard to work with, precisely because it belongs to an ancient, well-defined Christian tradition which is no longer acceptable. Let me make it clear, then, that my use of the word is not theological but symbolic.

Spirit, as the North American Indians speak about it, is the pervading, abiding, indwelling presence in all things. It is the ground of existence, present everywhere, in everything. It is, as the Brhadaranyaka Upanishad[6] puts it, 'unseen but seeing, unknown but knowing'. This is the mystery upon which both Indian and Chinese thought lighted in the sixth century before

48

Christ. They called it Brahamin, Atman, Nirvana, Tao, but these are only names for what we cannot name. Soul is the deep centre of *personal* being which is at one with the ground of universal being, the spirit.

For the momentous truth is that the spirit, the Tao, the divine reality must not be sought as something far away, separate from us, in a heaven to which we may ascend only after death; but rather as something close at hand, forever and forever in the inmost of us: 'more interior to us', as Thomas Aquinas says, 'than we are to ourselves'.[7] Thus the holiness of life is not a kind of attribute but inherent in the divine nature of the ground, the divine spirit of man.

Such reflections are confirmed each time we respond to the beautiful or, for that matter, to a vision of reality which moves us into timelessness – when, for example, looking at the budding sycamore we not merely see but live it. We become pure Being. Then, the temporal confronts the eternal; the 'I' of the soul and the 'thou' of the tree are united in a 'we' – a timeless hymn of praise for the flow of life in the sap and cells, the crackling buds, the leaping choreography of branch and grass and beast and hill: the one in many and the many in one.

The joy of this union, when the apparent barrier between subject and object drops away has been described by St Teresa[8] in words which remind us of the Upanishads written more than two thousand years before:

> It is like water falling from heaven into a river or fountain, when all becomes water, and it is not possible to divide or separate the water of the river from that which fell from heaven; or when a little stream enters the sea so that henceforth there shall be no means of separation.

Such experiences of the ultimate unity are aesthetic, for at such moments, face to face with a Masaccio, a Botticelli, (Plate 11) a budding sycamore tree, there is none of the hard separation of me and mine which divides us from the 'outer' world. Individual

Plate 11
Sandro Botticelli
Primavera, (c.1478), detail
Tempera on wood panel;
80″ × 123½″
Uffizi, Florence

49

identity is lost; time ceases, finite and infinite coalesce. The secret of life is to be found in such self-forgetfulness.

I used to wonder if this transformation of consciousness could be achieved through standard education. Now, I doubt it. Direct insight, the truth of the soul, cannot be reached by abstract reason alone but by transcending the ego, the centre of all conscious thought, through struggle, meditation, the gift of grace, or sacrifice. It may be discovered, too, through the informing (and transforming) experience of being with a true teacher and, no less profoundly, through the arts. Many people in our own era have found renewal through, for example, music or painting and drawing whether in the service of a church or shrine or, as with Rembrandt's visionary works, (Plate 12)[9] Janácek's *Glagolitic Mass*,[10] or Mahler's *Eighth Symphony*,[11] outside the context of any formal religious occasion. A drawing such as Botticelli's *Abundance*, or *Autumn*,[12] may even feel more 'religious' than one based on a biblical theme. It is not the religions they serve which validate the arts; on the contrary, it is the quality of its own imaginative vision that validates a religion.

The tragedy of our contemporary predicament is that 'art' and 'religion', as commonly understood, are virtually unorientated towards the free experience of the divine. The language of the dominant religion, certainly in the West, is full of mental concepts and stale terms. The language of the contemporary arts is no less specialized and recondite. Yet somewhere in the labyrinth is a right passage, and the key that opens the last door to the light. We are artists and have been empowered, through the gift of life and the creative imagination to make our contribution to an unlimited reserve.

So understood, the imagination can be the very essence of human life. It is the principle of oneness in man; the faculty by which we apprehend living beings and living creatures in their individuality, as they live and move, and not as ideas or categories. For imagination makes us understand human life vividly and intimately in ourselves because we have felt it in others. The life and movement and individuality of human

Plate 12 (right)
REMBRANDT
The Return of the Prodigal Son, (c.1669), detail
Oil on canvas; 104½″ × 82″
Hermitage, Leningrad

50

51

beings, and of beasts and birds and trees, their feelings and moods and mischances are everything to it.

Is this, or something like this, what Jacques Maritain[13] meant when he described imagination as 'the intercommunion between the inner being of things and the inner being of the human self'? And what Blake[14] meant when he wrote that true religion was the exercise of the imagination, for by it men could perceive 'the infinite in everything' and be released from their imprisonment to reason? I believe so. The true artist, the inspired poet, speaks not from personal self and experience but from the level beyond the personal which is common to us all. He or she speaks with imagination from and to the soul.

Imagination embraces all possibilities of existence. It can depart from the known, become one with what is found, bond together all the bits and pieces of life into a new, unified whole. It is, as Einstein believed, more important than knowledge for knowledge is limited, whereas imagination embraces the entire world. It can, in fact, perceive and respond to the inner ecology, the truth of the soul, and in that moment give entrance to the other mind beyond the mind of the ego. It is the voice of what is eternal in us. In other times and places – and even now in some small measure – art has flourished (or decayed) in accordance with our understanding of the sacred – the timeless source. It has flourished in those cultures or individuals which possess, however unconsciously, a sense of the numinous, withered in those which have either lost the power of seeing spiritual truth or have divided soul from body and from the world.

Such a culture is our own. There is nothing equivocal about this point. This rift is a flaw in the mind that runs deep, affecting or afflicting every part of it. Yet, since creation is unified and whole, spirit and body cannot be divided: their unity is inescapable. The creation, any creation, is not the freeing of the spirit from the flesh, from matter; it is their marriage, their union, their reconciliation. No wonder the French philosopher Henri Bergson,[15] has compared the love of God for His creation to the love for creation that moves the soul of the artist:

This is my conclusion to which the philosopher who accepts the mystical experience must come. The whole creation will then appear to him as a vast work of God for the creation of creators, for the possession of beings who are co-workers with Him and worthy of his love.'

In every civilization the artist (the artist, that is, in every human) has borne authentic witness to the mind of the Creator of whom he is the earthly representative. Making use of matter in a wholesome or a holy way – by working it with reverence, by respecting its and our own natures – we may sanctify it, glorify it, consecrate it, lift it close to the light of mystery. In the Cabbalistic[16] phrase we may cause the sparks to fly.

This can happen by plot or accident at any time. It only needs the imagination to fructify, to incarnate itself in the materials of the world in careful acts and well-made things, for the potter's clay, the painter's colour, the musician's sound, the gardener's plants, the cook's pastry – even the writer's words – to become a sacrament. Otherwise life would be barren; art and music an empty interlude and ornament.

Yet all things on earth, by the incomplete workings of the human mind, may easily become snares. Even a mineral, perhaps a diamond, whose contemplation can give us a living experience of light, may be reduced to an object of intellectual interest or possession, an object of greed by means of which we may feel ourselves to be greatly magnified. Thenceforward we may become victims of matter, tied to time and with an attachment to permanence which the Buddhists aim to renounce. Matter, then, is not flame but cinder, denegrating rather than illuminating both us and our world.

Which brings us back to our own age, the age whose primary reality, that by which all else is evaluated and measured, is matter. Matter which can be manipulated and utilized in such a way that we may 'be enabled to enjoy without any trouble the

fruits of the earth and all its comforts'. I wanted to quote from Francis Bacon, the Elizabethan humanist,[17] because his writing is filled with the bright hopes and humanitarian intentions, obscurely mingled with the hidden forces of dehumanization, of the New Philosophy. Bacon was among the first to envisage the world in which we now live. He saw its worldly power, its affluence, its cumulative knowledge – but not its psychic distress. In this he failed to see that when the reign of quantity is supreme whatever escapes the net of numbers must, by definition, be held in low regard – almost as if it did not exist; that those who speak, for example, from any other stance but the objective and material are to be dismissed as offering 'but so many stage-plays, representing worlds of their own creation after an unreal and scenic fashion'.[18] It was therefore inevitable that the left-over realm of mind and spirit should come to be regarded as less and less habitable during the last 300 years and that, in due course, more and more people should suffer from spiritual impoverishment. Inevitable, too, that artists and poets, mystics and contemplatives should be largely ignored. No wonder then that the poet Schiller,[19] speaking for them all, cried out in horror against 'the disenchantment of the world' – the dying out of the magic of things, the slow, inexorable, drying out of ancient, sacred, springs.

I began with a mystery, Lascaux, and would end with another, Quarr. Not a Catholic, not even a Christian, I go for a few days every year to a Benedictine monastery on the Isle of Wight. I go there for a number of reasons but chiefly to experience something which I can find in few places elsewhere. It is the mystery, the mystery of silence praised in plain-song, the mystery of life expressed in love. The painter Marc Chagall[20] sums it up:

> In our life there is a single colour, as on an artist's palette, which provides the meaning of art and life. It is the colour of

54

love. I see in this colour of love all the qualities permitting accomplishment in other fields.

It is this colour and the resulting accomplishments which I experience at Quarr where the point at which the finite and the infinite, the temporal and the eternal, the many and the one, meet and touch more vividly and more often than most places elsewhere.

For me, Quarr is important because it bears witness, in however archaic a form, to a way of life in opposition to materialism. And if, as I believe, our first priority is to reclaim and cultivate wholeness of being, then communities like Quarr or Findhorn[21] or Father Bede Griffiths' ashram in Tamil Nadu, India,[22] may be the models of a way of life lived in ecological simplicity, both materially and spiritually, from which we can learn. For the people who live in these communities are attempting to put into practice on a small, local scale – no doubt imperfectly – a harmonious and therefore responsible pattern in which the parts have been joined harmoniously to the whole. In the words of E.F. Schumacher: 'It is a question of finding the right path of development, the Middle Way between materialist needlessness and traditionalist immobility, in short, of finding "Right Livelihood".'

Some years ago, I discovered in San Francisco another community with a comparable sense of mutual aid, a comparable capacity to live self-reliantly with a local and domestic economy, and a comparable appreciation of the wealth that lies in modest means and simplicity of need. It was at the Zen Center where young men and women have created an environment not just of the welfare of the spirit but of a larger harmony, including the immediate environs of the city itself. Here, too, the spirit has embodied itself in the materiality of the world, producing food, shelter, worship, well-made artefacts emblematic of the best and most responsible care. 'Art' as such does not exist; the aesthetic dimension is integral. 'Education' as such does not exist; it grows naturally from a passion for excellence and a desire to learn.

55

'Work' as such does not exist; it is an essential part of practice, a way to realize the nature and needs of social existence.

At Quarr, and the Zen Center, at Bede Griffiths' ashram in India, at Findhorn, and no doubt elsewhere, everyday work, worship, reverence, the sense of a group of people in harmony with themselves, have brought heart and mind into some faint intimation of a human order that can accommodate the various concerns of culture to each other. If they are anything to go by the integrated life is – just – an attainable ideal. What we need to do now is to take their achievements and bring them back to a community style of life which is not necessarily monastic.

In the meantime we must live in our own world where the task before us is great indeed. We have to rethink some of our most firmly-held assumptions about property and privacy, security and success. We have to rethink the whole of what might be called the religious life from the bottom up. We have to discover the importance of imagination, the creative act, without which we cannot be human. We have to discover art and life as one; art, that is, as an act, not an object; a ritual, not a possession. We have to rediscover that we can all be involved one with another in a seamless web of kingship, responsibility, and love. We have to rediscover the unity of all things, that the spirit moves in all created things – man and beast and star and plant and dirt. Nothing less will do, and nothing will be more difficult to bring about.

4

CHANGING IMAGES OF MAN

PAR. Canto 30

Changing Images of Man

The theory and tactics of the Revolution of the dictatorship of the proletariat has very little to do with art. The forms and styles of art production evolve in a much smaller ratio than do the social forms of commodity production. The forms and styles of art develop more along the lines of Human Consciousness and are related to that particularly to greatest degree and to economic conditions and prevalent social relations to a much lesser degree.

David Bomberg 1934 – 8[1]

OUR ATTITUDE TO ART largely derives from the Renaissance, more particularly from Florence, where the modern world was born. It was in Florence that Vasari wrote his history of art formulating the idea of progression. It was in Florence that the principle of ordered recession to create an illusion of pictorial space was first discovered by the architect Brunelleschi – who built the first dome to combine both Gothic and Classical systems of construction. Secular collecting began there, and the invention of double entry bookkeeping is almost certainly a Florentine discovery. But from our point of view something of even greater consequence took place there than the fact that the citizens of Florence put the innovations of others to use on a new scale. The Florentines, it has been said, 'invented' the modern world and hence the way we think about art.

This is not to deny the contribution of other Italian city states or the work of other artists or centuries. It is rather to draw

Plate 13 (left)
WILLIAM BLAKE
Dante in the Empyrean, Drinking from the River of Light, (1824–7)
Water colour drawing;
20⅝" × 14⅝"
Tate Gallery, London

attention to the palpable and hardly accidental concurrence in the realm of time and place of a whole new way of thinking and picturing the cosmos, an economy of conditions, an idea of existence, and its matching aesthetic, equally visionary, equally unexpected, equally charged with potentialities not to be realized until a much later date. Rooted in the same myth, the new image of man and a redefinition of ways of seeing were, in essence, one and the same thing.

Such indivisibility is best exemplified, I believe, in the life of Piero della Francesca, painter, mathematician, town councillor, architect, town planner; the greatest artist of the fifteenth century, and one of the chief mathematicians of his age.[2] In his person Piero was able to combine innovation and tradition, technics and imagination, making the first and oldest new and contemporary. Little is known about his life or character. He was born between the years 1410 and 1420 in a little Tuscan town surrounded by walls: Borgo San Sepulcro. Here, in 1442, he was made a councillor of its people; here, too, he painted his greatest single painting, a fresco, *The Resurrection.* (Plate 14) 'Damp has blotted out nothing of the design, no dirt obscured it', writes Aldous Huxley.[3] 'We need no imagination to help us figure forth its beauty; it stands there before us in entire and actual splendour, the greatest picture in the world.'

At every epoch of his career, whether working for the Dukes of Ferrara or Urbino, or for the Pope himself, Piero would return to discharge local business and execute commissions for local bodies. For the last fifteen years of his life he never left the town. Even the pellucid forms of his great fresco series, *The Story of the Cross,* have the grainings of Tuscany in them. Its shapes mirror the quiet flowing laterals of the Tuscan fields and hills. Love for place has always been the beginning of sanity.

Direct knowledge of the forces and energies of the universe are also to be found in *The Resurrection* (c. 1462-4) which for me, like Huxley, is a mighty paen in praise of human dignity; complex, grand, and resonant of visionary strength. The grey light of morning, the Tuscan countryside, the face and body of a

60

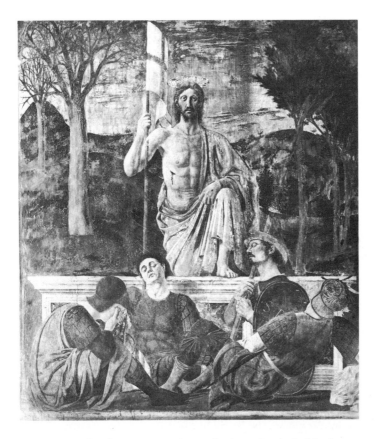

Plate 14
PIERO DELLA FRANCESCA
The Resurrection,
(c.1462–4)
Fresco; 88½″ × 78½″
Palazzo Communale,
Borgo San Sepolcro

country god, the resurrection of the classical ideal are concentrated into something emblematic. *The Resurrection* is surely one of the outstanding works of religious art in the world.

Renewal is a good word for Piero and the culture he embodied in his art. The quest for certainty, the mystique of measurement, the commitment to the new seem unimportant in comparison with the reassurance, the colossal amplitude of his universe. Here, one feels, is a completely sane and balanced person, genuinely noble as well as talented. Here, one knows, is a painter at one with himself, his society, and environment, a painter familiar with the human boundary established by ancient tradition, a painter who saw the ephemeral and contingent

61

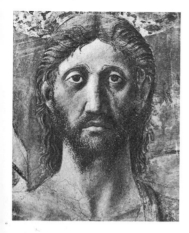
Detail from Plate 14

nature of the world and all that is in it but did not ignore the spirit.

Holding an image of man, lofty and dignified, he loved grandeur and exalted ceremony, magnanimity of gesture and nobility of shape. He celebrated humanity's place in the order of creation, cherished and augmented it. He showed the mystery – and the darkness – of life, and yet his art, instinct with stillness, and a held-in immensity of life, are luminously clear and optimistic. I like to think his statuesque forms might come alive in the measure of a dance in which the elements of a preserved and preserving continuity – trees and horses, women and clouds, towns and settlements, angels and archangels – all play their stately and allotted part. No painter pictured the soul life of his period as a sacred event with more naturalness.

Three centuries stretched between the death of Piero and the birth of William Blake (1757–1827). But the gap between the two was greater than can be measured in time. For Piero the world was enchanted; it had meaning, cohesion, purpose. It bore the impress of divine creation of which his art is both tribute and celebration. It is a chorus or litany of praise to God for the wonders of the world. For Blake, however, or rather for Blake's contemporaries, the world had become a different place. Many of the caring, feeling, loving values, which the sense of the feminine in man promotes in life, had been displaced until only an arid, rational, masculine intellectualism and power-obsessed urge remained. Not for everyone, of course; for the young Wordsworth, the young Goethe, the young Turner, for Mozart and Haydn, the world was rich with wonder. Workmen and women, too – peasants, fishermen, foresters, and farmers – would have found little changed. None the less the 200 years following the publication in 1637 of Descartes' *Discourse on Method* experienced a profound change in attitude amongst intellectuals, law-makers, scientists, and mechanists – the ruling elite.[4] Even as early as 1611, 150 years after Piero's death,

everything had been largely redrawn. The poet John Donne[5] lamented, ' 'Tis all in pieces, all cohearance gone The new philosophy calls all in doubt.'

What, then, translated into everyday language, did this new philosophy mean? It meant a feeling of total reification. It meant that humans lived in an indifferent, mechanical universe, subject to 'laws of nature' operating autonomously, outside mind and thought. It meant that the cloak of unconsciousness descended over the 'inferior orders' – nature, animals, women and, of course, the 'coloured' races. It meant that the natural beauty of the human mind and the natural dignity of life at its normal, natural, ancient, slower pace had been destroyed. It meant, too, that the artist, the prophet, and the mystic now worked, as Blake did, in growing and extreme isolation, at best, dedicated and lonely men and women without an audience; at worst, scorned.

Blake – body, mind, and soul – rejected this. Every word he wrote, every image he created, was made to counter the empty, clever modern age. For him the materialist philosophy was not one hypothesis amongst others all as harmless as old volumes on a shelf, but a deeply dangerous spiritual state. He called it the 'sickness of Albion', the national being of England. With his unfailing grasp of essentials Blake saw the whole edifice of western rationalism full of disasters unconsciously invited. He saw the psychic condition of a people for whom materialism would become a god and described and pictured their agony in prints and paintings of supreme art.

Newton (Plate 15) and *Nebuchadnezzar,* (Plate 16) two complementary colour-prints, are part of a series executed in 1795 of which the most important are now in the Tate. Compared with the perfect unity and monumental certitude of Piero's art, Blake's poetry and painting can seem nervous, unstable, imperilled, stark. Yet since all works of art are a spiritual as well as an earthly event (and timeless only in so far as they truly belong to their own time), *Newton* and *Nebuchadnezzar,* conceived as a pair, can be considered as much

63

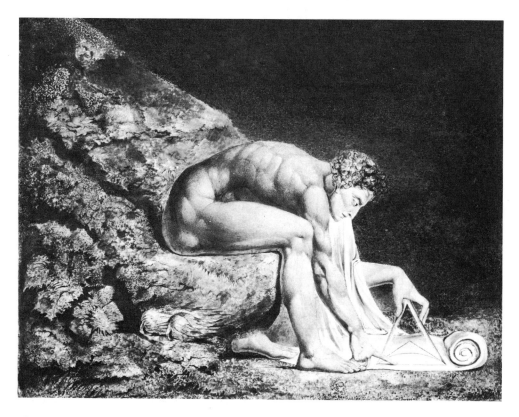

Plate 15
WILLIAM BLAKE
Newton, (c.1795/c.1805)
Colour print finished in
pen and water colour;
18⅛″ × 25⅝″
Tate Gallery, London

the index of a modern state of soul as Piero's frescoes of his time
and place. This, Blake says, is what happens when instead of
attempting to make known the divine plan, man puts himself in
the place of God.

The figure of *Newton,* (Plate 15) a founding father of the
scientific revolution, features frequently in Blake's work. In this
print he is pictured seated on a rock at the bottom of the sea
(traditional symbol of material creation) trying to reduce the
world to a mathematical formula. We see him staring at a
geometrical design; his left hand holds an open compass, symbol
of limitation and restriction – of creation by the reason
unenlightened by imagination. Newton, he tells us (and for
Newton read all those who have internalized the mechanistic

64

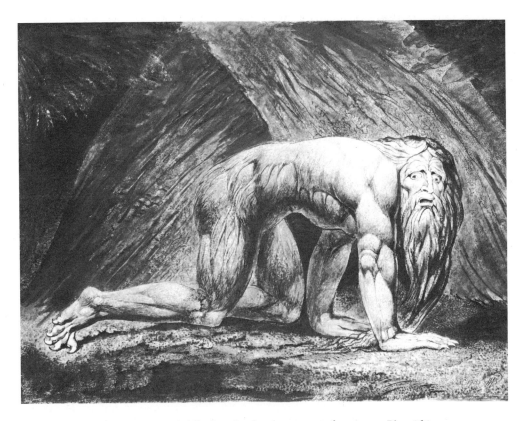

description of the universe), is blind to the duty we owe to forces greater than ourselves. 'He who sees the Infinite in all things sees God,' claims Blake, but 'he who sees the Ratio only sees himself.'

The other half of the pair is, if anything, even darker in spirit. *Nebuchadnezzar*, (Plate 16) condemned to live like a beast, symbolizes a further stage of man's degradation: the madness of the materialist with 'single vision', bestial in seeking sustenance in material things alone. *Newton* had shown man abandoning imagination in favour of reason only; in *Nebuchadnezzar* reason has vanished. Man has submitted himself wholly to the dictates of the senses. Blake's image is based on an almost literal rendering of the scene in Daniel[6] where the Babylonian king,

Plate 16
WILLIAM BLAKE
Nebuchadnezzar,
(c.1795/c.1805
Colour print finished in
pen and water colour;
17⅝″ × 24⅜″
Tate Gallery, London

65

Detail from Plate 16

driven from society, 'did eat grass as oxen, and his body was wet with the dew of heaven, till his hairs were grown like eagles' feathers, and his nails like birds' claws' – until, that is, he acknowledges God's universal dominion when his reason is restored. The disfiguration of the image of man in the West had never before been more compellingly or painfully expressed.

Since the death of Blake almost all he prophesied has taken place. As the century advanced, the growing power of the machine, the blind forces of materialism, fastened like a disease on the body and soul of the 'Giant Albion', creating a godless world, one of quantity and ultimately of human despair. The wasteland of the spirit Blake foretold became the irredeemable condition, the psychic experience of multitudes. To his uncomprehending contemporaries he warned that Albion would be dead to Eternity. And so it has become.

A despairing culture is not merely an unfulfilled culture or a culture without happiness; it is one where human beings, however comfortable in material terms, suffer an unconscious grief – the knowledge of their self disfigurement. It is one where an unquenchable hatred impresses all that is alive – in particular on most kinds of gentleness and refinement, femininity and all its characteristics. It is one where people, with no means of repairing the debt they owe to life, project their self-loathing onto the good, the true and beautiful. It is one where the good is hated precisely because we know its rectitude calls our being into question. 'What man passionately wants is his living wholeness and his living union,' writes Lawrence and when this is lost then what is left save yearning for the sense of being, of being alive in the flesh, or oblivion, that may be found through violence, resentful vandalism or a drug-induced trance?

Nowhere on this planet, I suggest, would it be possible to choose a painter more expressive of modern soul-life than Francis Bacon. In the foreword to a major retrospective of Bacon's work at the Tate Gallery in 1985 Alan Bowness writes:

66

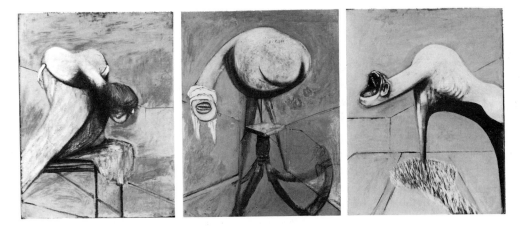

His own work sets the standard for our time, for he is surely the greatest living painter; no artist in our century has presented the human predicament with such insight and feeling. The paintings have the inescapable mark of the present.

Bacon was born in Dublin in 1909 of English parents, his childhood background one of violence. At the age of fourteen he left home for good; he had no formal training in art but began painting in oils in 1929. Bacon's first mature work – his *Three Studies for Figures at the Base of a Crucifixion* (1944) (Plate 17)[7] marked not only his recognition as a major influence, but revealed many of the characteristics of his later work. It is a triptych; three paintings in one, taking the pain of Blake's *Nebuchadnezzar* (Plate 16) several stages further. The three figures, part human, part beast, part avenging furies, have no eyes but only mouths. A sense of scream, visibly speechless, hovers like an echo across the anguished paint. In this work, like Munch's famous painting, there is no house for the soul which has been driven screaming into the inner and outer dereliction which continues to proliferate around us. Some dreams, some poems, some musical phrases, some pictures, wake feelings such as one never had before – spiritual sensations as it were,

Plate 17
FRANCIS BACON
Three Studies for Figures at the Base of Crucifixion, (c.1944)
Oil and pastel on hardboard; each panel 37″ × 29″
Tate Gallery, London

67

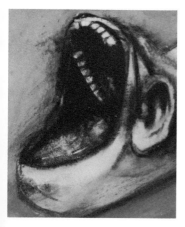

Detail from Plate 17

hitherto unproved; here in the *Three Studies*, dated 1944, private and secret, the modern world, its bloodletting, its violence, its suffering, its descent into hell, is experienced for the first time.

In the years following the completion of the *Three Studies* Bacon began to produce the oils for which he has become world-famous: a series of popes based on Velasquez' *Portrait of Pope Innocent X,* and others derived from the nurse from the Odessa-steps sequence from Eisenstein's film *Battleship Potemkin.* Photographs illustrating human and animal motion by the Victorian photographer Eadweard Muybridge[8] provided a further fund of images. More recently Bacon has painted a number of large, powerful, ferociously vivid canvases of naked men, in blank and empty rooms. They fight, copulate, vomit, defecate, and scream. Looking at them I am reminded of a line from the *Oresteia*[9] which haunted Bacon for some time: 'the reek of human blood smiles out at me'.

The reek of human ignominy, a menace of desolation, sets Bacon apart from all predecessors. His anguish might represent for us humanity's horror and sense of helplessness at the discovery of evil – the infiltration of animality into the human world, naked cruelty, and appetite – but this I think is not the case. Goya's was the voice of protest. With Bacon it is different. There is no melioration, no catharsis, no sacrifice, no relief of pain; neither charity nor tenderness. Never before has human desolation been pictured with such genius.

What then is Bacon's aim – apart that is from 'pure painting'? It is, says Michel Leiris,[10] a personal friend, to strip down the world to its 'naked reality' – to cleanse it of 'both its religious halo and its moral dimension'. Such 'realism' is rooted, I don't doubt, in the painter's clear-sighted conviction of life's irredeemable meaninglessness. As Bacon himself says:

Man now recognises he is an accident, that he is a completely futile being, that he has to play out the game without reason. I think that even when Velasquez was painting, even when

68

Rembrandt was painting, they were still, whatever their attitude to life, slightly conditioned by certain types of religious possibilities, which man now, you could say, has had cancelled out from him. Man now can only attempt to beguile himself for a time, by prolonging his life, by buying a kind of immortality through the doctors. You see, painting has become, all art has become – a game by which man distracts himself. And you may say that it has always been like that, but now it's entirely a game. What is fascinating is that it's going to become much more difficult for the artist, because he must really deepen the game to be any good at all, so that he can make life a bit more exciting.[11]

Bacon, we are told, is a man with no religious beliefs, no secular ethical values, and he lives his life in consonance with this view of man. The link with Blake's *Nebuchadnezzer,* bestial in seeking sustenance in material things alone, is inescapably direct. For if Bacon's extremism is an entirely private characteristic, the general tenor of his despair, the tone of his pessimism, is broadly shared by a host of others now living, as Rilke puts it, 'a dummy-life amongst pseudo-things'.[12]

In 1895 Yeats wrote:

I cannot get it out of my mind that this age of criticism is about to pass, and an age of imagination, of emotion, of moods, of revelation, about to come in its place; for certainly belief in a supersensual world is at hand again.[13]

Just over a decade later – in 1909 – the painter Henri Matisse[14] created, in areas of flat local colour, a decoration, *The Dance,* (Plate 18) which prefigured the age Yeats had prophesied.

Efforts have been made to trace the origins of its group of figures but Matisse himself was always evasive when questioned on the subject. No wonder. He had reached down into the

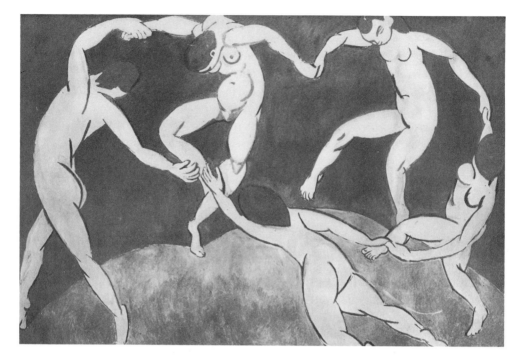

depths of being to bring forth one of the most tremendous images of things to come. In some aspects it is a simple composition: a circle of figures dancing above a hill. But the figures are linked, we note, not only to one another but by a deeper rhythm as elemental and harmonious as the waves of the sea. The landscape, too, reduced to essentials, is part of this rhythm as are the three intensely saturated colours – the ultramarine of the sky, the pink of the bodies and the green of the hill – forming as it were a chord of music. 'Our only object is wholeness,' claimed Matisse at the time. *The Dance* is also, of course, a highly sophisticated painting, one of the most dazzlingly courageous of the early twentieth century; colour and shape have been chosen to maximize the pure wave-like rise and fall of the composition and its key-emotion: an elemental radiance. *The Dance* speaks of a largesse of spirit, an optimism, a life-abundance, at once reverent and familiar with the great

70

spring of being. I would call it, first and last, a religious work.

Wisdom speaks first in images. And in *The Dance* we may discern, I believe, many of the elements of the age Yeats prophesied. There is, for instance, a mythic dimension wholly absent in Impressionism. There is a sense of Dionysian energy, a return to the deep roots of things; an archaic substratum. There is, too, a sense of the essential unity or oneness of all life; a delight in spontaneity *and* intellectual rigour, the archaic *and* contemporary, people *and* nature, creativity *and* discipline, proposing connections and relationships of fresh kinds.

Such balance, such complementarity, is as characteristic of the emergent paradigm as it was of the way the painter operated. Matisse explained:

> My reaction at each stage is as important as the subject . . . it is a continuous process until the moment when my work is in harmony with me. At each stage, I reach a balance, a conclusion. The next time I return to the work, if I discover a weakness in the unity, I find my way back into the picture by means of the weakness – I return through the breach – and I conceive the whole afresh. Thus the whole thing comes alive again.

In *Mind and Nature,* published in 1979, Gregory Bateson argued that relationships should be used as a basis for all definitions. Anything, he believed, should be defined not by what it is in itself but by its relations to other things. Intuitively Matisse knew this truth. He also sensed, I suggest, the elemental and contemporary importance of the dance theme. For why else should he have painted the dance of the creative art, that for artists, for mystics and physicists alike underlies the basis of all being? Matisse's whole output could be seen as a hymn to creation as a divine play.

Like *Newton* and *Nebuchadnezzar, Dance* is one of a pair. Its companion, *Music* (1910) (Plate 19)[15] shows another group of figures seated on the grass, 'in silence, pensive meditation'.

71

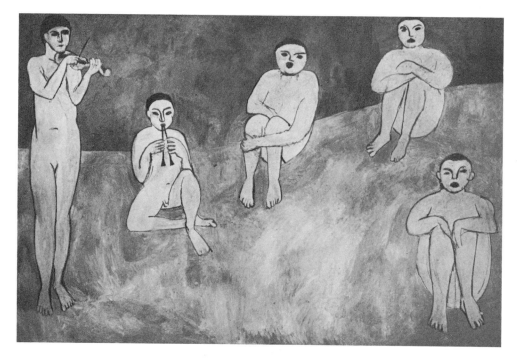

Plate 19
HENRI MATISSE
Music, (1910)
Oil on canvas;
101½″ × 153½″
The Hermitage, Leningrad
© Succession Henri Matisse/DACS 1988

'Here I picture,' said Matisse, 'a scene of music-making with attentive listeners.' In contrast to the fierce, creative exuberance of *Dance, Music* conveys a feeling of contemplative relaxation; a matching inwardness and, as Matisse suggests, attentiveness. The two panels have more in common than a form as primitive as the colour that has filled them; both share a joy in art's celebratory, redemptive power – its capacity to educate the inner being – and a deeply-felt reluctance to establish hierarchies. The exacting adjustments of colour, the undifferentiated human beings, the ease with which the role of listener and performer can be interchanged are also evidence of a radical insight into the non-dual nature of reality. At one stroke Matisse created an emblem of the new synthesis, asserting the importance of meaning and relationship as the primary need in human life, and the role of art in this process.

Almost three quarters of a century after the decoration had

been painted the idea of a paradigm shift – a profound change in the thoughts, perceptions, and values that form our current vision of reality – is no longer exceptional; the revolution in modern physics foreshadows an imminent revolution in all the sciences and a concomitant transformation of our worldview and values. It is even arguable that the last decades of the century have produced as many important thinkers as the West produced at the time of the Renaissance or, for that matter, in the 100 years of fermentation preceding the development of the Romanesque and, later, of the Gothic style. There is now an equal renaissance of wisdom astir, it seems; a comparable renewal of energy.

Reference to the correspondence between scholasticism and early Gothic architecture is far from arbitrary; its concurrence of art and philosophy has parallels with the current mutation. Then, too, the foundation-work took place over a long period. Then, too, men and women turned for insight to the springs of creation at the deepest level of their being. For the mediaeval 'revolution in consciousness' was developed not only by means of deep thought, important as this has always been, but by seizing key images, myths, and archetypes, unfolding symbols. In dreams, as Yeats said, begin responsibilities.

What stage have we now reached in the evolution of our own consciousness? I have heard it said that the New Age is imminent but this I do not believe. People are responding less and less to dualism but a full-scale rejection is not yet in sight. We are still immersed in the realities and heroics of our own culture – only just beginning to appreciate that the Faustian vision is not always the highest and most successful embodiment of legitimate human aspiration but, all too often, a hindrance to the development of a valid alternative. Nonetheless, metaphysical reconstruction moves on apace; the first steps of the Buddhist 'Eightfold Path', namely 'Right View', have been taken.[16] Tentatively, but with growing confidence, we are learning to give precedence to process, to uncertainty, to wholeness, to relationship, to local identity, to spirit. Can we

73

now pay the same attention to one of rationalism's greatest casualities: the aesthetic. I don't doubt it. The very parameters of the mind change make this inevitable; we are on the brink of recognizing that even if we value more deeply those with particular artistic gifts, we are all artists and deeply creative in our own unique way. We are creative not by choice but by nature; creativity, one might say, is the condition of our existence. Once open to the energies of integration there are, as Gary Snyder says, 'basic and ancient conditions from which we flourish.'[17] And one of these is that well-being is a statement about the integrity with which we live our lives as works of art. This is the level on which men and their societies once lived – and will, I trust, live again.

The new practice therefore carries certain consequences: the rejection of art in terms of entertainment, decoration and market values; the rejection of the artist as solely a specialist creator; of art answering only to its own laws; the pure aesthetic without a function. Ultimately, the aesthetics of the new philosophy will involve a shift from specialism to universality and integration. 'Art' will increasingly come to be regarded as not only a province for professionals, not simply in terms of commodity and performance, but as part of daily life – the life of the streets, of the home, of physical labour, of technology and science and religion. For we must now, ourselves, become the life-bearers and discover, or not at all, the same ground from which all civilization sprang. Each of us must undertake the inner journey, the creative quest, there to discover the fountain of life we all share. 'It is the fitting together that we praise,' wrote David Jones in his great essay, *Art and Sacrament*'[18] 'the process of perfecting.'

The struggle to regain these powers, to rebuild the broken bridges, to evolve a new aesthetic, a new set of values in humankind, will be long and hard, taxing all our powers, but a necessity.

In this chapter I have chosen a small number of images which may be read as symbols, as hieroglyphs of collective human experience. To conclude, I would like to take a further watercolour by William Blake, the man who wrote: 'The Whole Business of Man Is The Arts and All Things Common'; the man whose relevance to the present age, whose importance to those who are themselves trying to escape from the dominance of materialism, can hardly be exaggerated.[19]

Blake, in fact, offers us a prospect both inspiring and sane. He offers us a golden thread with which to travel through the dark labyrinth and slay the Minotaur at its centre. Energy, he says, is the basis of all existence. If you don't reach it through your imagination, if you lose touch with it in the unconscious, you will wither and die. You will become brutalized. Your life will be hollow, paralyzed. I therefore leave you with a final image. It sums up Blake's view of the essential role of the artist in achieving salvation and the pattern of his own life which both calls for and offers a new vision of creative renewal. It is *Dante in the Empyrean drinking from the River of Light* (1826) (Plate 13)[20] – a heavenly vision forging emblems of life and light.

From the crucible of the enormous spiritual sun a torrent of coruscating light pours down in the form of a river dividing the composition into two parts: masculine on the left, feminine on the right. Four great rays, symbolic of the 'fourfold vision' beam from the sun's sides. Within the torrent and all about it are various sprites, 'the living sparks' or jewels which are mentioned by Dante. The figures above him and on either side of the river are not however in the text. They symbolize the arts represented by an aged, laurelled, poet (perhaps the regenerate Urizen) and a scene of painting and engraving – in the group is a figure, rather like Chagall, standing before an easel with a palette and brush. The river and the clump of foliage on the left are alive with tiny figures – 'infant joys' as Blake described them.

On the other (right hand) side is Nature, represented by Enion, guardian spirit of the earth and Vala, the Female Will.

Plate 13
WILLIAM BLAKE
Dante in the Empyrean, Drinking from the River of Light, (1824–7)
Water colour drawing;
20⅝" × 14⅝"
Tate Gallery, London

75

The whole scene thus represents, according to Roe's interpretation[21], Art and Nature raised to the Eternal World through the agency of the River of Divine Imagination which for Blake is the only real life. Dante has drunk at the River of Life – the River of Divine Imagination – he has drunk (as we may) at a place of renewal of the spirit. He has lived according to the imagination of which the arts are the expression. Thus art and nature may be regenerated, made whole again, in the eternal world. There is no need for a separation between inner and outer worlds, no need for duality, no need for division; these have disappeared. Feminine and masculine, the light and the shadow, religion and science, have been united as they were in the painter himself. A few months before he died, Samuel Palmer still thinking of the old friend of his youth, wrote: 'I certainly knew *one* man who was an Unity, but he was one of a thousand, of *Ten* thousand; – the greatest Art genius this country ever saw. Of course I allude to William Blake.'

5

FORMS OF ADORATION

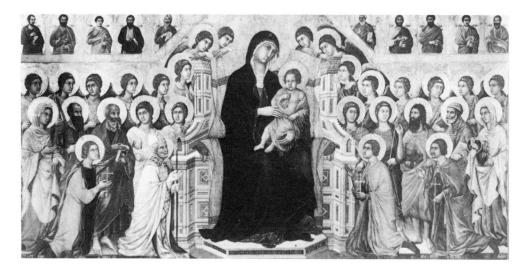

Plate 20
DUCCIO
The Virgin Enthroned
with Angels and Saints
(Maestà), (1308–1311)
Tempera on wood panel;
83″ × 168″
Museo dell' Opera del
Duomo, Siena

Forms of Adoration

Duccio: The Sacramental Vision

O N 9 T H J U N E 1 3 1 1, Duccio's glowing masterpiece of the Virgin in Adoration, the *Maestà*, (Plate 20) completed after three years work, was carried in triumph from his workshop to the high altar of the cathedral in Siena. An anonymous author of the great event writing towards the mid-century says:

> The shops were shut; and the Bishop bade that a goodly and devout company of priests and friars should go in solemn procession, accompanied by the Signori Nova and all the officers of the Commune and all the people; all the most worthy followed close upon the picture, according to their degree, with lights burning in their hands; and then behind them came the women and children with their great devotion. And they accompanied the said picture as far as the Duomo, making procession around the Campo as is the custom, all the bells sounding joyously for the devotion of so noble a picture as this. And all that day they offered up prayers, with great alms to the poor, praying God and his Mother, who is our advocate, that He may defend us in His infinite mercy from all adversity and evil, and that He may keep us from the hands of traitors and the enemies of Siena.[1]

The importance of Duccio's *Maestà* for the city and people of Siena was not only reflected in its treatment upon completion; it had been commissioned to replace the *Madonna degli Occhi Grossi,* which previously stood on the high altar of the

cathedral – the single, most revered object in the city. It was to this icon that the Sienese attributed their victory when, against all the odds, they routed the invading Florentine army at the Battle of Montaperti in 1260.

On the eve of the battle, Buonaguido, the syndic 'barefooted and bareheaded . . . came forth into the presence of all the citizens and in his shirt betook himself to the Duomo' where he dedicated the threatened city to the Virgin. In the afternoon, a miraculous sign of her protection, Mary's mantle was seen flowing in the sky over the battlefield. Next morning the Florentines were defeated; Siena was saved. Even in Europe where the cult of the Virgin was omnipresent, the Sienese had exceptional reasons for devotion and thanksgiving. Siena was, to the Sienese, *Civitas Virginis*. Her seal[2] was set on all affairs of state, and she was rendered homage not merely as Queen of Heaven but as protectress of the city and, indeed, its very ruler. Her hold was absolute: as Queen of Heaven she was the chief mediatrix with the deity; as a mother – a mother amongst mothers – she was not so much solemn and mysterious as compassionate and wise. Not for nothing does the visitor still feel that Siena is amongst the most, if not the most, feminine of all European towns.

A blending of matriarchal and patriarchal elements – the all-loving, all-forgiving mother who could comfort and intercede; the all-powerful father conceived by the theologians with the majesty of an impersonal idea – represented one of the main reasons for the Church's psychological power over the people. But there was another reason why the Virgin's hold on them was so secure. The reassertion of the feminine both within and outside the Church has been rightly interpreted as a return to the old but never forgotten beliefs and cults of the Mother Goddess. It was also perhaps something else. The transformation of the feminine into an ideal (largely through the representations of the Virgin Mary, the poetry of the troubadours and minnesingers, and by the compilers of the Arthurian legends) might also be interpreted as a return to an

80

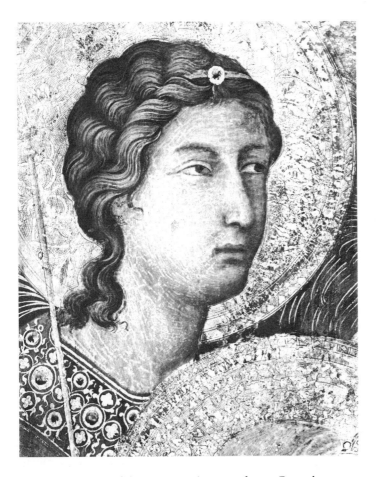

Detail from Plate 20

archetype, to one of the recurrent images of man. By such means was the Eternal Feminine (in an unearthly guise) re-acknowledged and made acceptable to the male Christian West.[3]

Standing in front of the *Maestà* today (in the Museo dell Opera del Duomo in Siena) we are left with a feeling of indescribable peace – a deep sense of refreshment and consolation for the spirit. This, we know, is a Great Goddess – a no more powerful or beautiful figure could exist nor one which could bring such complete healing to our soul. Gazing in reverence we seem to be carried away by a great wave of prayer.

81

We seem to share mystically in the life and death of the universe – its oceans and rivers, crystals and stars – whose language has its own music, its own rhythm, its own harmony and dance. There is indeed a continual dance of the higher emotions, those of love, understanding and compassion and a new sense of sharing, of conscious participation; of empathy. As Paul Hills writes[4] 'We are aware only of a radiance that is continuously renewed. The eye, pathway to the soul, roves long over these alternations of colour and the mind is held in prolonged contemplation.'

Imagine then its original impact, first seen on that bright June day, gleaming like radium, in the Duomo's dark, thickly incensed, almost oriental nave. Imagine its effect on unlettered men and women who saw it in the light of candles in a state of prayer. Once the surrender had been made they, too, would have found their minds had been expanded into an infinitely greater whole. A whole which prompted them to rise above themselves, to love more deeply, and enter the ground and substance of their souls. But being less sophisticated, less disillusioned than ourselves, the mesmeric impact of the icon must have been a thousandfold more potent than it is for us today.

Today we see – or do we see? – much of the original work.[5] We see the Virgin Mary, the Queen of Heaven, the Queen of Majesty, enthroned with the Christ child on her knee and a great company of saints[6] and angels, forty in all, standing and kneeling on either side. We see the great ivory-coloured, gothic throne and the roll and gold cloth upon which the Madonna sits. We see the loving gaze of the winged angels behind her head, the flutter of hands, the fall of vestments, the sinuous calligraphy of gold thread and ornament. We may also see on the footrest, no minor detail, an inscription which calls for peace and, by implication, eternal fame and recognition for Duccio[7] – MATER SANCTA DEI * SIS CAUSA SENIS REQUIEI * SIS DUCIO VITA * TE QUAI DEPINXIT ITA – which reads, Holy Mother of God, may you give peace to Siena, may you give life to Duccio, who has painted you thus. This is amplified by the choice of the four most prominent

82

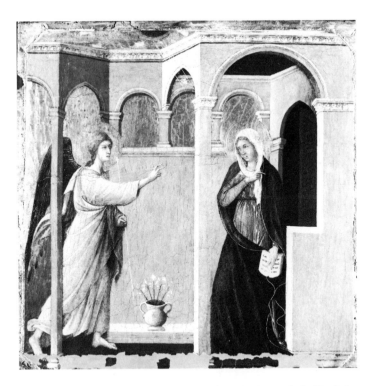

Plate 21
DUCCIO
The Annunciation,
(1308–1311)
Tempera on wood panel;
17$\frac{2}{5}$″ × 18″
National Gallery, London

Sienese saints who intercede with the Virgin on behalf of the
city. The theme of the *Maestà* is one of thanksgiving and
supplication to the Virgin as the patron of Siena.

On the picture's back we may also observe forty-six of the
original small panels[8] illustrating the Life and Passion of Christ
and, and on the predella and frame, scenes from the Life of
Christ and the Virgin (Plate 21). And if by good fortune we have
trained ourselves or been trained to use our eyes, we may also
find something more: an abstract splendour of movement and
design, of colour and texture, which stands comparison with the
most moving areas of paint in the world.

Yet, it is clear, Duccio gave no thought for aesthetic
delectation as an attribute in its own right. The primary purpose
of his work was not delight but instruction, not pleasure but
illumination, not temporal distraction but ultimate truth – the

83

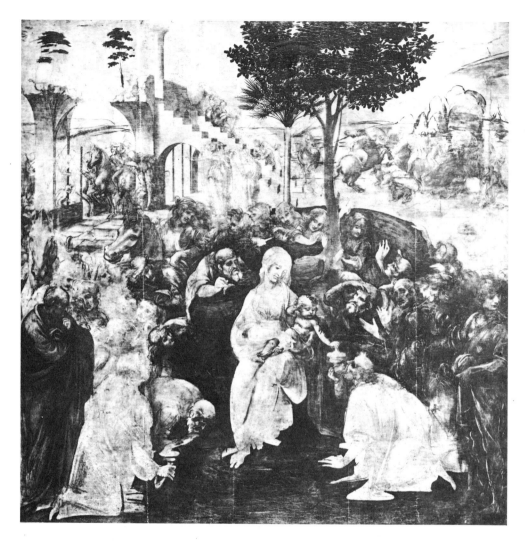

Plate 22
LEONARDO DA VINCI
*The Adoration of the
Magi,* (c.1481)
Oil on wood panel; 96¾″ ×
95½″
Uffizi, Florence

truth of the divine reality. Its goal was to integrate, uplift, and inspire.[9] In this respect, the *Maestà* can be seen as the painterly equivalent of Le Thoronet[10] or Chartres, Amiens or Notre Dame, a means to awaken the soul to this hidden mystery, to allow the divine presence to make itself known.

Leonardo: Disciple of Experience

One hundred and seventy years after Duccio's *Maestà* was carried in triumph through the streets of Siena to the cathedral on its hill, Leonardo da Vinci, aged twenty-seven, made a contract with the monks of San Donata a Scopeto, a cloister outside Florence. He would paint them an altarpiece (Plate 22) and finish it in twenty-four or, at most, thirty months. His subject, the Adoration of the Kings. Leonardo set to work at once but the oil (on a wooden panel) was never finished. But although abandoned[11] it is, in all but a technical sense, complete.

In the background of the composition, amongst buildings whose flights and stairs are reminiscent of a Piranesi engraving,[12] naked men are in combat; elsewhere, horses and riders cavort and tumble in a noiseless dream. In the foreground the Virgin has taken her seat in a natural setting;[13] she is clearly the still centre of this particular cosmos, the hub around which an arc of agitated figures circle, crouch, and kneel in a sweep of movement, at once disquieting and ambiguous. None of this belongs to the universe of certainty which Duccio inhabited and painted. It is the turmoil which later broke out in Michaelangelo's *Last Judgement* – a late icon, like a Tibetan mandela – of Christianity's tumultuous spirit, its unresolved dualism. It is the ambiguity and wisdom of a mind which can state, as Leonardo did: 'Among the great things which are to be found among us, the Being of Nothingness is the greatest.'

On left and right of the composition two figures stand; their significance has defeated every interpreter. One of them, in deep meditation, gazes inwards; the other, a romantic figure of a handsome youth in armour, has turned his back on the worshippers with an indifference unusual, not to say scandalous, in an Adoration. Nonetheless, whatever their contrasting gestures symbolize – and youth and age, moral and physical beauty, active and passive intelligence have been suggested – both figures contribute to the sense of uncertainty so characteristic of this remarkable painting.

During Leonardo's lifetime he was a legend, regarded with wonder and admiration; 500 years have only increased his fame. The vast range of Leonardo's mind, the extent and depth of his speculation about the physical world, his unsurpassed abilities – all these are widely and rightly admired. Yet Leonardo, even for his own time, was a solitary figure. He worked alone, had no apprentices, and treated his art as a secret pursuit, half science, half magic, like alchemy. Moving from patron to patron, working to commission, he maintained his independence and fierce integrity. He was, we would now say, always his own man. In this and much else I am reminded of another Renaissance contemporary. Columbus,[14] too, sailed out of sight. He also, after long absence, returned with messages of discovery. The same perpetual experimentation, the same disregard for limits, the same unstable equilibrium, the same scientific and mathematical bent, the same notion of progress, the same concern for space and time, reason and calculation, engaged them both.

Individualism, as it pertains to the arts, is not an unmixed good. Cutting himself off from the mediaeval worldview, from a shared and sacred vision, from his fellow citizens and the traditions of his craft, Leonardo was one of the first to formulate private problems and a rarefied language. He was also one of the first to give expression to the individual will, to break with the experience of the past. Fragmentation is implicit in his work and accounts for its spectacular variety. We observe it, for example, in Leonardo's notebooks[15] – one of the most voluminous and complete records of a mind at work which has come down to us – which record so many separate facets of the world: the secrets of nature, mathematical demonstrations and formulae; questions about the construction of certain machines; questions about the first principles of dynamics, all jumbled up, without continuity, a kind of jigsaw of opinions and knowledge as inherently meaningful and divisive as the 'knowledge' of our own time. Leonardo's attitude to mathematics is perhaps no less indicative of the sea-change of consciousness then affecting the best minds. To him, living on the eve of the Reformation, the

86

most incontrovertible of facts was not the revealed world of Holy Truth, the Divine law or the Pythagorean aesthetics of number – the ideal order of Duccio – but a detailed knowledge of natural objects which Leonardo at no point regarded, as earlier artists had, as an intellectual revelation of the divine.[16]

Leonardo, in fact, made regular use of the mechanical model. He described the tendons of the human body as 'mechanical instruments' and the heart as a 'marvellous instrument'. He also wrote that 'the bird is an instrument operating by mathematical law', a principle underlying his attempt to construct a flying-machine. The mechanization of the world was in seventeenth-century Italy, and not least in Leonardo, already re-defining the traditional view. He was part of this movement; one of its fathers, yet for him art, science and nature were as yet undivided.

Detail from Plate 22

With preternatural foresight Leonardo's genius also fathomed its decline. From the first he is obsessed by a vital force at the heart of creation – 'the force that through the green fuse drives the flower'.[17] He studied rocks, dissected corpses, analysed the structure of the embryo, the seed pod, and the flower. Then as his scientific researches developed, Leonardo learned of the vast power of natural forces and pursued technology as the means by which these energies might be harnessed for the advantage of human good. The further he penetrated the secrets of the universe the more he became aware of human impotence: his studies of hydrodynamics suggest a power of water beyond human control; his studies of geology show that the earth has undergone upheavals of which ordinary earthquakes are but faint and distant echoes; his studies of embryology point to a central problem of creation apparently insoluble by the human mind.[18] Towards the end of his research there is further evidence that Leonardo became disheartened by the mass of his recorded observations which not only by their bulk, but by the nature of their evidence, had passed out of his control. Then around 1514, five years before his death in France, he produced the great but disheartening series of 'Deluge' drawings as if consciously or unconsciously he was reminding us of our own potential fate.

Plate 42
LEONARDO DA VINCI
The Pointing Lady,
(c.1515)
Black chalk on paper;
8¼″ × 5¼″
Royal Library, Windsor

Mystery, the Gioconda's smile, was the source of Leonardo's questing speculation. His search to lift the veil which clothes the visible world, his attempt to give symbolic form to the sustaining spirit within creation, were both motivated by this deepest instinct. Year by year he studied the movement of water and was reminded of the relentless continuum of natural force; he studied geology and formed the concept, centuries before James Lovelock[19] and Lynn Margulis, that the earth was alive and renewing itself like a living organism. Everything in nature he discerned was in a state of flux. But the source and centre of this inexhaustible energy remained mysterious to him.

According to Vasari,[20] Leonardo was not a man of faith, believing rather 'that it was perhaps better to be a philosopher than a Christian'. In this, I think, he was in advance of his age which already, in its art, its greedy pride in naturalism, was already beginning to behave as if man were God. Yet, here again, Leonardo's intuition was in advance of his contemporaries bent on capturing the external world and subjecting it to systems and theories. He sought to express not nature in its outward form but the manner of its operation: the secret key to creation. (Plate 42) He sought to understand, as Goethe says in *Faust,*[21] what it is 'that girds the world together in its inmost being'.

As an icon of this mystery Leonardo's painting is supreme. Thus in his own 'modern', idiosyncratic way, his *Adoration,* like Duccio's is an expression of devotion; an act of worship and a song of praise. For in this work – symbolized by the kneeling figures, the pointed finger, and the smile – Leonardo has revealed the primal act of creation, the inexhaustible, prodigious, 'fathering and all-humbling' act, before which, like the figures in his own *Adoration,* we can only kneel and gaze and shade our eyes in wonder. Raphael[22], it is told, stood in front of Leonardo's *Adoration* in reverent silence. Nearly 500 years later we, too, can only respond in the same way.

Plate 23
JEAN DOMINIQUE INGRES
Napoléon I on the
Imperial Throne, (1806)
Oil on canvas; 104⅝″ ×
63″
Hôtel National des
Invalides, Paris

Ingres: The Artist as Hero

Standing before this giant[23] idol in the Musée de l'Armée (Plate
23), I feel, and am intended to feel, mesmerized – like an
undersized devotee. In front of me stares a new god. Less tender

than the Virgin, less loving and poetic, male and implacable, this icon revives something of the power of a Christ pantocrator, ruler of the universe, in a Byzantine church.[24] Images like this, looking down from other and more ancient walls, had been such a perfect archetype of the divine that to the painter of this portrait, Jean Dominique Ingres, there appeared to be no reason to change it.

Napoleon on the Imperial Throne, one of the first of a new kind of state-sponsored adoration, presents the subject as more than a mere flesh and blood male. Like thundering Zeus, like Jehovah inspiring terror, this god-king is more divine than human, more powerful than compassionate; a judge rather than an intercessor, a secular Christ on the judgement day. The triumph of manhood is implicit here.

Yet the triumph of the male principle and the seemingly viable social order built upon it had, by the time this portrait was painted, been under considerable attack. Blake's *Urizen* (1793), represented in one of his smallest engravings, *Aged Ignorance,*[25] as an old man clipping the wings of a youth, had already symbolized the propensity of the period to limit consciousness to reductionist thought. Blake knew the collapse of eighteenth-century rationalism was inevitable. Too many deep-rooted instincts had been repressed. The problem was that when these instincts re-asserted themselves they eagerly lost the bearings which had once held them in place. The instinct to worship and revere, no longer directed by a system of religion, projected itself upon a hero and upon the nation state. The experience of divinity, of martyrdom, increasingly translated into the realms that lay beyond the pale of the Church, became in turn an appetite to be quenched only by adventure or, in the case of the Napoleonic armies, by dazzling violence. Instead of an acceptance of the present there grew up a nostalgia for the romantic past – the past of chivalry, of knights, and troubadors.[26] The culture which informed this work had lost the certitude Duccio took for granted and Leonardo may have known as a youth.

Ingres was born in 1780 and finished *Napoleon on his Imperial Throne* in 1806 – Napoleon, aged thirty-seven was then at the height of his power. Two years earlier Ingres had painted *Napoleon as First Consul*[27] standing full length in a suit of paprika-brown velvet before a window overlooking Liège. Within the room, upon a table covered by a deeply fringed velvet cloth, are manuscripts and quills. A richly ornamented chair stands upon the carpeted floor.

Throughout his life Ingres took the keenest pleasure in the representation of the material world. His *Mme Rivière* (1806)[28] is enveloped in a cocoon of rich materials, his *Mme Moitessier* (1856)[29] even more abundantly dressed – the sitter is smothered by a material opulence which has subsequently become the acquisitive aim of a large part of humanity. The silk, the velvet, ermine and other fabrics in *Napoleon on his Imperial Throne* are also painted with the self-same coldly objective weighting of fact. 'Thingness' in Ingres is all.

In comparison with the this-worldliness of *Napoleon,* heavy with the materiality of the century (which Dickens, too, so masterfully portrayed), the *Maestà* belongs to a different world. This was a world permeated with symbolic meanings for even the material opulence of the Virgin's vestments, the cosmatesque inlay of the throne, the extraordinary actuality of St Catherine's cloak on the left and that of St Agnes on the right, are expressive of the human as incarnate image of the divine. We are in fact privileged to witness not dead matter, but an event in the court of heaven and the shimmer of the silks and damask cloths, though not as fierce as in Byzantium, still gleam as metaphors for an inner state of consciousness. 'There is nothing to be found in the whole world', wrote the Renaissance magician, Agrippa von Nettesheim,[30] 'that hath not a spark of the virtue (of the world soul). Everything has its determinate and particular place in the exemplary world'. From this point of view matter was not a substance (as it had become in Ingres) but a veil that hides but also reveals God.

In spite of (or because of?) this adherence to the prosaic world

Detail from Plate 23

of fact – inevitably mediated by the inner logic of the composition – there is more than a hint of agitation, even eroticism, under the frozen surface of *Napoleon*. Look, for example, at the snaking folds of the fallen ermine above the dais. What certainty is here, and yet what fever! What ice-cold passion! And what emptiness! Hiding behind the vast dimensions of the canvas, *Napoleon on his Imperial Throne* has an inner smallness exploding the painters grand design.

All the difficulties of life for Ingres' generation can be detected in this painting where, with addictive obsession, Ingres has attempted to find a foothold for his loss of faith in the property of concrete particulars: the world of fact. God, for him, was dead; religion an increasingly empty shell; 'art' the safest refuge in the ensuing cosmic storm; 'I have to give myself up to my surroundings,' wrote Ingres' German contemporary, the painter Caspar David Friedrich,[31] 'to be united with my clouds and rocks to be what I am.' In like manner, it seems, Ingres had identified with the velvet and the ermine of Napoleon's cloak.

The opposition of soul to all that would butcher or purchase it had by now taken two divergent forms: revolt and acquiescence. Against the tide of secularism a small number of artists and

92

prophets, the English nature poets amongst them, offered resistance and a deeply thought-out argument. Against the rational mind, they offered a feeling response. Against ideology – humanism, socialism, industrial growth – they offered 'awakeners' of the individual soul. In a culture already endangered by its determination to exclude a transcendent order, they affirmed the unconscious, the night-side of nature, and the sacred. But their teaching and their warnings fell on deaf ears. The century, 'blind to all the simple rules of Life',[32] proceeded as if no warning had been made. Others took a different, more acquiescent path. Choosing to avoid the battle, they retreated into the high palace of art; a temple consecrated to spiritual values. Mammon shall not enter. They also saw themselves as an elite. They argued that art has no purpose beyond the purely aesthetic, that it cannot thrive constrained by religious, ideological or social demands. The myth of the artist as moral and spiritual legislator for mankind, whose integrity was measured by the extent of his disregard for worldy concerns became the model for the artist in modern times.

Jean Dominique Ingres is the supreme poet of this difficult but energizing phase of human experience. In Paris, Florence, Rome, a high priest of the new cult of art, he lived and worked in a sort of reservation carefully and deliberately staked out from the everyday world. He survived, and survived in comfort, by producing commodities for sale: portraits and also historical and romantic compositions – for example, *L'Age D'Or* (1862)[33], *Jeanne D'Arc at the Coronation of Charles VII* (1854)[34], and *Le Bain Turc* (1863)[35] – which look back to a more soft-focused, pre-industrial world. For a sensitive artist like Ingres there was by the mid-century no alternative but to face an uncomprehending bourgeoisie and dream. 'To brave everything,' Ingres wrote, as if to confess the alienation of his position, 'not to work except to please first one's own good conscience, then a few people in the world, that is the first duty of an artist.'

From the perspective of this book, there is something over-

heated, almost poorly, about Ingres' later work; its waxwork perfection resembling the preserved immobility of an exotic orchid, myrrh-scented, voluptuous, exotic – but sterile. The memorable sanity of Duccio's masterpiece is an emblem of more majestic adventure in the soul-life of western man.

Warhol: The Artist as machine[36]

'God was Big Business in the eleventh century' Truda was telling me as we lay in bed listening to the bells. I myself wasn't prepared for this kind of beginning but nothing seemed to stop her once the idea had been found. 'Mammon', she exclaimed, 'is Big Business now'.

We had returned after an absence to find Florence plagued by a virus of Italian school children and other, older, tourists shuffling and guzzling through the streets. Under their bland, ad-like faces, their blown-dry hair, there was a woeful sense of boredom. Gone the chaster charms of the post-war generation; four-square and direct. Gone, too, the noble restraint, the uncompromising severity of this once-proud city abandoned now, or so it seemed, to endless, effortless greed.

Under the austere but virile beauty of the tower of the Palazzo Vecchio, under the pure and refined beauty of Giotto's Campanile, under Brunelleschi's marvellous eerie dome, they congregated like blue drones (blue, because of the ubiquitous denim). They lounged, too, on the steps of the Duomo (amongst a litter of spent tins), drifted through the Uffizi, or blew gum, as I once observed, before Botticelli's vernal *Primavera*. (Plate 11). The fall of the birthplace of humanism, inevitable but tragic, was a shock for which we should have been prepared.

Yet surprisingly one of the most instructive comments on what we had been witnessing had been made over a hundred years before. In 1861 Edmund de Goncourt confided in his *Journal:*

The day will come when all the modern nations will adore a sort of American God, about whom much will have been written in the popular press; and images of this God will be set up in churches, not as the imagination of each individual painter may fancy him, but fixed, once and for all, by photography. On that day civilization will have reached its peak, and there will be steam-propelled gondolas in Venice.[37]

That day had now come and passed.

It came, I suggest, in the early 1960s when the cult of humanism was at its peak and a young artist of Czech parentage, Andy Warhol[38], silk-screened his first picture of Marilyn Monroe. In point of fact Warhol's image was the result of a joking suggestion. Until the early 1960s he had earned a meagre living as an illustrator and commercial artist working for the most prestigious glossy magazine and the more exclusive New York department stores. Then, one evening early in 1962, as Calvin Tomkins tells us, it all changed:

Muriel Latow told Andy that she had an idea but it would cost him money to hear it. Muriel ran an art gallery that was going broke. 'How much?' Andy asked her. Muriel said fifty dollars. Andy went straight to the desk and wrote out a cheque.
'All right', Muriel said, 'Now, tell me Andy, what do you love more than anything else?'
'I don't know', Andy said, 'What?'
'Money', Muriel said. 'Why don't you paint money?'
Andy thought this was a terrific idea. Later on that evening Muriel also suggested (gratis this time) that he paint something that was so familiar that nobody even noticed it any more, 'something like a can of Campbell's soup.'
The next day Andy went out and bought a whole lot of canvas and painted the money pictures and the first Campbell's soup pictures. This was before he discovered the silk-screen process, so everything was painted by hand; when he learned about silk-screening it went much faster.[39]

Soup cans were quickly followed by the 'portraits' of Marilyn Monroe – not only the *Marilyn Diptych* (Plate 24), but the *Round Marilyn*, the *Two Marilyns*, the *Four Little Marilyns*, the *Six Marilyns* and the *Twenty Marilyns* – all based on repetitions of the same image – a silk-screened photograph of Marilyn Monroe, almost a grotesquely made-up mask, from a film *Niagara*, shot in 1955. In the same year, 1962, Warhol created a painting 'composed' of different imagery but closely related to the same theme: 168 pairs of the actress's lips and teeth. The painting, over 14 foot by 13 foot in size is called *Marilyn Monroe's Lips*.

At much the same time Warhol also produced in multiple sets pictures of Liz Taylor, Troy Donahue, and Elvis Presley; these were exhibited alongside the soup tins and Monroe series in New York in the same year. The timing was exactly right. Warhol, who had always wanted to be famous, became a celebrity overnight.

Following this success he took a studio on East 47th Street which he named The Factory and went into mass production. From August 1962 to the end of 1964 Warhol and his assistants produced some 2,000 pictures subsequently displayed and bought by public museums for the high prices his work commands. He also manufactured further multiple-image portraits of Presley, Jackie Kennedy, and Liz Taylor and, in 1963 and 1964, a series of images of car wrecks in which human bodies have been trapped in the remains of their overturned and mangled machines. Another series, no less distasteful, is of an electric chair. Warhol's preoccupation with violence, justified on the grounds that his art was an 'indictment of American society in the sixties as scathing as Goya's merciless portraits of the Spanish Court',[40] was insatiable and endemic.

The savagery of Goya's portraits and his set of etchings, the horrifying *Disasters of War*,[41] is mediated however by the painter's own detestation of cruelty, a compelling sense of engagement. In Warhol, on the other hand, the chilling feature is not their subject matter, horrible as this can be, but the almost

96

total absence of an engaged sensibility – of any warmth of outrage or human pity or expression of life-giving tenderness. The feeling for people and things is featureless, merciless, and ice-cold.

In his book on the German concentration camps, *The Informed Heart*,[42] Bruno Bettleheim describes the dehumanizing process and its effect on those who could so easily dispense with a human being. 'Only after this attitude to persons had become their own . . . could they disregard the person in the prisoner; only then could they treat prisoners as numbers, not individuals.' I quote from Bettleheim because Warhol, amongst the most morally numb of all twentieth-century artists, so often claimed for himself the depersonalization, the alienation, the absence of continuity, which has characterized our era. The disdain for uniqueness and tradition, the obsession with quantity and multiplication, the repetition of sameness, of only slight and slow variations, these are just a few of the features that relate Warhol to the standardized, reductive tendencies of a civilization based on reason and money.

In his quest of an art that could be machine-like, that would look as though no human hand produced it, he also wanted to encourage the idea that anybody and everybody could and should be able to produce art. 'I'm using silkscreens now. I think somebody should be able to do all my painting for me . . . I think it would be so great if more people took up silkscreens so that no one would know whether my picture was mine or somebody else's' Sameness was all for Warhol: the modular anonymity of modern mechanical production, the techniques and anaesthesia of advertising, the malignantly decadent aspects of monopoly capitalism were therefore welcomed with open arms. 'I love Los Angeles,' he says, 'I love Hollywood. They're beautiful. Everybody's plastic. I want to be plastic.'

On another occasion Warhol voiced the view that he wanted to be a machine and his statement, like other pronouncements, was treated with reverential respect. By the late 1960s Warhol had become not only the most talked about artist in New York[43]

97

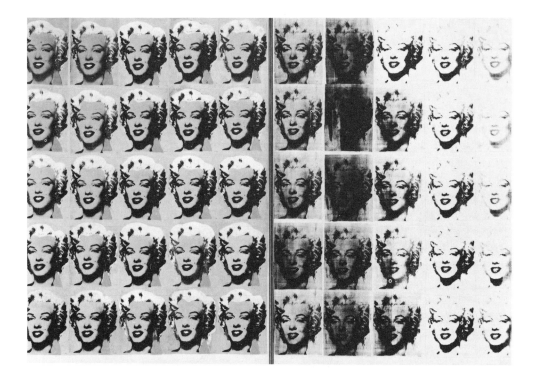

Plate 24
ANDY WARHOL
Marilyn Diptych, (1962)
Acrylic and silkscreen on
canvas; 82" × 57"
Tate Gallery, London

but a world celebrity of quasi-divine status – like John Lennon
or Picasso – in the shadow-play world of what used to be called
'The Show Business' and, at the same time, fabulously rich.

Daniel Boorstin once pointed out that the modern celebrity is
now famous for being famous – nothing else. Warhol's own
self-parody and honesty would, I believe, have claimed little
more; he had, it seems, few illusions. 'If you want to know about
Andy Warhol,' he once said, 'just look at the surface of my
paintings and my films and me, and there I am. There's nothing
behind it.'

I am looking at one of his works and I agree. It is the *Marilyn
Diptych* of 1962; (Plate 24) a large work nearly 7 foot by 5 foot
in size, divided vertically into two halves. In fact, the painting is
made up of two adjacent canvases and except for the fact that the
former is coloured, the latter, black and white, a sombre grisaille,

98

there is little to distinguish between the two. In this work fifty identical silk-screened portrait heads – some sharply printed, others smudged – are repeated over and over again, ten in a row, five rows deep, coloured on the left, black and white on the right. Taking his clue from advertisements Warhol is intentionally puerile in the narrowness of his forms and the raucousness of his colour and paint. Asked to define Pop art in 1957 Richard Hamilton said it was: 'Popular (designed for mass audience)/Transient (aimed at youth)/Witty/Sexy/Gim-micky/Glamorous/Big Business' – a fair description of the *Marilyn Diptych.*

The capacity to create convincing, replenishing and consoling images of nature depends not only on seeing, but also on belief. Behind the sphinx there was, as Truman Capote said of Warhol, no secret. Behind the irony, the trickster's melancholia, there was, it seems to me, an absence of any conviction; an absolute blank. When journalists confronted with the *Electric Chair* paintings asked Warhol about social criticism in his work, he always replied in the negative: 'No meaning, no meaning'. In this, as in so much else, Warhol was not so much a critic of the nightmare of the American Dream as a cause of the disease itself, celebrating the same values – instant success, ephemeral hedonism, brashness, casualness of style – which has made the Dream so powerful throughout the world.

Is it mere coincidence that in the midst of so much technological mastery and economic abundance, the 'art' of Warhol, the 'art' of our time, should project a nihilistic imagery, a sense of spiritual exile, unparalleled in human history? I refuse to believe there is no connection between these facts. The rejection of skill and tradition, the refusal of all notions of aesthetic propriety, the polemic against elite views of art in which uniqueness is a metaphor of the aristocratic, is in Warhol both highly self-conscious and deeply defiant. Less conscious and therefore more pervasive is the underlying anaesthesia, the spiritual vacuity which marks all his work. Yet all of it, conscious and unconscious, conceals a hatred of life. It is a mask which

99

conceals a bitter existential despair.

Warhol's 'art', a desolate commodity, lies in the area beyond enduring purpose, undying value – a kind of no man's land of the spirit, a waste land stripped of meaning, emptied of mystery, but insistent and restless as only the art of an essentially secular imagination can be. There is in him no glimpse of a world transfigured in the divine light. No redemptive spiritual element. Neither loving devotion nor happiness nor living communion, nor that celebratory relish in the matter of the world which from Titian to Bonnard has been one of the unparalleled pleasures of western art. Warhol cultivated a style in which soul has been exiled; the world purged of its sacramental intent. In place of the painter of feeling we have the painter of objects, objects whose language, as Peter Abbs writes,[44] 'derives not from true art discourse, not from aesthetics, but from the illicit application of the methods and working assumptions of science and technology.' We find, too, a paradoxical mixture of de-personalization and ego-gratification, anonymity and an obsession with fame, profanity and idolatory, parody and greed, the subordination of qualitative experience to quantitative generalization. The *Marilyn Diptych* is an emblem of a society which is essentially bereft of soul.

I counted three MARILYNS, two SEX PLEASE and five DALLAS's on the T-shirts of the dough-faced youngsters in Florence. They were all, as far as I could judge, under fourteen.

THE FLASH OF VISION:
FIVE TWENTIETH-CENTURY PAINTERS

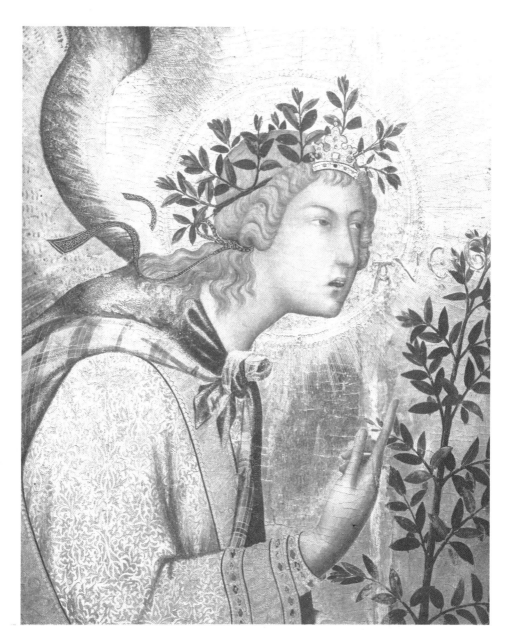

102

The Flash of Vision:
Five Twentieth Century Painters

THE SOUL COMPREHENDS IN images. There is one in particular I have in mind painted at the springtime of the Renaissance, not in Florence, but in Siena, an *Annunciation*,[1] (Plate 26) by Simone Martini who, like his predecessors, created a vision of holiness, an experience of the numinous, so concrete, so authentic, so whole-hearted that it stands before us centuries later with the vivid actuality of a steaming loaf of bread.

Seen across one of the Uffizi galleries it can stop the breath with its fierce, sparse, thrilling intensity. Against a self-luminous, gold background (symbol of incorruptibility, the quality of sacredness), the Archangel Gabriel has this instant arrived from heaven – the words coming from his mouth, *Ave gratia plena,* are clearly visible. Mary shrinks away, her gesture one of humility. Between them a still vase of white lilies, symbols of virginity,[2] stands before the gold whose radiance is a fitting metaphor for the Virgin's Annunciation as described by Jacobus de Voragine: 'The power of the most high overshadowed her, while the incorporeal light of the godhead took a human body within her, and so she was able to bear God'.

The Annunciation has an inexplicable splendour. But this has been used, not for its own sake but to show forth the mystery of the divine word; to manifest it not in abstract terms to the reason only, but in its concrete embodiment, appealing to eye, to heart and soul. In other words the picture's outward glory has been subordinated to its end: to enable the soul to pass through the outward form to its inner meaning; to contemplate the word

Plate 25 (left)
SIMONE MARTINI
Angelic Messenger from
The Annunciation (see
plate 26)

103

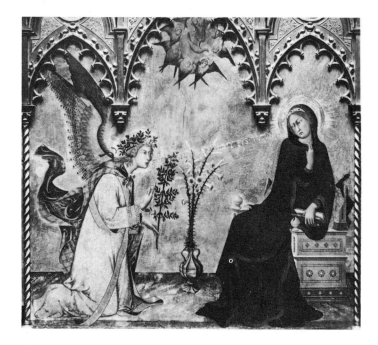

Plate 26
SIMONE MARTINI
The Annunciation, (1333),
detail
Tempera on wood; 52⅛″ ×
118¾″
Uffizi, Florence

being born out of the silence, of God becoming human.

In my experience, the solemnity of the mystery has never been expressed to such perfection. The experience of the holy has been rarely shown to such effect: not only known but loved, experienced, too, in the very seat of consciousness, the source of all creation where, as Raissa Maritain[3] writes, 'intelligence and desire, intuition and sensibility, imagination and love, have their common source'.

Few of us, I imagine, would deny that in general, the painting of the last 100 years rarely, if ever, touches the transcendental level of existence, awareness and emotion Martini, in inspired fashion, has communicated. It has been brilliant, innovative, unhindered, exciting, but rarely in contact with the soul in the sense, for example, that Van Gogh's art can be interpreted as the world seen through the eyes of God. Great art there has been; there can be no doubt of it. Cezanne[4] and Matisse prove the point. But since our culture is no longer united by a common

104

faith or common purpose, we are left with the impression that the art of this century has not avoided a species of flimsiness. It is often tentative and ephemeral, existing, as technology does, in expectation of being displaced. It has about it something despairing and disturbed. The struggle to make an absolute statement in an individually conceived language probably accounts for the impression of eccentricity and self-indulgence, even at times of mental aberration, in much twentieth-century work.

Another difficulty resides in the prevailing frame of mind. Painting and, of course, sculpture have become infected by an outlook summarized in Roger Fry's[5] arid dictum that 'The one constant and unchanging emotion before works of art had to do always with the contemplation of form and that this was more profound and significant spiritually than any of the emotions that had to do with life.' In similar vein he boasted, 'It's all the same to me if I represent a Christ or a saucepan since it's the form, and not the object itself, that interests me.' No pre-Renaissance painter could have uttered those words but since, say, the late nineteenth century, it has become generally accepted that the art of painting exists solely within its own cloistered, self-referring ghetto without reference to symbol, literary or metaphysical association, message. 'The big moment came', writes Harold Rosenberg in his appropriately titled *The Tradition of the New,* (1959), ' when it was decided to paint . . . just to PAINT. The gesture on the canvas was a gesture of liberation, from Value – political, aesthetic, moral.' The obfuscatory eruptions of performance art, art-and-language, and conceptual art[6] have further depleted the power of painting to express the transcendent imagination. A similar process of depletion has been applied to the art of the past. To formalist art historians, whose influence is especially strong in modern art museums, the importance of a work derives from the position it occupies in the evolution and diffusion of forms. Other meanings, such as Simone Martini's devotional frame of mind, Friedrich's message of faith, Van Gogh's concern for the

mystical divinity of light, have been eagerly, and ruthlessly, dismissed in favour of only one thing: the telling use of formal relationships as the principal source of aesthetic enjoyment. André Malraux[7] once said that the museum, by its very nature, 'ruled out associations of sanctity'.

But if the majority of artists, art critics, and historians of the last 150 years have consistently neglected, even ridiculed, the significance of the supernatural, a minority – and it is indeed a small number – have nonetheless kept faith with a vision of the soul in a modern world of doubt. Gustav Moreau (1826–97) was one of these; Odilon Redon (1840–1916) another; Georges Rouault (1871–1958) a third. Vincent Van Gogh (1853–90), Emil Nolde (1867–1956), and Eduard Munch (1863–1944) are also masters for whom the passionate scrutiny of nature had the power to evoke the spirit of divinity and mystery.[8] For each of these the loss of soul was both diminishment and degeneration; it was to pass from the *sacramentum* to the *res,* from the infinite to the finite, from inspired vision to soulless 'realism'. Other painters, some of which I shall now discuss, shared the self-same concern to reconstitute a sacramental vision in their art. They, too, were concerned to return to the primordial tradition of sacred art.

The first of these artists, perhaps the most famous, possibly the most misunderstood, is Marc Chagall (1887–1985) who was working up to three days before his death at the age of 97. His output was, indeed, prodigious – he never, it seems, rested from creation. 'Everything that had to be bought with money seemed to him an extravagance,' writes Virginia Haggard who lived with him for seven years, 'whereas it amused him thus to create a gift out of nothing.' To make, to create, to enchant, to weave a dream and a fresh reality, was the raison d'être of his life.

Much of this work, inspired by his Jewish spirituality, was explicitly illustrative of Biblical themes. He regarded the Bible as the 'greatest source of poetry of all times' and never ceased to take delight in the transformation of its ancient, mythic world into the language of contemporary art, most notably in the

106

Plate 27
MARC CHAGALL
*Bouquet with Flying
Lovers,* (c.1934–47)
Oil on canvas; $51\frac{3}{8}''$ ×
$38\frac{3}{8}''$
Tate Gallery, London

Musée National Message Biblique Marc Chagall in Nice.[9] But Chagall's wide-ranging output was never limited to one theme. For inspiration he drew upon innumerable sources – the inspiring power of the feminine, memories of a village idyll, Jewish mysticism – to give expression to the mood of his unconscious. Flowers and fruit were also always with him (Plate 27), and his sympathy for nature made it natural for him to exclaim 'gardens bloom within me'. He was then, as he himself

said, content 'to sing like a bird'. Yet the lyricism, the folkloric charm, the sensuousness of his work have tended to obscure the fact that Chagall is, in all probability, the greatest religious artist of our age.

In Chagall there is a glimpse of a world glowing and miraculous. There is a sense of fundamental underlying unity – of human and animal, the human and divine existing within and moved by the divine energy. There is also a feeling that common veneration and rejoicing are the foundations of the good life. The cock crows; a flash of red like a trumpet. The moon rises; a glow of green before the dawn. David plays his harp and all the world is colour; rainbow-fresh as it is after a storm. A sense of timeless miracle pervades, as it did in the Garden of Eden, everything upon which he set his hand.

Yet Chagall's involvement in dream and childhood-play is anything but indifference to the happenings of his time. Day by day Christ is re-crucified, the villages burn, the refugees flee, homeless, into the night. In one work, *The Falling Angel* (1922–33–47)[10] – perhaps an allegory of the course of recent history – a flame-red angel, the angel of darkness, sweeps downwards in its perilous fall; in the foreground a tiny figure escapes, but only just, the scalding brightness of its wing. The fugitives in Chagall's pictures mourn and suffer more profoundly than the figures in Picasso's *Guernica*.

Why this should be so it is difficult to say but I suspect it has something to do with the quality of Chagall's emotion and the continual dance of love which he expresses in his art – love giving itself, losing itself, and finding itself again. No painter since Rembrandt has bathed his art in the radiance of the feminine with more veneration than Chagall. He is, as Erich Neumann[11] says, 'a man drunk with love, whose rich palette bears witness that creative man is made in God's image, and in whose pictures of human life in the world the Creation begins forever anew'.

This dance of love is conceived in the depths of the soul where poetry and religion have their common source. But Chagall as an

artist was not religious in the narrower, limited sense of the word. As he himself said of a painting of Christ:[12]

> I cannot imagine Christ from the point of view of a creed or a dogma. My picture of Christ is intended to be human, full of love and sorrow. I don't want to stress the religious element: art, painting, is religious by nature – like everything creative Dogma means separation; and separation means conflict, struggle, hate, war I can't produce religious art, programme art – that would be dreadful.[13]

Yet for him if creeds and dogmas, theories and methods, prescriptions and interdictions, meant nothing at all, painting was always an aspect of the devotional life: an offering to God, with the seal of the spirit, the seal of beauty, on it.

As a Jew and mystic, Chagall set out to give embodiment to a unitive vision as comprehensive, though more personal, as that of the Middle Ages. Another artist, no less attendant to the shaping spirit of imagination, had few pretensions of this or, indeed, of any kind. Pierre Bonnard (1867–1947) was, so far as I know,[14] (for he spoke so little of these matters), an agnostic or even an atheist. True, he loved the vital earth – its fruits and flowers – with an almost pantheistic joy. He also favoured a simplicity which might be regarded as austere. Yet it is difficult at the best of times to think of Bonnard – as one thinks of Van Gogh – as a religious man. None the less the radiant lyricism of his art sets out to retrace a world known only in a state of vision.

Because of his links with Impressionism and Post-Impressionism, his personal modesty and unpretentious subject-matter, Bonnard has been cast as a *petit maître*, a charming but innocuous decorator. And so, in one sense he was. But Bonnard was also, of course, much more: a visionary. A visionary who could reveal, one foot in Eden, the transcendent beauty of the everyday. 'I saw Eternity the other night,'[15] wrote Henry Vaughan. Bonnard painted it: the power of being present every day at the birth of the world.

Plate 28
PIERRE BONNARD
Almond Tree in Flower,
(1946)
Oil on canvas; 21⅝" ×
14⅝"
Musee National d'Art
Moderne, Paris
© ADAGP, Paris/DACS, London 1988

Look, for instance, at his *Almond Tree in Flower,*[16] (Plate 28)
his last canvas, finished only days before he died on 23 January
1947; a painting of simple devotion. It is the tree he saw every
morning on the walks in his beloved Le Cannet garden,
hallowed with 'an infant Eye'. It is the burning bush. It is the
Tree of Life. It is the world on the first day of Creation. With no

110

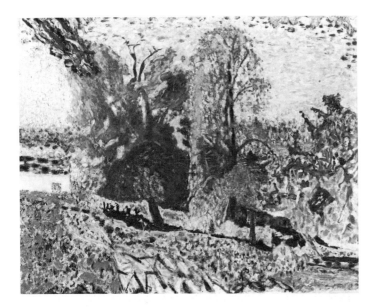

Plate 29
PIERRE BONNARD
Landscape in Normandy,
(1920)
Oil on canvas; 24⅝″ × 32″
Smith College Museum of
Art, Northampton,
Massachusetts
© ADAGP, Paris and DACS, London
1988

discernible narrative, with no recourse to high ideals, it simply exists. An 'ordinary' tree in flower takes on the mystery of revelation. Hurrahing, praising, glorying, and quiet adoration – these explain Bonnard as a painter in whom the gift for exaltation remained intact.

His is an art which, without resource to great size or grand themes, expresses joy and induces metaphysical reverie. It never addresses itself to the passions but always to the quieter functions of the inner life – contemplation, memory, the affections. It is the record of a meditative heart opened by a visual imagination through the mystery of the two lights: sunlight falling on what he saw and the other light perceived by his imagination. For just as Brother Lawrence[17] discovered the divine amidst the pots and pans of a monastic kitchen (something which, if I remember rightly, St Teresa did as well) so Bonnard reminds us, as we view *this* plate of cherries, *this* landscape of summer trees (Plate 29), or his partner Marthe floating like a multi-coloured sea-anemone in her prosaic enamel bath, that poetry is imminent in the least of things.

111

Vision is supreme; sight a sacrament. John Ruskin[18] wrote:

> The greatest thing a human soul ever does in this world is to
> *see* something, and to tell what it saw in a plain way.
> Hundreds of people can talk for one who can think, and
> thousands can think for one who can see. To see clearly is
> poetry, philosophy, and religion – all in one.

Looking at the deep innocence, the celebratory joy, the endless
sense of wonder of Bonnard's work, it is as if Ruskin had written
those words with only him in mind.

Another artist whose paintings carry a profound reflective
vision is the Italian Giorgio Morandi (1890–1964) who resided
in Bologna, a town he barely ever left. In his apartment,
Morandi lived, like Bonnard, a simple, uncomplicated life. And
there he painted, in complete silence, innumerable small-scale
canvases (Plate 30) of the humblest boxes, little tin cans,
outmoded oil lamps; vases, pots, and dusty bottles, characterized
by their poetry and trembling reserve. Even the photographs of
his studio taken after his death have the stillness and gravity of a
monastic cell.

I stare and stare at these extraordinary still-lives – at the
extreme beauty of their shapes and the shrine-like formality of
their subject matter. I see the little pots and basins suspended in
silence, invested with a marvellous purity and light. And I am
reminded of these words of Paul:

> Whatsoever things are true, whatsoever things are honest,
> whatsoever things are just, whatsoever things are pure,
> whatsoever things are lovely, whatsoever things are of good
> report; if there be any virtue, and if there by any praise, think
> on these things.[19]

The sacrament of the present moment has rarely been felt with
such truth. For in the presence of these tiny visions –
'messengers of divine silence' as Dionysius the Areopagite[20]

might have called them – we feel the need to act quite
differently: not loudly but in whispers, not casually but with
grace, not arrogantly but with a tranquil mood of adoration. The
poetry of praise has rarely been uttered so selflessly. The
awakened heart has no other impulse but to bow.

The desire to bow, to bend the knee, and the heart's leap
which precedes both gestures is, in my cipher, the indelible sign
that we're in the presence of the numinous in whatever guise it
may take. It is the natural response to what is sacred and
mysterious. 'Everything is mystery,' Morandi said, 'ourselves,
and all things both simple and humble.' No artist who saw such

Plate 30
GIORGIO MORANDI
Still Life, (1946)
Oil on canvas; 14¾″ × 18″
Tate Gallery, London

113

mystery – objects of everyday life changed by contemplation into ritual vessels or artefacts – could be called other than a sacred painter. Morandi, clearly, was one of these. The English painter, Stanley Spencer (1891–1959), was another. Yet besides the fact that they were almost exact contemporaries they had nothing else in common.

Spencer was born in the village of Cookham-on-Thames, near Maidenhead, Berkshire. He was given the nick-name 'Cookham' as early as 1908; this, in recognition of his uniquely intimate association with the place of his birth and upbringing. In point of fact the greater part of his life was spent in that village and the greater part of his work was a celebration of its life – his parents' house,[21] its tradespeople, its streets and gardens and churchyard, all feature in his work. Stanley Spencer peopled Cookham with figures from the Old and New Testaments and saw enacted in its streets, its open spaces, on its river, the mysteries of the life of Christ.

In his writings, too, he never tired of describing this heavenly Jordan. In 1917, writing from Salonika,[22] he speaks of his devotion to the place. Cookham, for Spencer, was the visionary world he had left behind, the source of all his greatest painting, what he called 'an unreachable world of the spirit, creating its way in the sunlight'.

I remember how happy I was when one afternoon I went up to Mrs Shergolds and drew her little girl. After I had finished I went into the kitchen, which was just such another as our own (only their kitchen table and chairs are thicker and whiter), with Mrs Shergold and Cecily. I nearly ran home after that visit, I felt I could paint a picture and that feeling quickened my steps. This visit made me happy because it induced me to produce something which would make me walk with God I go upstairs to my room and sit down at the table by the window and think about the Resurrection; then I get my big Bible out and read the book of Tobit: the gentle evening breeze coming through the open window

slightly lifts the heavy pages.

I will go for a walk through Cookham Churchyard. I will walk along the path which runs under the hedge. I do so and pause to look at a tombstone which rises out of the midst of a small privet hedge which grows over the grave and is railed round with iron railings I return to our house and put it down on paper I go to supper not over-satisfied with the evening's thoughts, but know that tomorrow will see the light, tomorrow 'in my flesh shall I see God' 'Tomorrow' I say and fall asleep During the morning I am visited and walk about in that visitation. Now at this time everything seems more definite and to put on a new meaning and a freshness you never before noticed. In the afternoon I set my work out and begin the picture, I leave off at dusk feeling delighted with the spiritual labour I have done.

Two paintings in which this visionary character is already clearly apparent are *The Nativity* (1912)[23] which was painted in Spencer's last year at the Slade and *Zacharias and Elizabeth* (1912–13) (Plate 31)[24] based on a passage in Luke. The latter was inspired by a beautiful garden in Cookham (the scene from the rear window of the staircase-landing on the second floor of Wisteria Cottage, looking towards Cliveden Woods) which Spencer imagined as Zacharias' own garden with an altar where he and Elizabeth were 'walking in all the commandments and ordinances of the Lord blameless'.[25] There is about it an almost unearthly stillness and expectancy, a Wordsworthian intimation of 'something infinite behind everything'. How rarely has the earth been felt like this as a numinous event.

In the mid 1930s Spencer wrote about *Zacharias and Elizabeth:*

It was to be a painting characterising and exactly expressing the life I was, at the time, living and seeing about me. It was an attempt to raise that life round me to what I felt was its true status, meaning and purpose.[26]

And when he asked himself what exactly was the mystery he was trying to express he said that it was the same as in *The Nativity* and another painting of the same period, *The Apple Gatherers:* the mystery of sex, both a profane and sacred mystery.

Few artists have found the means to express the holy and

116

secret energy of vision, the flush and fertility of the world, as Spencer did.[27] Samuel Palmer was one of these when, between his twentieth and thirtieth years, he saw, along the Darenth at Shoreham, a natural world on the edge of Paradise. A similar vision is present in Van Gogh in whom the golden seas of corn seem sacramental.[28] There have been others, too, but their number is small. It is an uncommon thing to *see,* as Spencer wrote 'this especial and unique meaning that an ordinary object has' in a twentieth-century painting. But someone who did – also English and a contemporary – was Paul Nash (1889–1946), a visionary who painted pictures of an ecstacy, a stillness and a purity, the finest of which can rival Spencer's greatest visionary work. I am thinking especially of Nash's last great watercolour series, *Sunset Eye* and *Sun Descending,* painted in the last winter of the painter's life.

Detail from Plate 31

Nash and his wife, Margaret, had spent Christmas 1945 at the 'Rising Sun', a hotel on Cleeve Hill, outside Cheltenham, overlooking the vast, tree-dotted plain below. The next few months were dedicated to transcribing his vision of the glowing, dying splendour of what he had seen. There are seven studies in each group but each possesses a vastness of conception far transcending the narrow limits of the small sheets on which they have been painted. We see the sun, a few shafts of light, the distant range of hills, the calligraphy of cloud and tree, but more than this, much more, we experience something of the dewy freshness, the genial radiation, the strangeness piercing down to the purest essence of the eternal world which Traherne had likewise observed with his inner eye, the eye which transfigures a literal event into an image of soul. In these mystic watercolours Nash foretold his end.

Paul Nash had come to realize that his own death would soon release him also into the world of 'aerial images': aerial flowers and sun and moon. 'If I take me wings of the morning and remain in the uttermost parts of the sea, even there shall thy hand lead me,' might have been written by Nash himself. Working against death, death lead him into a world beyond

Plate 6
PAUL NASH
Eclipse of the Sunflower,
(1945)
Oil on canvas; 28″ × 36″
The British Council

mortal knowledge.

Nash then set his heart upon the execution of a final series of four great oil paintings devoted to the symbolism of the sunflower and the sun. Two were completed – *Eclipse of the Sunflower* (1945) (Plate 6)[29] and *Solstice of the Sunflower* (1945)[30] – and rough sketches for the third have survived. So magical, so potent with immemorial symbols, so contemporary in their proclamation of the ancient forces of the earth, these paintings stand among the most exuberant – and most radiant – canvases by any English artist since Turner's death in 1851. In them Nash lived with sun and earth, with the world of sky and light. The mystery stands at long last revealed: the worlds of life (sun) and death (moon) are one.[31]

Shamans, we are told, are specialists of the sacred. They are men and women able to 'see' the spirits, to go up into the sky and meet the gods, to descend into the nether world and fight the demons, to vanquish sickness and death. For the good of others they have discovered ways of using ecstacy; they have transcended the normal state of man. In these last great canvases was not Nash one of these? It is very likely that Nash,

118

through his continual search for the metaphysical reality which hovers at the precipice of human life, has pointed the way to a new image of humanity. But he was not, I believe, alone. The other painters I have been discussing can also set us travelling to the end of time with a renewing and infinitely renewable capacity for fresh revelation.

Their contribution is not unique. A roll-call of paintings by those other artists who also recognized and painted the divine in things earthly and familiar must inevitably be a personal choice but mine would include: the majority of Van Gogh's radiant, ecstatic paintings; the spiritual sensuality of Monet's (1840–1926) great water-lilies series mostly painted in his last years; the late, metaphysical works of Georges Braque (1882–1963), calm like frozen music; the serene luminosity of Gwen John's (1876–1939) contemplative figure-subjects, and the archetypal images of Brancusi's (1876–1957) radiant sculpture. It would also include, though more selectively, paintings by Mark Tobey (1890–1976), by Georgia O'Keefe (1887–1987), by Morris Graves (b.1910) and by our own David Jones (1895–1974) whose eucharistic watercolours of flowers in a chalice are amongst the most sacred paintings of the twentieth century. Others no doubt will follow at the right time.[32]

These artists fall, I suggest, very broadly into two kinds. The first group, including Bonnard, Morandi, Stanley Spencer, and the late Monet, have seen in the everyday – in bowls of peaches, dusty bottles, and irridescent ponds – a glimpse of the eternal. As in Spencer's description of one of his paintings, they have celebrated 'the glorifying and magnifying' of the world as it is.

In the second group – including both Chagall and Paul Nash, for example – it is not so much observed particulars as abiding symbols which carry the mystery of revelation; to this their lives have been so consecrated. Perhaps, inevitably, the scale of the enterprise has been so vast that much of their work has an unrealized, even a flimsy, air. Yet, I believe, the response of these artists to the crisis of spirit and psyche in our lives contains the greatest promise of things to come. They alone among their

contemporaries have performed the Odyssean task of, as Homer puts it, 'pointing the way to the gates of the sun and to the land of dreams'. They have worked, whether or not society has valued their contribution or found it heedful, because without art in this deep and serious sense they and the nation would die. They have worked to create, against all the odds, images of reconciliation and abounding beauty, symbols of renewal and hope. Van Gogh, out of personal suffering, producing images, not of death, but glorious life-giving radiance; Henri Matisse (1869–1954), not of breakdown, but enchantment and fecundity, a world alive with hope; Braque, not of dissonance, but of a magisterial harmony; Morandi, not of the everyday, but the everyday transfigured by the light of the everlasting born, as that has always been and will be again, of our need. Everyone of the authentic architects of the imagination of our time has sought to realize, as Paul Klee expressed it, 'the reality that is behind visible things'.[33] In their work they have offered confirmation of a vision of the world as a place of soul.

At the beginning of this chapter I drew attention to a painting by Martini.[34] It was painted at that marvellous moment when the Roman and the Roman-Hebraic met the forgotten Greek and all three came together and produced the form of life we call 'Renaissance' – when the feminine and masculine, the romantic and the classic fused into a marvellous, new-minted whole. The image was a painting of the Annunciation where the angel –the messenger of God – announced to Mary – the eternal feminine – the coming of the seed, the seed of future life.

Another vision of a world at the moment of birth comes to mind. It is a painting by Cecil Collins, dated 1936, *The Promise*. (Plate 32).[35] Here within a primaeval environment, a deserted sea-shore from which life itself perhaps originally emerged, a swathed and isolated object like a chrysalis reclines undisturbed. The chrysalis is dormant, apparently lifeless, yet, signalled (or announced) by the gushing of water and the incandescence of the giant flowers, it is at the point of awakening. It is stirring into life.

120

A few years after this picture was painted, Marc Chagall, speaking in America in 1943, expressed the self-same shift of focus in the collective unconscious and the clamour for change from underneath:

Mankind is looking for something new. It is looking for its own original power of expression, like that of the primitives, of the people who opened their mouths for the first time to utter their unique truths. Will the former vision be replaced by a new vision, by an entirely new way of looking at the world?

121

Forty years later the question remains. Yet if we look backwards over the long perspective of the century, we can see that a new world within the human spirit, greater and, in my view, far more significant than the world of science and technology, has been anticipated by the visionaries of our time. In this light the paintings we have been considering are not simply adjuncts of distraction or the ornaments of a temple of art. They are the prophetic seeds of future life. They are our future, the germs, as Yeats says, 'of the flowers and the fruits of latest time'.

An ocean stream of change is moving beneath the tide. It is a sea-change of momentous scale that calls for a restoration of the original unity of being in which inner and outer worlds are one. It calls for a change demanding the most radical response imaginable. It calls, too, for the restitution of balance and that mysterious quality, beauty, which for the soul is the touchstone of truth. 'Mankind,' said Dostoyevsky, 'will be saved by beauty.'[36] I believe he was right.

(A paper read at the first Temenos *Conference at Dartington Hall, South Devon, November 1986, first published in* Resurgence. *Extensively revised).*

TOWARDS THE DAWN:
A TRIBUTE TO CECIL COLLINS

124

Towards the Dawn:
A Tribute to Cecil Collins

FOR CECIL COLLINS 1988 was an *anno mirabilis*. After forty years of solitary, largely unrecognized, endeavour – neglected by the art establishment and public alike – he came, at long last, into something of his own. Eighty this year, Collins celebrated his birthday with a group of friends and admirers in the Senior Common Room of the Royal College of Art where he and his wife, Elizabeth, had been students over fifty years before. A new exhibition of his latest paintings at the d'Offay Gallery coinciding with the publication of the first major study of his life and work,[1] the unveiling of a stained glass window, *The Mystery of the Holy Spirit,* in the church of St Michael and All Saints, Basingstoke, all added to the increasing regard with which his work is beginning to be held. It was, all told, a rich harvest.

The seeds were planted in the west country, in the city of Plymouth where Cecil Collins spent his first nineteen years. The only child of Cornish parents he received little formal education; he was, in fact, left to discover the natural world as unshackled by schooling as Stanley Spencer[2] or, for that matter, an earlier visionary, William Blake,[3] with whom Cecil shares a vivid conviction that the images of the imagination are truer than the sights of our eyes. It was, in fact, in the wood at the back of his parents' home in Peverell – a boy's paradise of paths, tunnels, secret, leafy rooms – that Cecil first discovered, as he later explained, 'the vision that has lasted me my whole life. You could say it was the seed experience, the discovery that paradise is in the minutiae of life . . . in the particulars.'[4] At much the

Plate 33 (left)
CECIL COLLINS
Head, (1939)
Etching; $3\frac{3}{8}'' \times 3''$

125

same age that Blake had seen, on Peckham Rye, 'a tree filled with angels, bright angelic wings bespangling every bough like stars'[5] and, on a diffferent day, 'haymakers at work and amid them angelic figures walking', Cecil experienced a state of being, a foretaste of unity, which affected the whole course of his life. This state of wholeness, of perfect consciousness and of selfless happiness – a state that can be called the lost Paradise – has been the ground image of all his later work.[6]

At the age of fifteen he won a scholarship to the Plymouth School of Art which he attended from 1923 to 1927. Cecil then moved (with the help of another scholarship) to London and the Royal College of Art, then under the direction of William Rothenstein, where he studied until 1931. It was a seminal period for in addition to the development of his work he met and fell in love with Elizabeth Ramsden whom he married, aged twenty-three, the year they left the RCA. Inspired by his love Cecil soon began to create a series of visionary paintings and drawings which celebrated her beauty. So strong and invigorating has been the fascination of her presence that it has summoned forth his most humble and tender devotion. Her face, and especially her eyes, have appeared in work after work over a period of nearly sixty years. As wife, counsellor, critic, muse – and in her own right a fine artist – Elizabeth has provided the principal support and abiding inspiration of Cecil's subsequent career.

Four years after leaving the Royal College, Cecil held, first, a London one-man show; then soon afterwards, tenuously influenced by the surrealist movement, he exhibited two paintings in the Surrealist Exhibition of 1936. But his link with Surrealism, based on support for its rejection of a materialist basis for art, was extremely brief. Cecil later recollected: 'I turned my back on it and went into the country and started to think . . . and meditate on what I wanted to do.' He has been meditating every since.

The retreat from London had one inevitable result. After an astonishingly productive working life Cecil remains the great

126

outsider of modern British painting; unfavoured by an art establishment largely content to demonstrate a rash, almost giddy, appetite for novelty, and nervous, not to say terrified, of so-called 'literary' and spiritual art. Yet this artist has never been what might be called an unfortunate man; his life and work have grown according to an inner logic, however 'illogical' this might seem to the rational mind. One such development, I would suggest, was Cecil's fortune in a chance meeting with the American painter, Mark Tobey,[7] whom he regards as one of the greatest of the century. Tobey, teaching on the Dartington Hall estate since 1931,[8] invited the Collins' to join him. The two arrived in the autumn of 1936; he was twenty-eight and already the author of a number of prophetic, poetic, visionary works including several in which the theme of the angel plays a prominent part. The seven years they spent at Dartington were more than a mere return to the county of Cecil's birth.

At the time of their arrival, Dartington was uniquely talented; 'the most remarkable decentralization of culture in England', as the potter, Bernard Leach later described it. Dartington's founders, Leonard and Dorothy Elmhirst, had drawn around them an outstanding group of artists including, in addition to Mark Tobey, the choreographer, Kurt Jooss and his ballet company; Michael Chekhov, a pupil of Stanislavski from the Moscow Arts Theatre; Rudolf Laban, the choreologist, with his radically new approach to movement; and the master-craftsman Bernard Leach. Outside the capital it would have been difficult, if not impossible, to find a more congenial or stimulating place for a young artist to live. The rich and bosky South Hams landscape, watered by the River Dart, also provided a further fructifying and important experience. 'I carry,' he wrote to me in 1980, 'the essence of the landscape within me as an ever-present inspiration.' The lyrical and twilight mood of many recent works have almost certainly been inspired by the landscape of the River Dart along which Cecil often walked between his home, Swan Cottage in Totnes, and the thickly wooded estate.

It was in the estate's beautiful gardens, adjacent to the

127

mediaeval hall, that Cecil experienced, unsought, a mystical vision of great subsequent significance.

> One April afternoon, there'd been a shower [he told Edward Lucie-Smith] and the sun was just sinking behind the woods, and the light was shining on this bush, and it had drops of rain on the leaves, and the leaves, the light was shining through them. They were like diamonds. And on top was a thrush singing. I suddenly saw that this bush was the shape of the song of the bird.[9]

Such exaltation, such union with reality, such capacity to see through the veil of appearances and rediscover the world in its virginal state, such a reading of, in Boehme's words, 'the signatures of all things', provided affirmation of the oneness of creation which only reinforced Cecil's latent knowledge that in the great cyclic totality there is neither *self* nor *other:* the two are but different aspects of one whole. 'I see all creation as a dance,'

128

he says.

The Second World War marked a turning point in both the histories of the Collins' and Dartington: with internment, the artistic community dispersed almost overnight and Cecil found himself, at a stroke, directing the Art Studio Workshop. It was his first experience of teaching drawing and painting but not his last. Teaching has subsequently proved not only nourishing in itself, but Cecil's way, upon which he places great emphasis, of disseminating his personal vision and the techniques associated with it. It has been essential to his own creative development.

The Devon period also saw the progress of his art. Not that the work of the mid- to late-thirties had lacked distinction – witness, for example, the powerful imagery of *Cells of Night* (1934) or the oracular mystery of *The Promise* (Plate 32) (1936), both in the Tate. These, surely, are 'houses and gardens and fields' for the soul to inhabit; paintings of astounding originality for a painter of only twenty-six and twenty-eight. At Dartington, however, Cecil's work took on an added maturity. Look, for example, at the large double portrait, the *Portrait of the Artist and his Wife* (1939),[10] painted in Swan Cottage, with the landscape of the South Hams (and of paradise) beyond the open window. Or the mysterious and crystalline purity of *Dawn* (1939); the prophetic etching, *Head* (Plate 33) (also 1939); or the small oil, *The Happy Hour* (1943)[11], featuring a perky, nonchalant fool, a flying bird, a tent, a flag, and ball. These are visionary works which prompt the heart to wonder and prayer.

The same magic is found in Cecil's *The Sleeping Fool* (1943) in the Tate. Here, again, in this exquisite oil we find the quality of grave pathos – a longing – which had characterized much earlier work and has been a constant ever since. *The Sleeping Fool* has a spring-like, dreaming air yet the envisaged paradise is infused with heartache; it is a melancholy that may be accompanied by a sense of the most exquisite happiness. Cecil, a highly articulate spokesman for his own work is fully aware of its qualities:

Plate 33
CECIL COLLINS
Head, (1939)
Etching; 3⅜" × 3"

129

Beneath all beauty is the wound, behind the paradise is the payment of pain and suffering. Behind the gaiety of Mozart is a subtle melancholy; that is what makes him a great artist. Paradise is two-edged; it is a rebuke.

The years at Dartington gave focus to these aspirations, this awareness, with a theme which Collins has subsequently made his own. The theme of the Fool enters his work in 1939. *The Vision of the Fool*,[12] a seminal essay (largely written at Dartington), was of particular importance: a closely argued and coherent *apologia,* masterfully sustained, underpinning fifty years of subsequent work. Even today, forty years after its first publication, the words spit and crackle with indignation and energy. What is art, he asks, and what role do we ask the poet and the painter to assume in the twentieth century?

The Saint, the artist, the poet and the Fool, are one. They are the eternal virginity of spirit, which in the dark winter of the world, continually proclaims the existence of a new life, gives faithful promise of the spring of an invisible Kingdom, and the coming of light.

The affirmation of the transcendent imagination, the conception of painting not as a career but as a vocation, has rarely been expressed with such conviction.

If Cecil can hardly be described as a cerebral person (he calls himself 'a man of feeling') he is none the less, as a metaphysical artist, deeply absorbed by ideas. And the idea of the Fool – 'the archetype of primal innocence, purity of consciousness and freedom'[13] – is probably his greatest contribution to the re-interpretation of a basic archetype. It has inspired some of his finest work. It is the series by which he is best known. It is one of the greatest attempts ever made to record one aspect of human life in its entirety.

Even earlier than the first Fool drawing – in 1939 – Cecil had already depicted another traditional image, the winged

130

messenger whom we call the Angel, which subsequently became a dominant and recurring motif. Another character, no less recurrent, is that of the Anima. She, too, enjoyed a long period of growth appearing first in many early portraits and portrayals of his wife Elizabeth dating back to the early thirties. But Fool and Anima, even the Angel, are, in one sense, interchangeable – they are friends, related in spirit, part of a climate of feeling in which his trees and skies, clouds and seas, suns and rivers, are also natural partners in the same richly numinous world. Each is unique, yet each draws upon emotions from the deepest pools of the mind.

Two images of the Angel are especially compelling: *Wounded*

Plate 34
Cecil Collins
Wounded Angel, (1967)
Mixed media; 30″ × 36″
Private collection

131

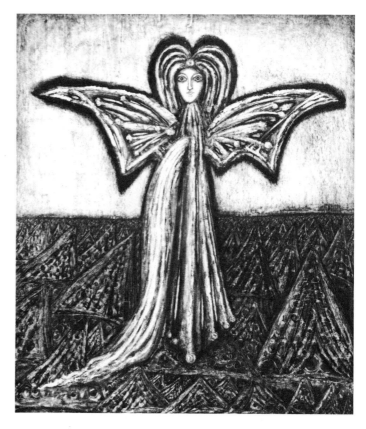

Plate 35
CECIL COLLINS
*Angel of the Flowing
Light,* (1968)
Mixed media; 48″ × 41″
Tate Gallery, London

Angel (Plate 34) (1967)[14] – it is of an angel resting on the ground of Paradise, recovering from wounds received on descent into our world – and the mesmeric *Angel of the Flowing Light,*[15] (Plate 35) a resurrected Angel, of the following year. In the latter a figure of magisterial simplicity stands, with butterfly wings, above or upon peaked mountain tops. 'It is dawn', he says, 'there is a pink skyline behind the angel. The angel is a butterfly and the head is a heart and out of its thigh comes this flowing river of light'.[16] The energy dispersing from this angel is concentrated in the extraordinary eyes; pink-rimmed, reproachful, compassionate, staring into our very souls. In a recent gouache, *Beside the Waters* (1980) an Angel leans

132

towards a river blessing it with his wings while a wooded hill rises behind him. In comparison with the power of the *Angel of the Flowing Light* the feeling is tender, radiant with peace; intensely prayerful; *Beside the Waters* is a hymn to love and the beauty of our world. A sense of blessing hangs about the picture whose mysterious emotional climate carries the quality of a great poetic utterance.

I have interrupted discussion of Cecil's life to give priority to three of his most central themes. Now perhaps it is time to return to the years following the departure from Dartington in 1944 after which Cecil and Elizabeth divided their time between London and Cambridge – then moved North to live near Halifax, Elizabeth's home ground – before settling in Chelsea where they have been resident for the last eighteen years. 'My life has not followed the usual order', he says, 'As a young man, I lived a retired country life, absorbed in my work. Now I lead a busy life in the city.'[17]

In one sense there is little left to chronicle: a succession of London exhibitions; a few trips abroad; a comprehensive retrospective at the Whitechapel Art Gallery (in 1959); another, much smaller one in Plymouth (in 1983); a number of tapestry commissions; a great many poems; the Arts Council film, *The Eye of the Heart*,[18] about his life and thought[19]; teaching at the City Literary Institute and the Central School of Art – these, and little else besides, have been outwardly uneventful milestones of an inner pilgrimage, imposed by the creative imagination, the ruling passion of his life. Over a period of more than half a century Cecil Collins has remained unflinchingly true to his calling yet he is always more than the sum of it.

In this long period, the forty years since Dartington, is there evidence of development in his work? In a sense, yes, there is evidence of change. In the late fifties, for example, the American school of Abstract Expressionism exerted a liberating influence on Cecil's art when he adopted its freedoms to the needs of his own work. *The Golden Wheel* (1958)[20] and the *Landscape of the Unknown God* (1960)[21] are fine examples of a more

improvisatory approach. The former gave expression to Cecil's conception of the sun as the symbol of fullness and joy, the latter to an image of mystical vision like a sun-burst over an uninhabited, paradisical land; both are moving examples of a freer, more lyrical style. Look, too, at the lithograph, *Sun Head*,[22] drawn directly on to the stone. Here, again, is a new freedom of approach with a subject – the sun as the creative spirit of the world – that had been worked in different media many times before.

No less moving are the works which Cecil has painted and drawn in recent years, a fitting climax to a lifetime's consecration to art. Small in scale, restricted in colour, they are almost classical in spirit, astonishingly fresh and pure; glowing with a luminosity, a formal detachment, found in no other artist of our time. These unmistakably belong to a period later than those I have just described; their repose, their innocence, has a distillation known only to the old. (Plate 36) None the less in spite of some stylistic differences nothing has fundamentally changed: the figures and landscapes remain states of being within the soul. Like Redon[23] and Moreau[24] (two of Cecil's favourites), the vision does not gutter; it burns bright and constant like a flame. Cecil's ability to convey the qualities of healing and consolation for the spirit have simply grown with the years.

Let us, therefore, abandon all talk of influence and development and enjoy one work for what it is. Look, for example, at the drawing *Fool and Flower* (1944) (Plate 37)[25] a seemingly innocuous, if pleasant work. On the left a pierrot-like Fool is leaning forwards with a gesture of tenderness and wonder. To the right there is a flowering plant and a single cloud, symbolic of paradise, in an empty sky. The Fool blesses the flower, the flower shines with joy. Simple enough, perhaps naïve; yet in the context of art bitter in the years of war, this adoration is a highly unusual work. To begin with Cecil has avoided all the old, generic categories and produced an image which defies classification. It is not a portrait, it is not a

134

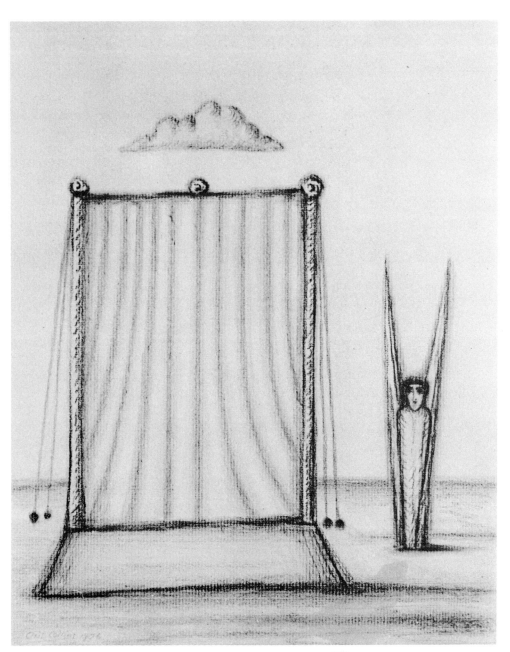

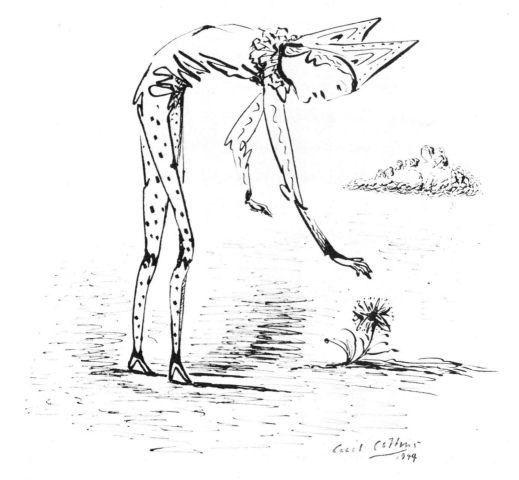

Plate 37
CECIL COLLINS
Fool & Flower, (1944)
Pen and Ink on paper;
11″ × 7½″
Private collection

landscape, it is not, quite clearly, an abstract, or 'modern' or 'progressive' by any definition. Nor is it a narrative work; there is no anecdote nor hint of what flower and Fool are doing here. Yet, there is, I believe – as there always is in Cecil's work – an unbroken stream of memories; a sense of entering something

136

we already know, something once and forever familiar, something issuing from a sacred source, an ancient and satisfying symbol of protective union. In this sense Cecil's work holds before us an imaginal reality, a soul-image at once fresh and old.

With refreshing tenderness *Fool and Flower* also expresses a deeply felt contemporary concern: the vision, embodied here, of man and nature as co-equals and in equilibrium. Flower and man face each other, are attentive to one another, need each other, can achieve unity only through tenderness. The protection of one human being for nature is a solemn responsibility. Like so much of Collins' work – and for that matter the man himself – the strength of this print, and the strength of its idea, may be hidden by a gentle, almost elegiac charm. Yet what it tells us is far more than whimsy. It speaks of the need of reverence for the world and, as William Anderson writes, for 'a shared and selfless communion with the silence and love of God, and, through God, with the angelic intelligences, with all created things and with our fellow men.'[26] It expresses, too, Collins' faith in 'the empirical gaiety and overflowing mercy' of the contemplative life and the need, the absolute necessity, for the deepest transformation of consciousness, if, that is, as a civilization we are to survive.

Transformation is the *leit motiv* of all Cecil Collins' work. In its insistence on the urgency of the quest for inner harmony and in the difficulties encountered on that search, much of it reflects the inner and outward disturbance of the last fifty years. In this sense, as Cecil himself has suggested, he is the primitive of a new age – a new age of poetic and spiritual consciousness. 'I feel,' he told me, 'that a new world is being born, a new civilization.'[27] Certain of this change he faces the future in much the same optimistic attitude as one of his own (autobiographical) fools. He moves towards it; he embraces it; he is not afraid. He shows, indeed, reserves of an almost childlike gaiety and courage which seem astonishing for someone of his apparent frailty – until, that is, we know his tenacity of spirit. For unlike so many of his

contemporaries for whom the pressures of irresponsibility, narcissism, or easy fame have proved so seductive, Cecil has always refused – with a fool-like obstinacy or innocence – to countenance despair or, like Duchamp,[28] nothingness. Sometime in his earliest years he made a different choice – to face away from darkness, to face as he says 'towards the dawn, the rising sun'. Unflinchingly, the mythic thread has been pursued. 'My art is that which faces the sun – the dawn, the coming of light. That I should say is the basic hidden theme behind my activity as an artist.'

Yet Cecil's apparent withdrawal from the 'realities' of twentieth-century life is no escape from the horrors of Auschwitz or Vietnam, no Hameau in the grounds of a doomed park. Rather, it is, I believe, the reponse of a deeply-perceptive man to the existential dilemmas of our century: a world menaced by nuclear threat, pathological divisions, a spiritual vacuity, a pervasive sense of hopelessness. In response, Cecil's work points to a new vision of humanity – the possibilities of a new image of man, a new kind of being, a new future, a new awareness of unity between man and the universe he inhabits. Few artists of our time have offered such a healing prospect; few, the vision of a new way of looking at the world; few, such an instrument of orientation; few, such an index of hope. 'Our consciousness,' says Cecil warming to the theme which perhaps he holds most dear, 'our consciousness has to grow wings in order to transform.' (Plate 38).[29] How strange and yet so apt that in a world uneasily awakening from three centuries of spiritual impoverishment it should be a long neglected English painter who should reveal, by non rational means, a vision of such empowering strength and youthfulness, the promise of renewal and refreshement.

It is never possible to foresee how posterity will treat a contemporary. One can, however, hazard that the order of merit in which the painters of the mid- to late-twentieth century will be arranged will be different from our own. In Cecil's case the question of stature is particularly difficult: no respresentative

exhibition has been held for almost thirty years, many paintings are in private hands and in consequence rarely seen; reproductions have been severely limited. Until the Tate retrospective in 1989 it is difficult to assess his achievement in relation to that of other twentieth-century artists, many much better known.

None the less, it is my conviction that his importance will increase as the century moves to its close. How he will eventually stand in comparison with other English artists of the twentieth century – painters like Gwen John and Stanley Spencer, Paul Nash and David Jones, let alone such masters as Matisse, Bonnard, Modigliani, Braque – I cannot say. Yet to my way of thinking he is an artist of universal importance. One of

Plate 38
CECIL COLLINS
The Island, (1944)
Roneo print on paper;
8″ × 11¾″
Private collection

139

those, as Blake said, inspired by the Daughters of Inspiration and as such not only of this but of all time.

First published as an introduction to the catalogue of an exhibition, Tribute to Cecil Collins, *organized by Plymouth Arts Centre, 1983. Revised.*

8

LIFE AND ART

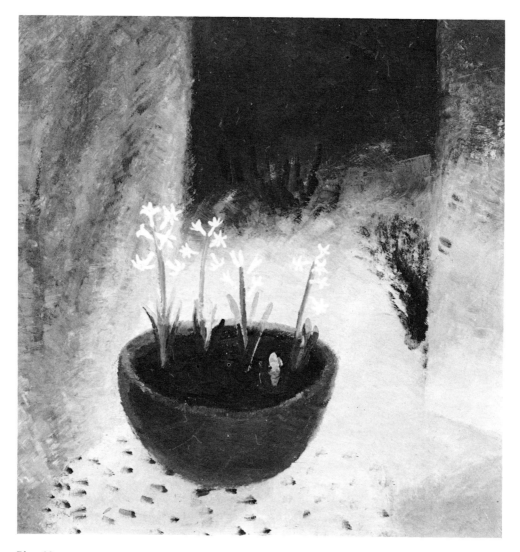

Plate 39
WINIFRED NICHOLSON
Candlemass I, (1951)
Oil on board; 23½″ × 23½″
Private collection

142

Life and Art

TODAY, ALMOST A CENTURY AFTER van Gogh's suicide the isolation of the professional artist remains fundamentally unchanged. According to Georg Baselitz,[1] the German neo-expressionist painter:

> The artist is not responsible to anyone. His social role is asocial There is no communication with any public whatsoever. The artist can ask no questions and he makes no statement; he offers no information, message or opinion. He gives no help to anyone, and his work cannot be used.

This is an extreme statement but not untypical; society at large has rejected its painters and poets, its architects and 'serious' composers, and for the most part they have rejected society. Making a virtue out of a necessity many still regard their work, with its private history and self-referring language, as a world with no other end but itself. The creative individual, they would argue, is one privileged to insist on absolute independence – freedom from previous art history no less than social and political norms – and to answer only to his own laws.

A significant and ever growing number of artists think otherwise. The practice of art and life, they argue, must be seen as an indissoluble unity, a unified field of being in which the creative element remains an important and integral part but not an arbitrary master. To separate one such element from another – for example, the aesthetic from the functional or imagination from 'everyday life' – is not merely foolish, ill-advised or hazardous; it is the proving ground for man's

143

destruction. The needs of the planet and the needs of the individual are no longer separate. They are one.

The radical revisions of the art of our time have barely begun yet the old orders of living and painting are already breaking down. Gone is the idea that the artist can only establish his identity by divorcing himself from society – and tradition. Gone, too, is the idea of art and life as separate entities, self-contained in themselves. In their place we have community artists and artists-in-residence developing concepts of service to people in the places where they live. Benjamin Britten's commitment to Aldeburgh and George McKay Brown's to Orkney[2] are leading examples of a growing sense of belonging and responsibility. They are perhaps, above all, the final expression between the old order of artist and the new.

In this chapter, however, I'd like to trace a more radical view involving the making of 'art' in a new set of relationships – to work and practical life, to nature and the living cultures of the past, to worship and occasion and locality – in which we can discern something which is not 'modern' any more, the germ of new directions in aesthetics akin to the emergent worldview. In this sense the aesthetic is concerned with all that works through and on feeling, sensation, and sensibility, to include every aspect of everyday life.

Such an attitude is not easy to define; the attempt to do so might prove academic. Instead, therefore, I have chosen to explore the testimony of three people in whom, I suggest, the living sense of intricate connection and relationship is in the fullest sense alive. Inevitably, the choice is arbitrary and personal; I don't doubt there are others whose biographies might prove as valuable, if not more so, than these three: Winifred Nicholson, Eric Gill and Wendell Berry. In this context I can think of such examplars as the potters Bernard Leach[3] and Michael Cardew[4] (with both of whom I had some contact), and the lesser-known David Drew, (whom I have never met). The latter is a basket-maker who carries out every stage of his work and sees it through from start to finish. He

144

personally grows the willows which provide the material from which he makes the baskets which he himself sells from his own house without advertisement and without a middleman. 'Work and leisure, labour and pleasure,' writes Richard Boston,[5] 'house, garden, food, drink, family: the different elements of David Drew's life are woven together into a whole which is greater than its parts – like a basket.' It would be interesting to trace this interchange of elements in the lives of other craftspeople whose work has not flourished upon, and fostered, the grievous division between life and art in our era. In them, we could say, as Robert Pirsig does, that 'Quality is not a thing. It is an event.'[6]

Winifred Nicholson (1893–1981), the painter, is perhaps the most exceptional. For one thing, intelligent, articulate, practical as she was, the dominant note of her nature was intuitive. She was, I would say, a great 'natural', responding to the here-and-now – the ever-fleeting moment and the endless flow – with a delighted, unselfconscious enjoyment of life on the wing. For Winifred the living spirit within creation, the cycles of birth, death and rebirth, were a matter of personal acquaintance; she 'knew' them with her soul; she 'knew' trees, clouds and flowers as an extension of her spirit; she 'knew' quietude even in the midst of a busy practical life. 'She knew things without being told,' writes Thetis Blacker, 'she knew what one's deepest needs were without being told, and she knew what one's deepest needs were going to be.' More than many other women and men she possessed insights which were integral to the spontaneity and seamlessness of her life and art. There is an abundance of documentation which testifies to the absence of compartmentalization in her life – it was a whole, or nothing.

She was born in 1893 into an eminent family, prominent in the arts and politics. Her grandfather, George Howard, Earl of Carlisle, a painter and close friend of the Pre-Raphaelites, chairman, too, of the Trustees of the National Gallery, was largely responsible for Winifred's early training. She studied at the Byam Shaw School of Art in London, though in later years felt the instruction she had received there had been of little use.

145

In 1920 she married the painter Ben Nicholson[7] with whom she lived for a decade; both Winifred and Ben were active members of the Seven and Five Society[8] which had Henry Moore, Ivon Hitchens, Christopher Wood, and David Jones among its members. At this time she was at the growing edge of artistic revolution, a firm adherent of Modernism, a vision purged of the past and of all outworn unnecessary embellishments. Intellectually, she remained loyal to it yet her life can be seen as a repudiation of the concerns of our century, an affirmation of more enduring human values.

Early in the 1930s the marriage broke. Ben Nicholson went to live with the sculptress, Barbara Hepworth, and Winifred moved alone to Paris with their three children born between 1927 and 1931. There, too, she became part of an avant-garde circle that included Mondrian, Brancusi, and Arp.[9]

Throughout her life Winifred Nicholson wrote many essays and stories, but the reminiscences of her life in Paris, published in 1987 in *Unknown Colour* – a collection of her paintings, letters, and writings[10] – are amongst the freshest and most joyful she ever wrote; fresh because they are unaffectedly personal, joyful because in spite of difficulties, there is never a hint of self-pity, envy, or ingratitude. In the deepest sense Winifred Nicholson knew not only how to paint, but also how to live.

After her departure from Paris in 1938, she returned to England and in due course, to the land of her ancestors, Cumberland. She spent the war years living at her parents' house in Boothby; she kept bees and goats and ran a small school for local children which left little time for her art. Later Winifred returned to an old stone farmhouse built on a mile-castle on Hadrian's Wall, where, overlooking the Pennines, she had lived with Ben Nicholson in the early years of their marriage. It is called Banks Head and here, in some isolation, she continued to paint amongst children and animals, flowers and plants, cooking and friends, until her death in 1981. She was eighty-seven.

Much of her life, no doubt, was chock-a-block with the many daily claims on her time and attention – 'I have father very ill,' she writes in 1944, '. . . he has to have a serious operation – and mother ill in bed. Kate and Andrew, clothes ready for their schools, and my animals, and do the cooking for the household' – but, somehow, somewhere, there was always time for marvel and, of course, for the vanishing trick which enabled her to paint. The adventure of painting, the exploration of the colour spectrum, was the dominant theme of her life. It was, as it were, the lodestar by which she found her course, though it remained one art amongst a multitude.

Winifred Nicholson's characteristic composition is of flowers in a jug, or a plant growing in a pot, or bulbs painted on a windowsill with a landscape beyond. (Plate 39) But the landscape, usually known, always experienced, is no mere backcloth, no mere ancillary to a foreground human world; people and nature are in relationship; two entities at play, an 'I' and a 'thou' in Martin Buber's famous phrase.[11] The 'deep-ecology' of her response was decades in advance of her time.

This respect for natural things, testifying to the naturalness with which her painting grew out of life, was an aspect of her profound intuitiveness. Winifred was inescapably a woman artist, one of the best, but not one who wore her femininity as a badge; she was too natural, commonsensical, for that. In so far as her painting arose out of the wisdom of her children, her contact with flowers and plants, it possessed to the highest extent those qualities of immediate and spontaneous apprehension so largely denied the western male. She painted. She brought up children, she cooked and gardened, she wrote stories and dyed cloth, as part of an individual flow of deep mysterious power. This perhaps was her secret: to paint from the flow of her life as the flowers she painted from the living earth.

In herself she recognized, as she put it, the 'twin dragons of art and life – art in the sense of music making, painting here and now, life in the sense of living, home, children, relationships' – and sought their reconciliation, not in thought,

Plate 39
WINIFRED NICHOLSON
Candlemass I, (1951)
Oil on board; 23½″ × 23½″
Private collection

147

not always in 'art', but in the practice of the sacrament of the present moment.

> No life practice is wrought out without effort and courage and patience and forbearance and love – and plenty of the other graces as well, as many as one can muster – and the work is done in the secret closet of one's own consciousness . . .
>
> The expressing of perfect home, perfect wife, perfect mother is very close to the expressing of perfect musical harmony – and when one reaches that point the two dragons become friends and helpmates.[12]

Winifred's ability to perceive the interpenetration, the close relationship between the practice of art and the continuity and conservation of natural forces is, I believe, one of the most notable aspects of her achievement.

The present was, therefore, as her friend Kathleen Raine[13] has written, 'an unfailing source of wisdom and delight, bringing with it the possibilities of new ways of painting, new ways of seeing and of being, in a world which holds the promise and fulfilment of inexhaustible life'. It was from first to last alive; and living, sacred. As in the Book of Revelation Winifred might have cried 'Holy, Holy, Holy is the Lord God Almighty', though in her published writing (surprisingly since most of her life she was a Christian Scientist and the Christian impetus stood behind everything she did) there are relatively few references to the divine. Few, perhaps, but unequivocal when they come: 'God', she writes, 'is the source of our being. We are God's expression. From our source comes our power, our inspiration, our freedom, our motive power'.

One painting in particular sums up for me her common wonder at the great epiphanies of a universe continually opening from a sacred source, 'the centres of the birth of life', as Boehme[14] and Blake describe it. *Sunroom* (1980) (Plate 40)[15] is a small picture, but its imaginative scale is vast. In an ordinary but

148

empty room, a sun-filled chamber (a day-bedroom at Banks Head), the paradisical and vivid goodness of four molten bars of light strike a white wall – spectrum colours like those which flash and glow with an ethereal irridescence in other late paintings of rainbows and prism-haunted rooms. There is a closed door, portal onto the unknown, and a window to the left. Nothing more. Yet the effect of this painting upon the soul is profound. How one feels the weight of the mystery here! How one senses glory renewing itself! No symbolism is intended, yet in this tiny, unpretentious canvas we are precipitated into an awareness of infinity.

Plate 40
WINIFRED NICHOLSON
Sunroom, (1980)
Oil on board; 22¼″ × 26¼″
Private collection

149

Eric Gill (1882–1940) was in many ways the polar opposite of Winifred, but for him the primacy of spirit was no less central. In all he said and wrote and did – and Gill was not simply a theorist but an intensely active and practical craftsman – he set his sights on the heavenly Jerusalem; he believed in first principles and was not afraid to state and live by them. 'The purpose of man's existence,' he declared, 'is to know God, to serve God and to love God on earth and to be with Him eternally in heaven.'[16]

Gill's fundamental objection to godless scientific 'progress', his personal search to reconcile production and need, beauty and function, work and pleasure in the daily pattern of his own life, all stemmed from his belief that western man had reduced knowledge to what conforms to logic and reason. It was therefore demanded of us that we turn (or return) to the springs of sacred truth. Without an understanding of the very heart and essence of tradition, no Jerusalem can be visible, no Chartres or Byzantium built. Without it humans can only exist – as they exist – in a material and mechanical system; a massive superstructure of brilliant, scientific achievement strung precariously over a chasm of meaninglessness.

Gill set out to demonstrate, as William Morris[17] had also tried to do, how in a fragmented and unbalanced society a life of balance and of wholeness might be lived – including, in his case, a frank and delighted avowal of sexuality. Yet Gill's life was, of necessity, an imperfect endeavour and one as full of failures and contradictions as that of his mentor. Because of these contradictions, because of his apparent oddities, because of his denial of technological development and espousal of religious dogmatism, it is all too easy today to dismiss Gill as a nostalgic reactionary who, in looking back to the ideals of an earlier age, placed himself out of court as far as the problems of the twentieth century are concerned. But this, I believe, is not so. Thoreau said, 'If a man does not keep step with his companions, it may be because he hears a different drummer.'[18] Like numberless others – artists, craftsmen, cultivators, and

150

philosophers – Gill had heard that other drumming and hearing it devoted his whole energy to following it.

His attention to first principles, to fundamentals, is important precisely because it draws our attention to problems which have not lessened but become only more acute with time. Since E.F. Schumacher[19] – who shared much in common with Gill, including Catholicism and the influence of René Guenon,[20] Ananda Coomaraswamy[21] and Hindu, Buddhist, and Islamic thought – the tradition in which Gill taught has spread far and wide: concepts of appropriate technology, smallness of scale, voluntary simplicity, and the necessity for the re-sacralization of work are now more widely understood. But the problems have also multiplied. Only those who have capitulated to the premises on which the fabric of our industrial economy rests would any longer reject Gill as an out-moded crank.

He was, however, not simply a profound and radical thinker about factory production and the nature of work; a writer of unanswerable prose. Gill was a maker, a workman never happier than at his bench, graver or chisel in hand. He was one of the supreme masters of two-dimensional design of this century; always more than the sum of his parts.

He was born in Brighton in 1882. As a child Gill shared a talent for drawing and decorative lettering, and at the age of seventeen was apprenticed to a London architect. He had begun to study masonry (at the Westminster Technical Institute) and, significantly in the light of his later career, lettering (at the Central School of Arts & Crafts headed by W.R. Lethaby).[22] Gill was one of the first pupils in Edward Johnson's now famous lettering classes. He also studied stone-cutting, a skill from which he later earned his living (Plate 41). From 1902 until his death in 1940 Gill was never short of work.

At first he moved in socialist and avant-garde circles. By 1909, however, he had repudiated the secular premises of Modernism and the Arts & Crafts movement; direct carving was part and parcel of this wholesale and uncompromising refusal of the modern world, an affirmation of a form of labour, at once

151

Felix qui potuit

A B C
D E F G H I J K
a b c d e f g h i j k l m n
L M N O P Q R
o p q r s t u v w x y z
S T U V W X Y
1 2 3 4 5 6 7 8 9 &
Z

rerum cognoscere causas. 1939
89

152

physical and sacramental. In 1913 he and his wife Mary were received into the Roman Catholic Church, by his own admission the most important event in his life.

Almost immediately he accepted the first of several major public commissions: the Stations of the Cross in Westminster Cathedral, which he carved in astringent relief. Further work soon flooded in: war memorials and inscriptions to begin with, then with a growing momentum, wood engravings, and typefaces for the Monotype Corporation which are still in general use. Like William Morris, Gill lived a life of unremitting activity; his output, too, was prodigious – at best austere and beautiful, at worst, neo-classical in its cool but mannered severity.

But Gill's achievement is not merely that of a distinguished craftsman, or an artist-prophet insisting that the ethical unsoundness of our society – and the capitalist system itself – is the natural consequence of turning away from true religion. He was someone who lived out – or tried to live out – the theory in practice, which he did in three celebrated quasi-monastic communities: at Ditchling in Sussex, at Capel-y-ffin in the deeper retreat of the Welsh mountains, and finally at Pigotts near High Wycombe. Mingling work with worship, cultivation with community, art with occasion, self-sufficiency and a dignified poverty, the family practised Gill's belief that, as he entitled one of his essays: 'It all goes together'.[23] Mary and the girls made the bread, the butter, and the wines; Gill and his apprentices cut and carved, and those who lived with them (and this invariably included a number of families and visitors) gathered together from their various workshops four times each day to sing the Little Office.

In all he practised, Gill was concerned to live according to sacred principles. Worship therefore was always central, and art, critical to human life, the inevitable and glorious outcome of good work – work, that is, conceived in terms of a right relationship to the divine. 'To labour,' he wrote, 'is to pray',[24] and again, 'Though not every man is called to the life of "religion",

Plate 41 (left)
ERIC GILL
Alphabet cut for Graham Carey, (1939)
Hoptonwood stone incised & painted; 22" × 17½"
Present whereabouts unknown

153

every man is called to the love of God and every man is called to give love to the work of his hands. Every man is called to be an artist.'[25] Visiting Capel in 1924 Count Kessler recorded in his diary[26] that 'Gill remarked that for him and for his friends, as probably for me too, art was now taking the second place, the main purpose being renewal of Life.' David Jones,[27] a life-long friend, has also reported that Gill once said: 'What I achieve as a sculptor is of no consequence – I can only be a beginning – it will take generations, but if only the beginnings of a reasonable, decent, holy tradition of work might be effected – that is the thing.'[28]

At the end of his life, in his last and finest book, the *Autobiography*,[29] Gill makes this especially clear. To my mind the ecology of art has never been more cogently or movingly expressed:

> Lettering, type-designing, engraving, stone-carving, drawing – these things are all very well, they are means to the Service of God and of our fellows and therefore to the earning of a living, and I have earned my living by them. But what I hope above all things is that I have done something toward re-integrating bed and board, the small farm and the workshop, earth and heaven.

The belief that there are no clear boundaries between art and other forms of life, the search for the connective processes, also inform the writing and the practice of a writer as different from Gill as he, in turn, was from Winifred Nicholson: Wendell Berry. First and foremost a practising farmer, a homemaker, and a married man, Wendell is also a poet, a novelist and, like Gill, a cogent and always radical polemicist whose essays on a wide range of current issues – agriculture, stewardship, economics, community and culture – are amongst the sanest, most hard-hitting of our time.

He was born around sixty years ago in the same part of Kentucky as he still lives. Home, in fact, is in the area of the

154

village of Port Royal, four or five miles from the Berry's present house. Five generations of Berrys have lived in or about this place, and all but one of them have farmed their own land. So roots are deep and place is nurturing: the association of tradition and experience, the enactment of connections, have been the central concern of Wendell Berry's life. 'My work,' he says, echoing Gill, 'has been motivated by a desire to make myself responsibly at home both in this world and in my native place.'[30]

After a period of exploration before the deepest roots were struck, Wendell and his wife, Tanya (an indispensable partner in all that they attempt), travelled widely in both Europe and the States. He taught in New York, California, and Lexington. Then twenty years or so ago they settled permanently to farm and write, combining the craft of earth and poetry. Today, as in the intervening years, Wendell's time is still divided between writing and working on the family's 75-acre farm.

As a practising but organic farmer I have no doubt that Wendell Berry is little different from many another committed husbandsman. He milks the house-cow, feeds the hens, ploughs with horses. I've been there; I've seen it for myself. As an artist-farmer, however, he is unique. Yet the two are inseparable; the one nourished by the other and both enlarged by the context of meanings they mutually provide. Unusually for an artist he has integrated both writing and the content of his life.

No writer since Hardy speaks of or from place with more knowledge and simplicity. The wind in the leaves, the flight of a kingfisher, the first hard frost are the material out of which his essays, his novels, and poetry have been fashioned. Yet if Wendell Berry's writing has its starting point in a knowledge of doing and place, he is no Flaubert, solely dependent on the concrete world, the outward world of physical fact. The presiding, unconcealed, interpreting intelligence is religious. The immanence of mystery and divinity enfolded in the physical is a recurrent theme in Wendell's work. 'The only outlawing is in division', he writes.[31]

155

For him therefore a poem is never merely an object of art; it is not a specialist's product. It is not, in itself, an isolated achievement, but dependent on a multitude of other acts and processes which deserve homage. 'Higher' and 'lower' activities are interdependent; indeed, for there to be a higher one at all the low or material culture must itself be vigorous. 'Real – that is, living – art and culture,' he says, 'rise from and return to action, the slightest as well as the grandest *deeds* of everybody's everyday life.'[31] How much excellence in 'the arts', then, is to be expected from a people who are poor at carpentry, sewing, farming, gardening, or cooking? 'To believe that you can have a culture distinct from, or as a whole greatly better than, such work is not just illogical or wrong – it is to make peace with the shoddy, the meretricious, and the false.'[32]

It is a fact that this poet and novelist, in my view one of the finest now writing,[33] has less to say about contemporary American literature than anonymous cultivators and craftsmen who are preserving (and have conserved) the fully integrated culture which he so much admires. It is they, he argues, the ones who are conserving (or have conserved) the 'ancient pattern of values, ideas, aspirations, attitudes, faiths, knowledge, skills that propose and support the sound establishment of a people on the land', who most deserve our approbation. Without their work, their skill, their dedication, the pattern would disintegrate, the pattern would fall apart. The continuity of creation needs to be stamped on everything, however humble, for 'masterpieces' to exist. In *Irish Journal,* based on a visit in 1982, he writes:

The real genius of a country, though it may indeed fructify in great individual geniuses, is in the fine abilities – in the minds, eyes and hands – of tens of thousands of ordinary workers Columcille's house [a ninth-century stone-built oratory in the town of Kells] was not like a monument of modern architecture, the work only of one individual genius, but grew out of many miles of stone walls around little fields and out of many cottages. Thus, coming to Ireland has

reminded me again how long, complex, and deep must be the origins of the best work of any kind.[34]

Wendell's life has a kind of irrefutable logic within it – the truth of demonstration and service. Thus, he argues, it is not 'their' but 'our' responsibility to heal the modern ills; the roots of every public problem are private and personal and cannot be solved by being institutionalized. 'To help each other, that is, we must go beyond the coldhearted charity of the "general good" and get down to work where we are.' 'He who would do good to another,' he quotes William Blake, 'must do it in Minute Particulars.' He then quotes Blake again:

Labour well the Minute Particulars, attend to the Little-ones,
And those who are in misery cannot remain so long
If we do but our duty: labour well the teeming Earth[35]

The 'problem' of art in our time is no different. This, too, it seems to me can only be addressed if we allow our own qualities to be expressed in action in our homes, amongst friends, at work, in our gardens, and the community where we live. By being good at our job and therefore taking pleasure in doing it; by celebrating, as a maker, the materials of the world; by good home-making, good parenthood and friendship and worship, the arts of life and the life of art can prove mutually beneficial. 'One of the most profound of human needs,' Wendell writes, 'is for the truth of imagination to prove itself in every life and place in the world, and for the truth of the world's lives and places to be proved in imagination.'[36] Proved, that is, not in a generalized abstract kind of way but as an intimate and ordinary daily right. To claim a new relationship to art is to realize that it is ourselves, rather than the world, that is in need of changing.

Like his prophetic forerunners, Nicholson and Gill, Wendell Berry proposes work as the meeting ground of spirit and matter. Time and time again he demonstrates that it is in the domain of craftsmanship, broadly defined, that, in AE's[37] phrase, the

157

'politics of time' may correspond with 'the politics of eternity'. In this, as in so much else besides, the three share a common view, an orientation rather than a credo, to which an increasing number of people are now responding.

Without fear and without self pity they have faced the frustration and defeats of our century with a vision of life at once unbroken, optimistic and affirmative. In a time of division they have shown that the care of the earth, the making of art and families is the true foundation of life and hope. In a time of profanity they have been concerned to know and to live sacred principles common to humanity and the matter of human work. Winifred Nicholson, Eric Gill, and Wendell Berry might best be described, I suggest, as reclaimers; men and women who built homes and communities, who made land fit for cultivation, who created good and lasting and beautiful things. They may best be seen, as Blake would have it, as the 'Golden Builders' of the Holy City, never resting from their labours

> . . . in Visions
> in new Expanses, creating exemplars of memory and of
> Intellect[38]

Or perhaps, most significantly of all, as builders of the Ark.

Witnessing the tragic spectacle of our time it is comforting to be reminded of those men and women who, to borrow Gill's phrase, have sought 'to make a cell of good living in the chaos of our world'.[39] Noah did no more and he saved the planet.

9

THE RECOVERY OF VISION

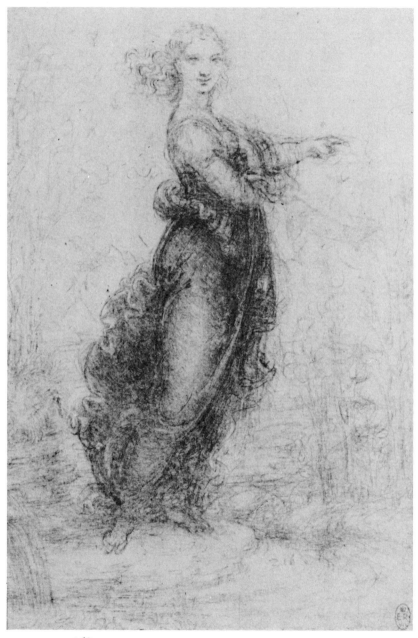

160

The Recovery of Vision

I SEE BOUNDLESS SIGNS OF encouragement in the emergent paradigm[1] which proclaims that everything exists in a unified field of being, everything is a membership of parts inextricably joined to each other, indebted to each other, receiving significance and worth from each other and the whole.

This is a fundamental view of the world. It says that when you make a thing (or thought) you cannot make that thing (or thought) in isolation without affecting the whole. There are, in fact, no things or thoughts apart from the agents that act upon them, and no agents apart from the things upon which they act. Whether we are planning a building, admiring a painting, planting cabbages, or educating a child, we stand in a dynamic, unbroken, and unrepeatable relationship with each activity entirely devoid of the divisions imposed on it by an alienated consciousness. We also stand, I suggest, in some relationship with a Universal Mind, spaceless and therefore infinite, timeless and therefore eternal, accessible to the individual under suitable circumstances. Certain to be rejected by the mechanist, the oneness of minds is no less certain to be accepted by future generations for whom the inner ecology (human emotional and psychic rhythms) and the outer ecology (natural and cosmic forces) will have been acknowledged as part of the continuum of human experience.

To observe matter as primary, mind as secondary, to observe divisions and ignore connections, as dualism does, is to hazard the destruction of the earth; it is to worsen our ever-worsening ills. It is, for example, to 'treat' illness without facing the reality of diminishing returns to health for rapidly increasing efforts. It

Plate 42 (left)
LEONARDO DA VINCI
The Pointing Lady,
(c.1515)
Black chalk on paper;
$8\frac{1}{4}'' \times 5\frac{1}{4}''$
Royal Library, Windsor

161

is to place economic institutions rather than those which have to do with wisdom, knowledge, religion, in a paramount position. It is to divide 'theology' from 'philosophy' and both from work; the practice of agriculture from the practice of health.[2] It is, in fact, to divide the whole of life into two opposing parts: feeling against intellect, sacred against secular, art against science. It is to polarise person-centred values – the subjective 'romantic' sensibility – in opposition to the Age of Reason's objective, 'patriarchal' emphasis. The prevailing model of art – ever-increasingly an activity apart, feeding on itself, lending no meaning to life – is the inevitable corollary of this dualistic approach. To acknowledge the shifting paradigm is to reverse this fragmented way of thought.

Wholeness implies an integration of concepts that before seemed opposed: matter and energy in physics, mind and body in medicine, humanity and nature in ecological thought; art and daily life, art and the sacred. The concept of integration and creative wholeness points towards changes not just in content but at the most fundamental levels: in how we define art and its place and purpose in culture. One such change must be an acknowledgement of the place of creativity in daily life. This will allow us to see more clearly how much that we do which we would never call art can, none the less, be deeply creative. Another must be the recuperation of aesthetic endeavour, our sense of beauty, as an inalienable human potentiality as fundamental as the capacity for language or the need for food. Since we have no choice but to alter our way of life it could be useful here, I believe, to consider such a change of attitude and behaviour in more depth.

To do so we might do no better than turn to those traditional cultures, like that of India,[3] where the 'arts' belong not exclusively to the gallery and concert hall, the cinema and theatre, but to the sacred shrines and temples, the streets and houses of the people, the living of life itself – where 'art', that is, is what people do, not what they own. From archaic times through antiquity and right into the early twentieth century

162

much the same has been the determining feature of every stable, fulfilling society; I choose India for no better reason than that I love it and have seen it with my own eyes.

It would be ungrateful and stupid to condemn or to turn our backs on the achievements of western art, which contain so much of value that we can cherish and learn from. Nevertheless, we cannot escape the fact that western music, western painting and poetry and architecture, western dance and story-telling since the Renaissance, have flourished upon and fostered a catastrophic division between art and life. An integrated culture, such as that of India, where beauty matters, has much to teach us at the present time.

'The heart and essence of the Indian experience,' wrote Ananda Coomaraswamy,[4] 'is to be found in a constant intuition of the unity of life, and the instinctive and ineradicable conviction that the recogition of this unity is the highest good and the uttermost freedom.' For the Indian, therefore, all life is embraced. The day's work and life have not yet, as in the West, become separate worlds, they flow together; they are ultimately one. Thus her vast and tranquil metaphysic is enfolded into her aesthetic, her aesthetic into her philosophy.[5] In this context the 'work of art', however simple, is seen in its manifestation not simply *of* but *as* spirit. It has indeed a specific sacred function: to give form to the formless, to reveal the divine immanence, to seek to discover the unknown through the known; to nourish the soul.

For the majority of Indian men and women – the millions who live in villages – the creation of such a work is not a self-conscious, individual thing; it is a celebration and invocation of the sublime. It is what we would call a yoga, a meeting of self and Self. 'In each glory of sound and sight and scent,' says the poet Rabindranath Tagore[6], 'I shall find Thy infinite joy abiding.' It is also true that it is a social act, fulfilling communal and kinship obligations.

The aesthetics of Indian religion therefore include a wide range of forms and activities in which are to be found both

163

social, sacramental and aesthetic intent. They can include, for example, the activities of the craftswoman – the embroiderer or weaver – who brings to her work enhancements and devotion in excess of utility. (Plate 43)[7] They can include the lover who makes for his girl some token of affection; a token which symbolizes not only his love for her but, by implication, his love for life itself. They can include the villagers who anoint a tree to symbolize regeneration or make a decorated image to protect the sanctity of a particular and much cherished place.[8] Such acts, such images, are 'tools' of the spiritual life; a means to an end, not the end in itself. A 'work of art' which accepts these conditions, and exists upon their terms, no longer feeds upon itself. By honouring the creation, it becomes a part of it, an adornment of life itself. (Plate 44)

In comparison with this richness, western culture, the culture of industrialism, has become a barren desert, shorn of mythological, aesthetic and spiritual wealth. In *Lady Chatterly's Lover*[9] D.H. Lawrence described it in a long passage of sustained rebuke; the sixty years between ourselves and him have, if anything, only furthered modern civilization's annihilationist designs upon the earth and all its life.

> The car ploughed up hill through the long squalid straggle of Tevershall, the blackened brick dwellings, the black slate roofs glistening their sharp edges, the mud black with coal dust, the pavements black and wet. It was as if dismalness had soaked through everyone.
>
> The utter negation of natural beauty, the utter negation of the gladness of life, the utter absence of the instinct for shapely beauty which every bird and beast has, the utter death of the human intuitive faculty was appalling. The stacks of soap in the grocers' shops, the rhubarb and lemons in the greengrocers! The awful hats in the milliners! All went by ugly, ugly, ugly, followed by the plaster-and-gilt horror of the

164

cinema with its wet picture announcements, 'A Woman's Love'! and the new big primitive chapel, primitive enough in its stark brick and big panes of greenish and raspberry glass in the windows . . . Just beyond were the new school buildings, expensive pink brick, gravelled playground inside iron railings, all very imposing, and mixing the suggestion of a chapel and a prison. Standard five girls were having a singing lesson, just finishing the la-me-do-la exercises and beginning a 'sweet children's song'. Anything more unlike a song, spontaneous song, would be impossible to imagine: a strange bawling yell that followed the outline of a tune. It was not like savages, savages have subtle rhythms. It was not like animals; animals mean something when they yell. It was like

Plate 43
Basket maker, South India
Photo: Bobby Cox

165

Plate 44
*Kansari, the Corn
Goddess, enclosed within a
square Mandala* (20th
century)
Painting on cloth from
Maharashtra; India
53″ × 41″

nothing on earth, and it was called singing. Connie sat and
listened with her heart in her boots, as Field was filling
petrol. What could possibly become of such people, a people
in whom the living intuitive faculty was dead as nails and only
queer mechanical yells and uncanny will-power remained.

It is a culture of this kind that now replaces the total experience
of an inherited tradition that the artist and poet, David Jones,
called the mythus; something rooted in the ways of feeling and
living, doing and being that belongs to the ancient cultures; the
cultures that begin at home: the cultures that produced the

166

Maesta (Plate 20) and the Navajo night-chant, the patterns of Islamic tiles or the beauty of Indian folk crafts.

And yet, the spirit is abroad that would challenge all our presuppositions and heal the split between intellect and imagination in the soul of the West. Buddhists call it a 'turning around in the deepest seat of consciousness'. Others, a total change of heart, a *metanoia*, which points to a convergence of science, mythology, religion and art. A number of artists, Ben Nicholson amongst them, have already recognized that 'painting and religious experience are the same thing, and what we are searching for is the understanding and realisation of infinity.'[10] Others will follow suit. The flight from the holiness of art has been only a brief and arrogant interlude. 'But that' as Dostoyevsky wrote in the last paragraph of *Crime and Punishment*, 'is the beginning of a new story, the story of the gradual re-birth of man, the story of his gradual regeneration, of his gradual passing from one world to another, of his acquaintance with a new and hitherto unknown reality.'[11]

The nature of this reality can barely be imagined for as yet we have hardly begun to align the human psyche – the world of dreams, of the imagination, of the spirit – with the soul of nature and our everyday experience. But when the imagery of the dreaming mind, the mythical substrata of our lives, breaks through; when, as Alan McGlashen writes, 'the dark sun of the unconscious rises above the mind's horizon and irradiates the world we live in with a new and terrible beauty',[12] then, and only then, may we hope to see the Tree of Life break into flower. Then, and only then, may we hope to attune the forces working through the universe and those working within us. Then, and only then, may we hope to heal the planet and ourselves. Then, and only then, may we see the world flashing and trumpeting a new beauty. How strange this is to us today! And yet, how commonplace for millions, the humblest and the poorest amongst them, for whom the need for beauty is a vital, insistent, necessity.

The creative imagination has always been the unfailing

167

source of regeneration, the instrument for making what is oldest in the human spirit contemporary and new. Civilization, seen in this way, is, in the first place, a matter of spirit, of symbol and vision, and, as such, capable of the renewal of societies and their outworn cultures; capable, too, of the exorcism of all the fears and troubles of a culture in decline. As such I cannot doubt that the Tree of Life will, once again, grow straight and strong; that a new civilization will be born. A new vision of humanity, a new understanding of the nature of consciousness, which is itself the chief mark and signature of man, is, as we have seen, now breaking through. Let it then release new energies! Let it beget fresh images; liberate a fresh aesthetic response, return to its source in the soul. Let the practice of the presence of the holy spirit become a daily event.

But whatever form this civilization takes, however awesome the convulsions and currents of the life current, however far our human society may move into areas at present unimaginable, there are certain templates of the human soul which have never changed and will not do so in the future. In these we must trust. The finite in man will always long for the infinite, the sacred and the beautiful. The imagination in man will always seek to find expression. The 'love that moves the sun and other stars'[13] will always move the heart and draw the human soul, 'smaller than a grain of sand', to the great soul of the universe, 'greater than heaven itself.'[14] A civilization built on any other truths is a civilization built on sand.

10

AN INTRODUCTION TO MY WORK

Plate 45
Truda Lane
Angel carrying a child,
(1977)
Pencil drawing on paper;
11" × 8"

An Introduction to my Work

I AM A PAINTER. THAT IS someone who creates images, painted images, from the inner world of the imagination. For my work I do not depend on the external world – the world I see, for example, from the window near where I sit. I love this scene, peaceful in the afternoon rain. I love the settled trees, the sheep in a far field, the blue rim of Dartmoor above the valley ridge. I love the curdled sky and the birds which are forever sweeping, black flashes, across the vision of my eyes. I love the knowledge it has been farmed, and walked upon, for thousands of years. I love these things, so beautiful one's heart contracts with joy; but I haven't and probably won't ever paint them. What I paint comes from somewhere else.

The same might be said about all rural places I have known. My original discovery of the country was the most memorable experience of my life; it seemed to me, then as now, like paradise. Other landscapes have left me no less deeply moved. Around Ripon, Colyford, Goathland, Wykeham, I knew every meadow, every hedgerow, every stretch of running water, as I might have known the features of, say, a beloved friend.

All the same I never painted these landscapes, not one of them. Nor all the other rural places where, at different times, we've travelled and walked. My painting may or may not have expressed the essence of these places, 'recollected in tranquility', but it has never been a record of them. So where does the idea for a picture come from? I have to confess I don't know; creation is a mystery. Art cannot be explained. I can categorize the subject matter, consider influences including that of different media, the development of a style, but none of this amounts to anything. I

know that there's a mysterious force working within me but that this also cannot be described. I find that a splendid admission of the natural, unaccountable element in creative work. 'The wind bloweth where it listeth,' says John, 'and thou hearest the sound thereof, but canst not tell whence it cometh, and whither it goeth: so is everyone that is born of the Spirit.'

Sometimes, of course, an idea may be drawn from memory, sometimes from visible sources. It comes, like a passing bird, caught (if one's on the mark) in the corner of one's eye. On one occasion, for example, looking across our yard, I saw a shower of yellow leaves dropping onto a slate roof. Then – in a flash – I saw these weren't only leaves but also flakes of light descending from a sun. I painted that idea a number of times. Other images, however, like the bird with outstretched wings, never seem to have had a starting point; I can't remember a time I didn't have them in my mind. The sun, too, is something I have *had* to paint. It makes demands on me. As soon as a sheet of paper is placed on the drawing board I find myself drawing the sun – or, better, drawn to it. The mandate is inescapable.

Sometimes, however, I don't start with an image in mind; I just work the material sensually to see what comes to mind – nine times out of ten from out of the reverie the seeds of an image are born. It is a special moment when an image comes towards you, as it were, out of the mist of the Great Memory. The odd thing about these procedures is the very definite sense the 'creator' in me has of what it wants: not this but *this,* it seems to demand. I'll try to explain how this works as far, that is, as it is explicable. I might start by drawing, say, a subject for which I have little feeling; all I feel in fact is a generalized sense of unease. Then perhaps, I'll change the subject; I'll draw something for which I have an empathy – say a tree. I may then sense a greater happiness. But it's only when I really *feel* the tree, when I experience the tree in the heart, that everything starts to work out harmoniously. The branches draw themselves. The colours sing. The picture paints itself.

There are certain subjects I enjoy above all others – for

example, trees or fountains, oceans or flying birds. Whenever I come back to them I am curiously refreshed. I feel at home with them and am content. Everyone needs his own holy land. For me, these subjects are my chief source of renewal. I wouldn't like to speculate over what they 'mean'. They mean, I believe, what they mean. But I could suggest that the birds which flutter in my paintings are, I think, not only birds but souls. The eyes one sees amongst the branches have something in common with the divine. Candles suggest a certain sanctity; hands a gesture of adoration; serpents a feeling of the earth's vitality. Fountains and water are likewise associated with the flux and flow of the world. I have a fear of going further, of being more precise.

When I think about it all my paintings have something to do with creation. There's one of a winding, serpentine river (glimpsed through trees); the river becomes the sun. Another is of hands drumming; out of the music a fish leaps up. These are, as it were, my own creation myth. An attempt to make the holy places more accessible. I suppose the basis of all my painting is a desire to give praise. The bands of colours or frames which surround the central image – and give it, I hope, some kind of focus – might likewise benefit from a few words of explanation. I'm not sure why I use these 'frames' (I'm not consciously sure why I do anything) but I believe they isolate the image and thereby remove it from surrounding normality. In this way I hope to be able to create something consecrated. I'd like the 'ordinary' world to be experienced magically. I'd like my paintings to serve the same kind of contemplative function as the icon in an earlier time. In one of his letters Rainer Maria Rilke describes the 'enormous aid the work of art (can) bring to the life of the one who must make it – that it is his epitome; the knot in the rosary at which his life recites a prayer'. I would wish my work, all work, to have that effect on others.

These are dreams, vast dreams, and I know I've never achieved what I set out to do. But if, to the smallest extent, I could realize one fragment of these hopes, I'd think it was worth all the difficulty I have encountered on the way.

All water-colours approximately 20″ × 14″

Sunrise with butterflies,
(1985)
Water-colour

Offering, (1985)
Water-colour

176

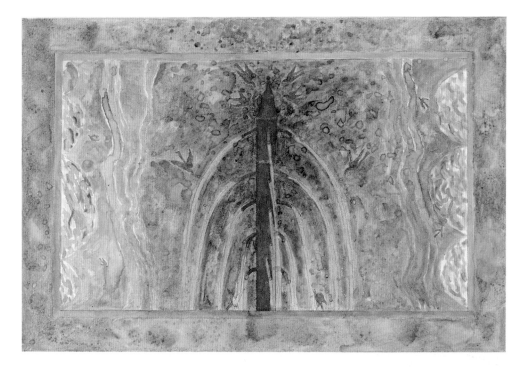

The Fountain, (1984)
Water-colour

Fish sun and sea, (1986)
Water-colour

178

Sky fish, Sea fish, (1985)
Water-colour

Blue landscape with
candles, (1987)
Water-colour

The Pond, (1987)
Water-colour

Tree Orison, (1986)
Water-colour

A Symphony of Birds,
(1985)
Water-colour

*Seven candles with the
sun*, 1987)
Water-colour

Yellow Poem, (1984)
Water-colour

Martyrd Bird, (1984)
Water-colour

Earth world, (1983)
Water-colour

*Bird rising through flakes
of light,* (1986)
Water-colour

188

Yellow dawn with
butterflies, (1986)
Water-colour

Bird Chorus, (1982)
Water-colour

Notes

INTRODUCTION

1. For the poet W.B. Yeats (who makes more than one appearance in this book) Byzantium was a symbol of the perfect culture. In *A Vision* he wrote about the end of the first Christian millenium:

> I think that in early Byzantium maybe never before or since in recorded history, religious, aesthetic and practical life were one, that architect and artificers – though not it may be poets, for language had been the instrument of controversy and must have grown abstract – spoke to the multitude and the few alike. The painter, the mosaic worker, the worker in gold and silver, the illuminator of sacred books, were almost impersonal, almost perhaps without the consciousness of individual design, absorbed in their subject-matter, and that the vision of a whole people.

2. Quoted from an address given on the occasion of Solzhenitsyn's Templeton Award in London in 1983:

> This unquenchable hatred then spreads to all that is alive, to life itself, to the world with its colours, sounds and shapes, to the human body. The embittered art of the twentieth century is perishing from this ugly hate, for art is fruitless without love. In the East art has collapsed because it has been forcibly knocked down and trampled, but in the West the fall has been voluntary, a decline into a contrived and pretentious quest where the artist, instead of attempting to make known the divine plan, tries to put himself in the place of God.

3. Hölderlin (1770–1843), a contemporary of Novalis and Beethoven, was one of the first to attack the European madness into which we have since fallen. The quoted line comes from a late poem: 'und wozu Dichter in duerftiger Zeit'.

4. Michael Tippet was invited to co-operate with the BBC on a documentary film in the series *One Pair of Eyes*. His text for this film, *Poets in a Barren Age,* is reprinted in a collection of papers, *Moving into Aquarius* (Paladin, 1974).

CHAPTER 2

1. *To Have or To Be,* Erich Fromm (Abacus, 1979).

2. See *The Tao of Physics,* Fritjof Capra; *God and the New Physics,* Paul Davies; *Wholeness and the Implicate Order,* David Bohm, and *The Dancing Wu Li Masters: An overview of the New Physics,* Gary Zukov.

3. The ways of escape from the reality of our situation are legion but none help us to face reality.

4. See *The Turning Point,* Fritjof Capra (Wildwood).

5. My own list would include Aurobindo, Gregory Bateson, Martin Buber, Teilhard de Chardin, Ananda Coomaraswamy, Erich Fromm, Mahatma Gandhi, Ivan Illich, C.G. Jung, Kirshnamunti, James Lovelock, Abraham Maslow, Lewis Mumford, Kathleen Raine, E.F. Schumacher, Wittgenstein. There are, of course many others I could have added.

6. See *Breaking Through,* Walter and Dorothy Schwarz (Green Books, 1987); *Human Scale,* Kirkpatrick Sale (Secker & Warburg, 1980), *New Renaissance, Essays in Search of Wholeness,*

Maurice Ash (Green Books, 1987) and *Global Mind Change: The Promise of the Last Years of the Twentieth Century,* Willis Harman (Knowledge Systems Inc, 1988).

7. The history of 'art', invariably written from a white, male, European standpoint, is in need of total re-vision.

8. *The Ohlone Way,* Malcolm Margolin (Heyday Books, Berkeley, 1978).

9. *Homo Ludens; A Study of the Play Element in Culture,* Johan Huizinga (Paladin, 1970).

10. In contemporary Bali it is as easy to buy cassettes of western pop music as it is in Europe. It is also western pop music which is likely to be heard in the restaurants of the more popular resorts. As for the traditional Gamelan music it is now being taught in a western way in the Conservatoire at Den Pasar, the capital.

11. *Children and Ritual in Bali,* Margaret Mead in J. Belo (editor).

12. From *African Crafts and Craftsmen,* René Gardi (Van Nostrand Reinhold Co., New York, 1969).

13. For a fuller understanding of the Muslim attitude to work see *Islam and the Destiny of Man,* Gai Eaton (George Allen & Unwin, 1985). Dominated by the belief that God is everywhere – which is why the whole world is the Muslim's Mosque or place of prayer – Mohammed Umanama makes beautiful objects because, first and last, he is not only a good craftsman, but a man of religion.

14. I am unable to trace which of Gill's books this quotation comes from. See chapter 8 and Suggested Further Reading.

15. Hölderlin (1770–1843), one of the greatest of Germany's poets.

16. *Working for Ford,* Huw Beynon (Penguin, 1973).

17. Sancta Sophia, Constantinople, is one of the great buildings in the world. It was built under Justinian (527–65).

18. Gilbert and George were awarded the Turner Prize and the accolade of a Hayward Gallery retrospective in 1987.

19. *The Cathedral Builders,* Jean Gimpel (Grove Press, New York, 1961).

20. The original meaning of the word 'artiste' was a member of a university faculty.

21. In the Ducal Palace, Urbino.

22. *Conversations with Claude Lévi-Strauss,* G. Charbonnier (Cape, 1969).

23. *The Annunciation,* painted in c. 1478, is in the Uffizi, Florence.

24. See *Duccio,* John White (Thames and Hudson, 1979).

25. See *The Work of William Morris,* Paul Thompson; *William Morris, Romantic to Revolutionary,* E.P. Thompson, and *William Morris, His Life and Work,* Jack Lindsay.

26. *Hopes and Fears for Art,* 1882.

27. Octavio Paz (b.1914), Mexican poet, writer and diplomat.

28. Andy Goldsworthy is a young artist (he was

born in 1956) who creates from nature's pure materials – stones, leaves, ice, and wood – an unconventional but beautiful and ecological art.

29. Some of Joseph Campbell's books are listed in Suggested Further Reading.

30. *The Decorative Arts,* 1878.

31. See *Engineers of the Imagination,* ed. Tony Coult and Baz Kershaw (Methuen, 1983).

32. From an article by Robin Thornber in *The Guardian,* 11 July 1987.

33. Ananda Coomaraswamy (1877–1947), orientalist, philosopher and art historian. See Suggested Further Reading.

34. *Form in Civilization,* W.R. Lethaby (Oxford University Press, 1957).

35. From *Inter Views* by James Hillman.

36. *Fas: Stadt des Islam* by Titus Burckhardt.

CHAPTER 3

1. From *Revelations of Divine Love* by Julian of Norwich (c. 1343 and after 1413). She is one of our most important mystics.

2. One of many haunting Navajo Night chants c. 1890. A religious Indian could find the energy of himself in every form of life.

3. A small but tragic instance was reported in *The Observer* on 13 March 1988: 'Hapless female dog whelks are growing penises and developing sperm ducts and scientists are "100 per cent certain" that pollution is to blame,' writes Geoffrey Lean. He goes on to say that this 'bizarre transformation – which, naturally, stops them breeding – has been threatening their future and they have disappeared entirely from some parts of the coast'.

4. W.B. Yeats (1865–1939), poet, playwright, and essayist. Yeats must be seen in the context of that 'revolt of soul against intellect now beginning in the world' of which the theosophical movement, Freud and Jung, Surrealism, and the revival of occult and magical studies are various aspects.

5. Gerard Manley Hopkins (1844–89) wrote a dozen or so poems of celebration which are unique in their visionary ecstacy. His *Journal* is also remarkable. Hopkins development of the word 'instress' – a sudden perception of that deeper pattern and unity which gives meaning to external forms – is relevant to the thoughts in this chapter.

6. The Upanishads are sacred Hindu texts whose dates range from 1,000 to 100 BC.

7. Thomas Aquinas (c. 1225–74), Christian thinker who developed his own conclusions from Aristotle. Recognized by the Roman Catholic church as its foremost philosopher and theologian.

8. St Teresa (1515–82), Spanish Carmelite mystic. This quotation comes from her *Life*.

9. See also Samuel Palmer's (1805–1911) visionary landscapes which were produced between 1825 and 1832 when he was living in Shoreham, Kent (Frontispiece).

10. Leos Janácek (1854–1928), the great Czechoslovakian composer, wrote his *Glagolitic Mass* in 1926. Although the mass accepts some conventions of traditional mass-writing, its basic character is quite out of the ordinary. The work is an exuberant hymn to life, a breath-taking affirmation

of the bond between the creator and mankind.

11. Gustav Mahler's (1860–1911) *Eighth Symphony* – the *Symphony of a Thousand* – was composed in 1906. In it he had a specific message to communicate: the impregnation of the entire creative process by a spirit none could escape and with whom all could claim identity.

12. This wonderful pen and brown ink drawing, now in the Uffizi, was made between 1475–80. Sandro Botticelli (1445–1510) is famous for his 'pagan' paintings which are on the whole more 'Christian' than those based on Christian subject matter.

13. Jacques Maritain (1882–1973), influential Thomist philosopher. His *Art and Scholasticism* extracted a coherent aesthetic theory from the writings of the schoolmen. It had a deep influence on Eric Gill.

14. William Blake (1757–1827), poet, painter, and visionary. England's greatest prophet.

15. Henri Bergson (1859–41), exponent of process philosophy and one of the most widely read early twentieth-century thinkers.

16. The Cabbala was originally a body of Jewish doctrines about the nature of God and the vital role of people in God's universe.

17. Francis Bacon (1561–1620), lawyer, courtier, statesman, and philosopher claimed all knowledge as his province. He advocated new ways in which humanity might establish a command over nature.

18. René Descartes' (1596–1650) *Discourse on Method* stands as a landmark in the history of western thought. It left a permanent imprint on later scientific formulations.

19. Friedrich von Schiller (1759–1805), German dramatist, poet, and literary theorist.

20. Marc Chagall (1887–1986), painter, mosaicist, print-maker. This passage comes from his introduction to the catalogue of the Musée du Message Biblique Marc Chagall in Nice.

Perhaps young people and the not so young will come into this house seeking an ideal of brotherhood and love such as my colours and lines have dreamed. Perhaps, too, the love I feel for all men will be put into words here. Perhaps eternity will cease to exist here and, just as a mother gives birth to her child with love and sufering, so the young and not so young will build a world of love with new colours.
And all, whatever their religion, will be able to come here and speak of this dream, far from unkindness and provocation.
Can this dream come true?
But in art, as in life, everything is possible so long as it is based on love.

21. Findhorn, near Forres, Scotland, is the oldest established and most innovative of the so-called New Age communities in Britain.

22. Bede Griffiths, an English Benedictine Monk. He has worked in India since 1955, pioneering attempts to found a Christian community following the customs of a Hindu ashram and adapting itself to Hindu ways of life and thought.

CHAPTER 4

1. David Bomberg (1890–1957), unjustly neglected British painter.

2. Piero della Francesca (c. 1410–20, died 1492). His great series of frescoes, the *Story of the True*

Cross, is in Arezzo. The best book on Piero is by Sir Kenneth Clark (Phaidon).

3. Quotation from the essay *The Best Picture* by Aldous Huxley. This essay is one of many on *Art & Artists,* ed. Morris Philipson (Chatto & Windus, 1960).

4. Robert Bly's anthology *News of the Universe, Poems of Twofold Consciousness* (Sierra Club Books), is especially good on this mutation. See also *Where the Wasteland Ends* by Theodore Roszak and *The Pentagon of Power* by Lewis Mumford. In these studies the importance of the French philosopher René Descartes (1596–1650) is fully developed. Descartes is the founding father of the scientific view of the universe.

5. John Donne (1572–1631), metaphysical poet.

6. Daniel, chapter 4, verse 33.

7. Now in the Tate Gallery.

8. Eadweard Muybridge (1830–1904), American photographer who documented human and animal locomotion.

9. *The Oresteia* by Aeschylus (c. 525–456 BC) consists of three plays, the *Agamemnon,* the *Choephoroe* and the *Eumenides* which form a connected story. The quotation comes from the third.

10. *Francis Bacon* by Michel Leiris (Phaidon), is one of many books on the painter. Bacon is one of the most difficult of all living artists to evaluate justly.

11. *Interviews with Francis Bacon,* David Sylvester (Thames and Hudson, 1975).

12. Rainer Maria Rilke (1875–1926), Austrian poet.

13. From The *body of the Father Christian Rosencrux* in *Ideas of Good and Evil.*

14. Henri Matisse (1869–1954), French painter; with Bonnard, the greatest of the century.

15. *Music* and *The Dance* were originally a commission from the Moscow industrialist Sergei Shchukin. They are now in the Hermitage, Leningrad.

16. Gerald Heard's summary of the Eight Steps – first you must see clearly what is wrong, next you must decide that you want to be cured, then you must act, etc. – have a pertinent contemporary ring.

17. Gary Snyder, contemporary American poet. This quotation comes from *The bioregional Ethic,* an interview with Michael Helm conducted in 1979. It is published in *The Real Work,* (New Directions, 1980).

18. David Jones (1895–1974), poet and painter. *Art & Sacrament* written in 1955, is one of a series of essays collected together in *Epoch & Artist* (Faber, 1959).

19. Amongst the numerous books on Blake see *Blake and the New Age* and *The Human Face of God* by Kathleen Raine, and *William Blake, Prophet of Universal Brotherhood* by Bernard Nesfield-Cookson.

20. One of a series of 102 watercolour drawings (and 7 engraved copper plates) illustrating Dante's *Divine Comedy* which Blake made between 1821 and his death in 1827. He did not live to complete the entire series.

21. Albert S. Roe, *Blake's Illustrations to the Divine Comedy*, 1953.

CHAPTER 5

1. Quoted in *Duccio* by John White (Thames & Hudson, 1979), a standard text on the painter.

2. The official seal was accompanied by the inscription: 'Salvet Virgo Senam Veterem quam signat amenam' – 'May the Virgin preserve Siena the ancient, whose loveliness may she seal.'

3. See *The Gothic Image; Religious Art in France of the Thirteenth Century*, Emile Mâle (Fontana, 1961); *Return of the Goddess*, Edward C. Whitmont (Routledge, 1983); *Alone of all Her Sex: The Myth and the Cult of the Virgin Mary*, Marina Warner (Picador, 1976).

4. *In The Light of Early Italian Painting*, Paul Hills (Yale University Press, 1987)

5. In point of fact the masterpiece which survives is a ruin and a shadow of its former self – only 46 of the original 54 or 58 panels survive and at least a further 15 scenes or figures have been lost. It is 83 ins by 168 ins in size.

6. The names of the saints are written on the panel at the bottom of the picture.

7. The very fact of the inscription reflects the beginning of a change in the hopes and aspirations of artists. Increasingly, self-awareness was accompanied by a growing realization of the artistic value of their creations.

8. Five of the original panels must be considered lost, and eight have now found their way into foreign collections, including the National Gallery of Art, Washington and the Frick Collection in New York. The National Gallery has a beautiful *Annunciation*. (Plate 21).

9. The same is true of all Indian and other traditional art. Traditional art is an expression of devotion, it is the handmaiden of religion. Its purpose is the transmission of divine truths and the cultivation of religious feeling. The function is also social (rather than individualistic) because it seeks to stabilize the community and remind its members – as Duccio did – that they are part of a greater, cosmic, whole; an order that is mirrored in the social order to which they belong. (see Chapter 9)

10. Le Thoronet, Cistercian abbey (near Lorgues in Provence), was constructed between 1160 and 1175.

11. It was left unfinished only seven months later – in the autumn of 1482. The painting is now in the Uffizi, Florence.

12. Giovanni Piranesi (1720–78), Italian etcher of dramatic ruins and architectural views.

13. According to Carlo Pedretti (who wrote *Leonardo; a Study in Chronology and Style* (Thames & Hudson, 1973) the trees under which Mary sits are symbolic of the event. One of these, in the background, is a palm, traditional symbol of peace. The other is probably a carob tree which is called *Locust* or *St John's Bread*, in reference to the belief that the 'locusts' upon which John the Baptist fed were actually carob pods. If so, the figure just below it, with the right hand pointing upwards, would be St John himself. The carob tree was also known as the tree from which Judas hung himself.

Pedretti also suggests that the background represents the pagan world in a landscape of ruins and moral decay as compared with the world of Christian faith in the foreground. But like every other interpreter, he also admits that the

197

iconography of the *Adoration* remains a mystery.

14. The explorer Christopher Columbus (1451–1506) was a close contemporary of Leonardo da Vinci (1452–1519).

15. The notebooks have been published in a number of editions.

16. There are numerous books on Leonardo. I would recommend *Leonardo da Vinci; an Account of His Development as an Artist*, Kenneth Clark (Penguin, 1967).

17. Title of a poem by Dylan Thomas (1914–53).

18. I am indebted to Kenneth Clark's *Leonardo* for these interpretations.

19. James Lovelock developed these ideas in *Gaia; a New Look at Life on Earth* (Oxford University Press, 1979).

20. Giorgio Vasari's work *The Lives of the Most Excellent Italian Architects, Painters and Sculptors* (1550 and, enlarged, 1568) is a source-book of information.

21. *Faust,* part I, scene I, translated by Louis MacNeice.

22. Raphael (1483–1520), Italian painter and architect.

23. The canvas is 104ins by 63ins. The painting, commissioned by the Corps Législatif, hangs in the Palais des Invalides, Paris.

24. For example the mosaic of Christ in the apse at Cefalù or in the dome in Daphni, Greece. In the latter case the figure is represented as the stern judge.

25. Urizen (from the Greek word, to fix a limit) symbolizes reason – the limiter of energy, the lawmaker, and the avenging conscience. The engraving comes from *For Children: The Gates of Paradise,* sixteen little plates, engraved and published by Blake in 1793. An aged, bespectacled Urizen is clipping the wings of youth to prevent him from flying.

26. I am indebted to Kenneth Clark for this interpretation.

27. The portrait (89ins by 56ins) is in the Musée des Beaux-Arts in Liège. I have never seen this painting but in reproduction it has a freshness like a vase of tulips.

28 *Mme Philibert Rivière* is one of a group of three portraits including her husband and daugher who died at the age of fifteen. It is 45ins by 32ins and of oval shape. All three portraits are of a surpassing elegance.

29. *Mme Moitessier,* in the National Gallery, London, is a much later portrait. It is 47ins by 36ins.

30. Agrippa von Nettesheim, one of the great Renaissance magicians of the sixteenth century.

31. Caspar David Friedrich (1774–1840) painted some of the most mysterious pictures of the nineteenth century. He was, as Robert Rosenblum says, 'a pivotal figure in the translation of sacred experience into secular domains'. See *Modern Painting and the Northern Romantic Tradition* (Thames & Hudson, 1975).

32 These words come from the prophetic *Jerusalem* published in 1808. Blake's understanding of the outcome of the Industrial Revolution is uncanny in its devastating accuracy:

They left the Sons of Urizen the plow and
 harrow, the loom
The hammer and chisel and the rule and
 compasses
And all the Arts of Life changed into the arts
 of death in Albion
The hourglass contemned because its simple
 workmanship
Was like the workmanship of the plowman
 and the water-wheel
That raises water into cisterns, broken and
 burnt with fire
Because its workmanship was like the
 workmanship of the shepherd:
And in their stead intricate wheels invented,
 wheel without wheel
To perplex youth in their outgoings and to
 bind to labours
In sorrowful drudgery to obtain a scanty
 pittance of bread in Albion
In ignorance to view a small portion and to
 think it All
And call it Demonstration, blind to all the
 simple rules of Life.

33. *The Golden Age* (18ins by 24ins) is the completed replica of unfinished frescoes at the Chateau de Dampierre. It is in the Fogg Art Museum, Cambridge, Massachusetts.

34. In the Louvre, Paris (94ins by 70ins).

35. In the Louvre, Paris (diameter 42ins).

36. Andy Warhol: *The Artist as Machine* is the title of an essay by Paul Bergin published in *Art Journal* in 1967.

'Elizabeth Taylor is a commercial property, as commercial as a can of Campbell's soup, albeit turned out by a different type of machine. She is a thing of our day and whether we like her or wish

for the old *National Velvet* girl, we cannot escape her, as we cannot escape soup or death. Miss Taylor is the person become machine product – commercial property – and Warhol's portrait of her is the final reduction of the theme of the machine, the central concern of all his work.'

37. Edmund de Goncourt (1822–96), novelist and man of letters; close collaborator of his brother – Jules.

38. Andy Warhol (1930–87).

39. From an essay 'Raggedy Andy' by Calvin Tomkins in *Andy Warhol* by John Coplans (Weidenfeld & Nicholson, 1968). See also *The Philosophy of Andy Warhol (From A to B and Back Again)* (Cassell, 1975).

40. Barbara Rose, *American Painting: The Twentieth Century* (Skira, 1969). The same author, in another book, called Warhol 'one of the principal didactic artists of our time.' Kurt von Meier has described the artist as 'one of the most thoroughly organised and consistent, modest and self-effacing geniuses in the entire history of art'.

41. Francisco Goya (1756–1828) Spanish portrait painter. The 82 etchings of his *Desastres de la Guerra* which were finished when he was seventy-three, reach an abyss of bestiality, diabolism and suffering, not seen in the work of any other artist.

42. *The Informed Heart,* Bruno Bettleheim (Penguin Books, 1986).

43. Galvin Thomas writes:

The fashion crowd went gaga with admiration. Artists were now dictating the new clothing styles, everyone wore a costume, and Andy whose soiled chinos and sneakers had been

superseded by a black leather jacket and silver-sprayed hair, seemed to be everywhere at once. For two years running he was out every night. Passive, pale as death, wearing his strange melancholia like a second skin, he was supremely visible. At the opening of Andy's 1965 show at the Institute of Contemporary Art in Philadelphia, the huge crowd went berserk at their first sight of Andy and Edie Sedgwick on the balcony; they had to be smuggled out of a side door to escape being crushed.

(from *Raggedy Andy,* see note 39 above.)

44. Peter Abbs, *Living Powers: The Arts in Education* (The Falmer Press, 1987).

CHAPTER 6

1. Lippo Memmi (died 1347?) and Simone Martini (1285–1344), both younger masters of the School of Duccio, painted this altar panel. It originally was made in 1333 for an altar in Siena Cathedral.

2. Lilies symbolize purity, peace, and resurrection. The lily also represents the fertility of the Earth Goddess. A branch of lilies depicts virginity, also regeneration and immortality. This complex of meanings adds immeasurably to the painting's transcendent significance.

3. Raissa Oumansouff (or Maritain, as she became after her marriage to Jacques Maritain) (1883–1960).

4. Paul Cezanne (1839–1906), greatest painter of the late nineteenth century; father of modern painting.

5. Roger Fry (1866–1934) Influential English art critic.

6. Performance art considers the human body to be its medium, and seeks to explore themes and emotions through live, unique performance.

7. André Malraux (1901–76), French art-critic, novelist, and politician. His books include *The Voices of Silence.*

8. There are, of course, many others. For example Henri Rousseau, Gustav Klimt, Paul Gauguin, Dante Gabriel Rossetti, James Ensor, Franz Marc, etc. See *Modern Painting and the Northern Romantic Tradition, Friedrick to Rothko,* Robert Rosenblum (Thames & Hudson, 1975) and *Beyond Time and Place; Non-Realist Painting in the Nineteenth Century,* Philippe Robert-Jones (Oxford University Press, 1978).

9. The Musée National Message Biblique Marc Chagall in Nice, France, was inaugurated in 1973. It contains seventeen large paintings based on biblical themes and sculpture, as well as stained glass windows, mosaics, and tapestries by Chagall.

10. On extended loan to the Kunstmuseum, Basle. Whatever the observer may read into this painting, it cannot fail to awaken feelings of tragedy, counteracting a view of Chagall as simply the master of lighthearted fantasy.

11. Quoted from an essay on Chagall in *Art and the Creative Unconscious* by Erich Neumann (Princeton University Press, 1959).

12. Chagall painted a number of pictures featuring Christ's crucifixion. The early *White Crucifixion* (1938) offers a commentary on contemporary events.

13. Quoted from a conversation with Walter Erben in his book *Marc Chagall* (Thames & Hudson, 1957).

14. Bonnard has been largely neglected by art-historians and publishers; there is very little published in English on his work. See *Bonnard at Le Cannet,* Charles Terrasse (Thames & Hudson, 1988).

15. The striking first line of *The World* by Henry Vaughan.

16. *L'Amandier en Fleur* is housed in the Musée National d'Art Moderne, Centre Georges Pompidou, Paris.

17. Brother Lawrence (1611–91), Carmelite friar, author of *The Presence of the Practice of God.*

18. John Ruskin (1819–1900), author of books on art and society whose modernity of message has yet to be rediscovered. See *The Darkening Glass,* John D. Rosenburg (Routledge & Kegan Paul, 1963); the same author's *The Genius of John Ruskin, Selections from his Writings* (Routledge & Kegan Paul, 1979); *John Ruskin, the Argument of the Eye,* Robert Hewison (Thames & Hudson, 1976); *Ruskin Today,* chosen and annotated by Kenneth Clark (Penguin Books, 1964).

19. Philippians, chapter 4, verse 8.

20. Dionysius the Areopagite (writing between 475 and 525) is the pen name of an unknown writer of three major works on mysticism. Strong influence on all medieval mystics.

21. His parents' house, *Fernlea,* and its neighbour, *Belmont,* figure together in one of Spencer's most famous paintings, *Christ Carrying the Cross* (1920) in the Tate Gallery. In this painting their ugliness has been redeemed, to use a favourite expression of the artist.

22. The letter, dated March 1917, was addressed to Desmond Chute, then a boy at Downside – he subsequently became a Catholic priest. Stanley Spencer served in the Royal Army Medical Corps, first in Bristol, then until the end of the war in Macedonia. His letter to Chute was first published in 1919 in a short-lived and occasional Catholic magazine, *The Game,* edited by Hilary Pepler in close association with Eric Gill and Edward Johnson. It is published in full in *Stanley Spencer: The Man: Correspondence and Reminiscences* edited by John Rothenstein (Paul Elek, 1979).

Spencer was no convert to Christianity in an institutional sense. In fact, no man could have been less fitted, by temperament or intellect, to belong to any institutional religion, the Catholic least of all. Nonetheless, he believed in God and Christ more passionately than most Christians and spoke not infrequently of his terror of Hell. For Spencer religion meant much more than church; it meant many things, sexuality in particular.

23. *The Nativity* oil on panel 40ins by 60ins belongs to University College, London.

24. *Zacharias and Elizabeth* oil on canvas, 60ins by 60ins is in the collection of Lady Bone.

25. Luke, chapter 1, verse 6.

26. Written in an introduction to a retrospective exhibition of his work at the Tate Gallery in 1955.

27. Spencer's visionary works, like Palmer's, were the product of a short period: 1910–16. In these years he painted *Swan Upping at Cookham* (1915), *Mending Cowls, Cookham* (1914), *The Centurion's Servant* (1914–15), and the study for *Joachim among the Shepherds* (1912). *Christ Carrying the Cross* (1920) and *The Resurrection, Cookham* (1923–7). Many of the Burghclere Chapel paintings – all possess the same visionary element.

28. In Van Gogh the experience of beauty is an experience of the divine.

29. *Eclipse of the Sunflower* (28ins by 36ins) is in the possession of the British Council.

30. *Solstice of the Sunflower* (28ins by 36ins) is in the possession of the National Gallery of Canada, Ottowa.

31. See *Interior Landscapes; a Life of Paul Nash* by James King (Weidenfeld & Nicholson, 1987) and *Paul Nash* by Andrew Causley (Oxford: The Clarendon Press, 1980).

32. In this respect the art of Norman Adams, Milton Avery, Adrian Berg, Alan Davie, Andy Goldsworthy, Morris Graves, Andrzej Jackowski, Ken Kiff, and Gulam Mohammed Sheikh, seems especially worth watching though I am not familiar with the full range of their work.

33. Paul Klee's writings are amongst the most wide-ranging and perceptive as any twentieth-century artist.

34. See n.1 above.

35. *The Promise* is in the Tate Gallery, London. It is an oil on plywood, 20ins by 24ins.

36. Fydor Dostoyevsky (1821–91), Russian novelist.

CHAPTER 7

1. *Cecil Collins: The Quest for the Great Happiness,* William Anderson (Barrie & Jenkins).

2. Like many deeply imaginative men and women Stanley Spencer received no formal education.

3. William Blake and Cecil Collins, in many ways dissimilar, both affirm the centrality of the Divine Imagination.

4. See the interview with Brian Keeble printed in *Temenos I,* 1981.

5. Quotations from Alexander Gilchrist's *The Life of William Blake* (Dent).

6. See n.4 above.

7. Mark Tobey (1890–1976) is probably best known today for the mature work of his fifties and sixties. He is a delicate and refined abstractionist who anticipated Jackson Pollock's all-over style –an artist of mystical bent, distinguished by his introduction of oriental technique and aesthetic to the modern western tradition.

8. See *The Elmhirsts of Dartington,* Michael Young (Routledge & Kegan Paul, 1982).

9. From an interview with Edward Lucie-Smith in 1981.

10. In the ownership of Cecil and Elizabeth Collins.

11. In the collection of the Dartington Hall Trust.

12. *The Vision of the Fool,* first published in 1947, was republished in 1981 by Anthony Kedros Ltd. Both editions are out of print.

13. See n.4 above.

14. *The Wounded Angel* (1967) is in a private collection. It is 36ins by 30ins.

15. *Angel of the Flowing Light* (1968) is in the Tate. It is 48ins by 41ins.

16. Interview on 19 April 1986.

17. Quoted in an article 'The Poet's Vision' by Philip Vann in *The Artist*, January 1986.

18. Directed by Stephen Cross in 1978.

19. There is also a BBC film, *Fools and Angels,* directed by Christopher Sykes and produced by Jonathan Stedall. It was first shown in 1984.

20. *The Golden Wheel* (1958) is in the collection of the Tate Gallery. It is 36ins by 48ins.

21. *Landscape of the Unknown God* is in the collection of Manchester City Art Gallery. It is 36ins by 48ins.

22. *Sun Head* was one of many lithographic prints produced in 1960, an exceptionally productive year.

23. Odilon Redon (1840–1916), French painter and print-maker.

24. Gustav Moreau (1826–98), French symbolist painter.

25. *Fool and Flower* (1944), a pen and ink drawing and a roneo print.

26. See n.1 above.

27. See n.16 above.

28. Marcel Duchamp (1887–1968), probably the most important avant-garde *provacateur* of the Modern movement.

29. See n.16 above.

CHAPTER 8

1. Georg Baselitz, a highly successful contemporary German Expressionist painter.

2. Britten's life in Aldeburgh and contribution to its festival is well recorded. The contribution of the poet and novelist George Mackay Brown to the culture of Orkney is less well known.

3. Bernard Leach (1887–1979), English potter and writer, wrote at length about the subject of this chapter:

> That these humble, ordinary, unknown artists of the past help to set us a standard is an encouragement, for it offers prospect as well as retrospect, art as part of normal life, not something separate or reserved for superior people. It tells of a buried potential in us, cut off from expression by our post-industrial way of life. But the over-flowing life-force and sensibility of exceptional talent is not thereby excluded.

See Bernard Leach, *Beyond East and West* (Faber & Faber, 1978), and other books.

4. Michael Cardew (1901–83), English potter. Cardew's favourite axiom is one he borrowed from Coomaraswamy – 'an artist is not a special kind of man, but every man is a special kind of artist'. He also said:

> Amateur, professional – how I hate those rigid categories. Amateur just means you love it; professional merely means that you are good enough at it to earn your living that way. But a good professional, if he stays alive, will never lose the spark and the freshness, even some of the clumsiness coming from his probably amateur beginnings. And the amateur is always

being drawn on inevitably by glimpses of things that at the beginning he never thought were in his range.

See Michael Cardew, *Pioneer Potter* (Longman, 1969), and *A Pioneer Potter: an Autobiography* (Collins, 1988), also Garth Clark *Michael Cardew* (Faber & Faber, 1978).

5. Richard Boston wrote the introduction to the catalogue of a touring exhibition of David Drew's baskets, illustrated by photographs by Chris Chapman. It was published by the Crafts Council in 1986.

6. Robert Pirsig, *Zen and the Art of Motorcycle Maintenance* (Bodley Head, 1974).

7. Ben Nicholson (1894–1982), English painter.

8. The Seven and Five Society included Ben and Winifred Nicholson, Henry Moore, Barbara Hepworth, Christopher Wood, John Piper, and Ivon Hitchens.

9. Piet Mondrian (1872–1944), Constantin Brancusi (1876–1957) and Hans Arp (1887–1966), leading Modernist painters and sculptors.

10. *Unknown Colour: Paintings, Letters, Writings* was published by Faber & Faber in 1988. See also the Tate Gallery Catalogue written by Judith Collins and published in 1987.

11. Martin Buber (1878–1965), Austrian theologian. The book from which this concept comes is *I and Thou.*

12. From an essay, *King Pellinore's wife,* published in *Unseen Colour.* It is undated.

13. Kathleen Raine has written on more than one occasion of her friend's work. See *The unregarded happy texture of life* in *Unseen Colour* and *Winifred Nicholson's flowers* in *Temenos* 8, 1987.

14. Jacob Boehme (1575–1624), one of the giants of mysticism. Author of *The Signature of All Things.*

15. Oil on board, 22¼ by 26¼ins. In the possession of the artist's family.

16. From *Art Nonsense and other Essays,* 1929.

17. William Morris (1834–96), poet, master-craftsman, and social critic.

18. Henry Thoreau (1817–62), American writer, author of *Walden.*

19. E.F. Schumacher (1911–77), economist; author of *Small is Beautiful* and other books.

20. René Guenon (1886–1951), French metaphysician. Author of *The Reign of Quantity.*

21. Ananda Coomaraswamy (1877–1947), social critic, art historian, and interpreter of the *philosphia perennis.*

22. W.R. Lethaby (1857–1931), principal of the Central School of Arts and Crafts, author and practising designer.

23. Published in 1944.

24. Gill also said: 'As the priest brings God to the marriage, the artist brings God to the work. All free workmen are artists. All workmen who are not artists are slaves.' *Art Nonsense and other Essays,* 1929.

25. *Art Nonsense and other Essays,* 1929.

26. Quoted in *The Life of Eric Gill,* Robert Speaight (Methuen, 1966). The diary entry was for October 1927. Kessler (1868–1937), a diplomat, writer, and patron of the arts counted numerous artists and poets among his friends.

27. David Jones (1895–1970), poet, painter, and friend of Gill's. See his *Appreciation* of Eric Gill, 1940, published in *Epoch and Artist.*

28. Quoted in *Eric Gill, Man of Flesh and Spirit,* Malcolm Yorke (Constable, 1981).

29. The *Autobiography* was published by Jonathan Cape in 1940 but is, like Gill's other books, now out of print. For the best of Gill's writing see Brian Keeble's excellent anthology, *A Holy Tradition of Working, Passages from the Writings of Eric Gill* (Golgonooza Press, 1983).

30. From the Foreword to *Recollected Essays.*

31. From a poem, *The Law that Marries All Things* in *The Wheel.* It was written in 1982.

32. Quoted from 'Notes: unspecializing poetry' published in *Standing by Words.*

33. As well as a poet and essayist, Wendell Berry has written a number of outstanding novels including *Nathan Coulter, A Place on Earth, The Memory of Old Jack* and a collection of stories, *The Wild Birds.*

34. *Irish Journal,* 1982, is published in *Home Economics.*

35. Quoted from *Two Economies,* 1983, published in *Home Economics.* The Blake quotation comes from *Jerusalem.*

36. From *The loss of the University,* 1984, in *Home Economics.*

37. AE was the pen name of George Russell (1867–1935). Key figure author in Irish literary renaissance, editor of *The Irish Homestead.*

38. William Blake.

39. From the *Autobiography.* The full quotation is:

> If I might attempt to state in one paragraph the work which I have chiefly tried to do in my life it is this: to make a cell of good living in the chaos of our world. Lettering, type-designing, engraving, stone-carving, drawing – these things are all very well, they are the means to the service of God and of our fellows and therefore to the earning of a living, and I have earned my living by them. But what I hope above all things is that I have done something towards re-integrating bed and board, the small farm and the workshop, the home and the school, earth and heaven.

All the published biographies seem to agree that Gill succeeded in this attempt.

CHAPTER 9

1. As indicated in the notes to chapter 2 the number of books on this subject is considerable.

2. Studies of the effect of these divisions which tear our lives apart with schizophrenic force are also legion. See, for example, Wendell Berry's *Unsettling of America,* a detailed examination of the effects of alienation on agriculture and community; or Capra's *Turning Point* for a study of its effects on health care. See also Edward Goldsmith's *The Great U-Turn* (Green Books, 1988).

3. See *The Speaking Tree: A Study of Indian Culture and Society,* Richard Lannoy (Oxford University Press, 1971).

4. From an essay *What has India contributed to human welfare?,* first published in 1915 and reprinted in *The Dance of Shiva.* See also *The part of art in Indian life* reprinted in *Selected Papers: Traditional Art and Symbolism* (Princeton University Press, 1977). Almost anything Coomaraswamy wrote is relevant here.

5. See *In the Image of Man: the Indian Perception of the Universe through 2,000 years of Painting and Sculpture* (Arts Council of Great Britain, 1982) and *The Art and Architecture of India* (Pelican, 1977).

6. Rabindranath Tagore (1861–1941), greatest of modern Indian writers, best known for his poems and songs which express his religious feelings. His religion was a poet's religion, his theory of art even more so. 'All that I feel about it,' he says, 'is from vision and not from knowledge.'

7. See *The Earthen Drum: an Introduction to the Ritual Arts of India,* Pupul Jayakar (National Museum, New Delhi); *Handicrafts of India,* Kamaladevi Chattopadhay (Indian Council for Cultural Relations, 1975); and *Indian Folk Art* (Heinz Mode, Alpine Fine Arts Collection Ltd, 1985).

8. See *Pathway Icons: the Wayside Art of India,* Priya Mookerjee (Thames & Hudson, 1987), and *Ritual Art of India,* Ajit Mookerjee (Thames & Hudson, 1985).

9. *Lady Chatterley's Lover,* was finished in 1928.

10. Ben Nicholson in J.L. Martin, B. Nicholson, and N. Gabro (eds), *Circle* (Faber & Faber, 1938).

11. *Crime and Punishment,* finished in 1866.

12. *Creativity and Levity,* Alan McGlashan (Chatto & Windus, 1936).

13. From Dante's *Divine Comedy.*

14. From the *Chandogya Upanished* of perhaps the sixth century B.C. The human soul, it says, is 'smaller than a grain of rice, or a grain of barley, or a grain of mustard seed', but also 'greater than the earth, greater than the sky, greater than the heaven itself, greater than all these worlds'.

206

Suggested Further Reading

Acquaviva, S.S. *The Decline of the Sacred in Industrial Society* (Oxford University Press, 1979).

Alexander, Christopher, *The Timeless Way of Building* (Oxford University Press, 1980).

Anderson, William, *Cecil Collins: The Quest for the Great Happiness* (Barrie and Jenkins, 1988).

Apostolos, Cappandola (ed.) *Art, Creativity and the Sacred: An Anthology in Religion and Art* (Crossroad, 1984).

Arguelles J.A. *The Transformative Vision; Reflections on the Nature and History of Human Experience* (Shambhala, 1982).

Bancroft, Anne, *Origins of the Sacred* (Routledge, 1987).

Bateson, Gregory. *Mind and Nature* (Wildwood House, 1979).

——— · *Steps to an Ecology of Mind* (Paladin, 1973).

Begg, Ean, *Myth and Today's Consciousness* (Coventure, 1984).

Berger, John, *Success and Failure of Picasso* (Penguin, 1965).

——— · *The Moment of Cubism* (Weidenfeld & Nicholson, 1969).

——— · *Ways of Seeing* (Penguin, 1972).

Berman, Morris, *The Re-enchantment of the World* (Cornell University Press, 1981).

Berry, Wendell, *A Continuous Harmony* (Harcourt Brace & Jovanovich, Inc. 1972).

——— · *The Unsettling of America* (Sierra Club Books, 1978).

——— · *Recollected Essays* (North Point Press, 1981).

——— · *The Gift of Good Land* (North Point Press, 1981).

——— · *Standing by Words* (North Point Press, 1983).

——— · *Home Economics* (North Point Press, 1987).

Blake, William, *Poetry and Prose* (various editions).

Bly, Robert, *News of the Universe. Poems of Twofold Consciousness* (Sierra Club, 1980).

Bohm, David, *Wholeness and the Implicate Order* (Routledge, 1980).

Burckhardt, Titus, *Sacred Art in East and West* (Perennial Books, 1967).

Campbell, Joseph, *The Masks of God: Primitive Mythology* (Penguin, 1982).

——— · *The Way of the Animal Powers* (Times Books, 1984).

——— · *Myths to Live By* (Paladin Books, 1985).

Capra, Fritjof, *The Tao of Physics* (Wildwood House, 1975).

——— · *The Turning Point* (Wildwood House, 1982).

Collins, Cecil, *The Vision of the Fool* (Anthony Kedros, 1981).

Coomaraswamy, Ananda, *The Transformation of Nature in Art* (Dover, 1956).
—— · *Christian and Oriental Philosophy of Art* (Dover, 1957).
—— · *Selected Papers I: Traditional Art and Symbolism,* ed. R. Lipsey (Princeton University Press, 1977).
—— · *Selected Papers II: Metaphysics,* Ed. R. Lipsey (Princeton University Press, 1977).
—— · *The Bugbear of Literacy* (Perennial Books, 1979).
—— · *The Dance of Shiva* (Dover, 1985).
Copland, Aaron, *Music and Imagination* (Oxford University Press, 1952).
Dames, Michael, *The Avebury Circle* (Thames & Hudson, 1977).
—— · *The Silbury Treasure* (Thames & Hudson, 1984).
Eco, Umberto, *Art and Beauty in the Middle Ages* (Yale University Press, 1986).
Eliade, Mircea, *The Sacred and the Profane* (Harcourt Brace & World, Inc. 1959).
—— · *Myths, Dreams and Mysteries* (Harper Torchbooks, 1960).
—— · *The Forge and the Crucible* (University of Chicago Press, 1979).
Eliot, T.S. *Selected Prose of T.S. Eliot,* ed. F. Kermode (Faber & Faber, 1975).
Fischer, Ernst, *The Necessity of Art; a Marxist Approach* (Penguin, 1963).
Fromm, Erich, *Man for Himself* (Routledge & Kegan Paul, 1949).
—— · *The Sane Society* (Routledge & Kegan Paul, 1971).
—— · *To Have or to Be* (Jonathan Cape, 1976).
Fuller, Peter, *Beyond the Crisis in Art* (Writers & Readers, 1980).
—— · *Aesthetics after Modernism* (Writers & Readers, 1983).
—— · *Images of God* (Chatto & Windus, 1985).
—— · *The Australian Scapegoat* (University of Western Australia Press, 1986).
—— · *Theoria: Art and the Absence of Grace* (Chatto & Windus, 1988).
Gablik, Suzi, *Has Modernism Failed?* (Thames & Hudson, 1984).
—— · *The Re-enchantment of the Arts* (Thames & Hudson, 1988).
Gill, Eric, *Autobiography* (Jonathan Cape, 1940).
—— · *A Holy Tradition of Working; Passages from the Writings of Eric Gill,* ed. B. Keeble (Golgonooza Press, 1983).
Godwin, Joscelyn, *Harmonies of Heaven and Earth; the Spiritual Dimension of Music from Antiquity to the Avant-Garde* (Thames & Hudson, 1988).
Graves, Robert, *The White Goddess* (Faber, 1971).
Guénon, René, *The Reign of Quantity* (Penguin Books, 1972).
—— · *Crisis of the Modern World* (Lucaz, 1975).
Handy, Charles, *The Future of Work: a Guide to a Changing Society* (Basil

Blackwell, 1984).

Hillman, James, *Revisioning Psychology* (Harper & Row 1977).

———— · *The Myth of Analysis* (Harper & Row, 1978).

———— · *Archetypal Psychology* (Spring Books, 1983).

———— · *Inter Views, with Laura Pozzo* (Harper & Row, 1983).

———— · *Suicide and the Soul* (Spring Publications, 1985).

Huizinga, Johan, *Homo Ludens: a Study of the Play Element in Culture* (Paladin, 1970).

Huxley, Francis, *The Way of the Sacred* (Aldus Books, 1974).

Hyde, Lewis, *The Gift, Imagination and the Erotic Life of Property* (Random House, 1983).

Jennings, Humphrey, *Pandemonium* (Andre Deutsch, 1985).

Jones, David, *Epoch and Artist* (Faber, 1959).

———— · *The Dying Gaul* (Faber, 1974).

Jung, Carl, G. *Memories, Dreams, Reflections* (Random House, 1965).

———— · *The Spirit in Man, Art and Literature* (Routledge & Kegan Paul, 1967).

———— · *Letters: Two Volumes* (Routledge & Kegan Paul, 1973).

———— · *Symbols of Transformation* (Routledge & Kegan Paul, 1981).

———— · *Modern Man in Search of a Soul* (Ark, 1984).

Kandinsky, Wassily, *Concerning the Spiritual in Art* (Dover, 1977).

Lipsey, Roger, *An Art of our Own* (Shambhala, 1988).

Mabey, Richard, (ed.), *Second Nature* (Jonathan Cape, 1984).

Marcuse, Herbert, *The Aesthetic Dimension* (Macmillan, 1979).

Maritain, Jacques, *Creative Intuition in Art and Poetry* (Princeton University Press, 1977).

Massingham, H.J. *Men of Earth* (Chapman & Hall, 1943).

———— · *The Tree of Life* (Chapman & Hall, 1943).

———— · *The Wisdom of the Fields* (Collins, 1945).

Morris, William, *Lectures and Essays* (Various publishers).

Mumford, Lewis, *Art and Technics* (Columbia University Press, 1952).

———— · *The Pentagon of Power* (Secker & Warburg, 1971).

———— · *Interpretations and Forecasts 1922–1972* (Harcourt, Brace, 1972).

Nasr, Seyyed Hossein, *Man & Nature; the Spiritual Crisis of Modern Man* (Unwin paperback, 1976).

———— · *Knowledge and the Sacred* (Edinburgh University Press, 1981).

———— · *Islamic Art and Spirituality* (Golgonooza Press, 1986).

Neumann, Erich, *The Great Mother* (Princeton University Press, 1972).

———— · *Art and the Creative Unconscious* (Princeton University Press, 1974).

Ortega Y Gasset, José, *Velazquez, Goya and the Dehumanisation of Art* (Studio Vista, 1972).

————· *The Revolt of the Masses* (University Notre Dame Press, 1985).

Raine, Kathleen, *Blake and the New Age* (Allen & Unwin, 1979).

————· *The Inner Journey of the Poet* (Allen & Unwin, 1982).

————· *Defending Ancient Springs* (Golgonooza Press, 1985).

————· *Yeats the Initiate* (Dolmen Press, 1986).

Read, Herbert, *To Hell with Culture* (Kegan Paul, 1941).

Regamey, P.R. *Religious Art in the Twentieth Century* (Herder & Herder, New York, 1963).

Robertson, James, *Future Work: Jobs, Self-employment and Leisure After the Industrial Age* (Gower/Maurice Temple Smith, 1985).

Robertson, S.M. *Rosegarden and Labyrinth: a study in Art Education* (Spring Books, 1982).

Rosenberg, John D. (ed.), *The Genius of John Ruskin; Selections from his Writings* (Routledge & Kegan Paul, 1979).

————· *The Darkening Glass* (Routledge & Kegan Paul, 1963).

Rosenblum, Robert, *Modern Painting and the Northern Tradition; Friedrich to Rothko* (Thames & Hudson, 1978).

Roszak, Theodore, *Making of a Counter Culture* (Faber, 1970).

————· *Where the Wasteland Ends* (Faber, 1972).

————· *Person/Planet: the Creative Disintegration of Industrial Society* (Victor Gollanz, 1979).

Sangharakshita, *The Religion of Art* (Windhorse Publications, 1988).

Schumacher, E.F. *Good Work* (Jonathan Cape, 1979).

Schuon, Frithjof, *The Essential Writings of Frithjof Schuon* ed. S.H. Nasr (Amity House, 1988).

————· *Transcendent Unity of Religions* (Theosophical Publishing House, 1984).

Small, Christopher, *Music – Society – Education: a Radical Examination of the Prophetic Function of Music in Western, Eastern and African Cultures with its Impact on Society and its Use in Education* (John Calder, 1977).

Storr, Anthony, *The Dynamics of Creation* (Secker & Warburg, 1972).

Tarkovsky, Andrey, *Sculpting in Time; Reflections on the Cinema* (Bodley Head, 1986).

Temenos, A Review Devoted to the Arts of the Imagination: Volumes 1 to 9, ed. K. Raine, 1981 onwards.

Tippet, Michael, *Moving into Aquarius* (Paladin Books, 1974).

Van der Post, Laurens, *Jung and the Story of our Time* (Hogarth Press, 1976).

Weidlé, Vladimir, *The Dilemma of the Arts* (SCM Press, 1948).

Whitmont, Edward, *The Symbolic Quest* (Princeton University Press, 1969).

————· *Return of the Goddess* (Routledge & Kegan Paul, 1983).

Wilson, F.A. *Art as Revelation* (Centaur Press, 1981).

——— · *A Vision* (Macmillan, 1978).

Yeats, W.B. *Essays & Introductions* (Macmillan, 1980).

——— · *Selected Criticism and Prose,* ed. N. Jeffares (Pan Books, 1980).

Yanagi, Soetsu, *The Unknown Craftsman* (Kodansha International Ltd, 1972).